INTRODUCTION BY

JAMES A. MICHENER

EDITED BY

GEORGE S. BUSH

The Genius Belt

The Story of the Arts in Bucks County, Pennsylvania

PUBLISHED BY THE
James A. Michener Art Museum

IN ASSOCIATION WITH
The Pennsylvania State University Press

Library of Congress Catalog Number 96-78366

James A. Michener Art Museum
 ISBN 1-879636-08-5 (cloth)
 ISBN 1-879636-07-7 (paper)
The Pennsylvania State University Press
 ISBN 0-271-01672-8 (cloth)
 ISBN 0-271-01673-6 (paper)

Design and Production: Tracy Baldwin
Copyediting: Paula Brisco
Picture Research: Susan Gray Detweiler
Photography: Rick Echelmeyer, Frank Pronesti, and Chris Whitney
Printing and Binding: Thomson-Shore, Inc.

Front cover, left to right:
Edward Hicks, *The Peaceable Kingdom*, c. 1837. Courtesy of the Mercer Museum of the Bucks
 County Historical Society
S. J. Perelman. Photograph by Maynard Clark. Courtesy of the James A. Michener Art
 Museum
Oscar Hammerstein II. Courtesy of The Rodgers & Hammerstein Organization
James A. Michener. Courtesy of the Urban Archives, Temple University, Philadelphia,
 Pennsylvania
Pearl S. Buck. Courtesy of The Pearl S. Buck Foundation, Inc.
Harpo Marx. Courtesy of Anne Kaufman Schneider
Henry Chapman Mercer. Courtesy of the Spruance Library, Bucks County Historical Society
Daniel Garber, *The Studio Wall*, 1914. Courtesy of The James A. Michener Art Museum
Back cover, right to left:
Lloyd ("Bill") Ney. Photograph by Jack Rosen. Courtesy of the James A. Michener Art
 Museum
St. John Terrell. Courtesy of St. John Terrell
William Lathrop. Photograph by Robert Neff Longacre, from *American Magazine*, November
 1927. Courtesy of William Lathrop Bauhan
Daniel Garber. Courtesy of the Garber family
George Nakashima. Courtesy of the Nakashima Studio
Newspaper fragment, 1930s. Courtesy of J. Carroll Molloy, Realtor

Contents

Imagine being forced from your home by government authorities and incarcerated in the stall of a prize racehorse, simply because of your racial heritage. As a young woman during World War II, Mari Sabusawa Michener not only endured this injustice, but was later imprisoned in an internment camp for Japanese Americans located only

Mari Sabusawa Michener (1920–1994)

seventy-five miles from her birthplace in Las Animas, Colorado. This experience was one of the defining moments of her life. From then on, she was committed to the cause of racial tolerance, eventually working for the American Council on Race Relations and becoming a major contributor to several organizations devoted to improving Japanese/American relations.

She could not have found a more passionate supporter of these beliefs than her husband, Bucks County native James A. Michener, whose impoverished childhood and Quaker upbringing taught him about the evils of intolerance. Following their marriage in 1955, Mari Michener became the author's friend, confidante, and constant companion in his nonstop journeys around the world. She was also an energetic partner in his activities as an art collector, taking an especially active role in building their collection of twentieth-century American paintings. After a long struggle with cancer, she died in her husband's arms on September 25, 1994.

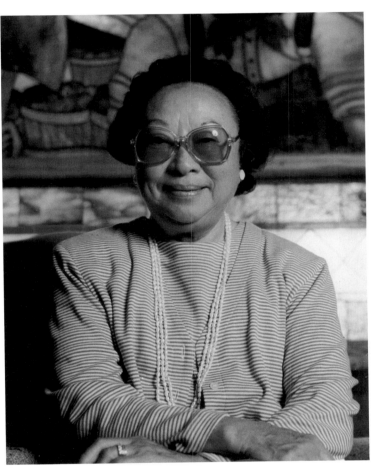

Mari Sabusawa Michener
Photograph by John Blake. Courtesy of
the University of Northern Colorado.

Aware of the need to honor the contributions of artists to society, she left the people of Bucks County a final gift: a $5 million bequest earmarked for the construction and operation of a permanent monument to the county's rich artistic tradition, located at the James A. Michener Art Museum. This new wing, which opened to the public on October 27, 1996, was appropriately named in her honor. It will be a fitting tribute to her generosity and vision for generations to come.

Contributors

George S. Bush, formerly an editor at the old *Saturday Evening Post, Look,* and *Better Homes and Gardens,* is the author of six business histories and more than 700 national-magazine articles and stories.

James A. Michener has authored more than forty major works of fiction and nonfiction, including such best-sellers as *Hawaii, Texas,* and *Centennial.* He won the Pulitzer Prize for fiction in 1948 for *Tales of the South Pacific.*

Dorothy Herrmann is the author of *S. J. Perelman: A Life* (Putnam's, 1986), *Anne Morrow Lindbergh: A Gift for Life* (Ticknor and Fields, 1992), and *With Malice Toward All* (Putnam's, 1982). She is currently working on a biography of Helen Keller, to be published by Alfred A. Knopf.

Philip Ruth is the author of seven nonfiction works on Pennsylvania regional history, and a frequent contributor to cultural resource studies of sites throughout the Commonwealth. His published works include pictorial histories of townships, boroughs, schools, businesses, and families. Ruth is descended from several generations of Bucks County farmers through his paternal grandfather.

Cleota Reed, a Research Associate of Syracuse University's Department of Fine Arts, is the author of *Henry Chapman Mercer and the Moravian Pottery and Tile Works* (University of Pennsylvania Press, 1987) and other books and articles concerning American ceramic art, stained glass, and the Arts and Crafts Movement. She is consultant archivist of the Syracuse China Company's historical collection and is preparing a book on that subject.

Patricia Tanis Sydney is the Associate Curator of Exhibitions at the James A. Michener Art Museum, where she curated *Katharine Steele Renninger: A Retrospective* (1995). A graduate of Mount Holyoke College, she received an M.A. and Ph.D. in the history of art from the University of Pennsylvania and an M.A.T. from Brown University. She has taught at Drew University, Massachusetts College of Art, and Temple University.

St. John Terrell (pronounced "Sinjin") was born in 1916 in Chicago. He broke into show business at age sixteen, when he was the first Jack Armstrong in the famous radio series *Jack Armstrong: The All-American Boy.* He later attended Columbia University and in 1935 made his first appearance

on Broadway in the play *Winterset*. Terrell moved to Bucks County in 1938 and founded both the Bucks County Playhouse (1939) and the Lambertville Music Circus (1949). He lives in Ewing Township, New Jersey, with his wife and two daughters.

W. **Lester Trauch** graduated in 1925 from Doylestown High School and was a classmate of James A. Michener. Trauch was employed for forty-seven years by *The Intelligencer*, a Doylestown newspaper, as a member of the news staff. He served thirty-four months in the Pacific Ocean area in the army, including the Battle of Okinawa.

Foreword

Many American children dream about stepping up to home plate, locking their fingers around a Louisville Slugger, and staring coolly at the pitcher. With the roar of the crowd ringing in their ears, they swing at a blazing fastball. The bat rings out with a loud crack, the ball sails over the heads of the stunned outfielders, and the scoreboard proclaims, "HOME RUN!"

Why does baseball ignite such powerful feelings in the hearts of so many children? What basic human need is fulfilled by scoring a home run and helping your team to win? Expressed in the simplest terms, it is the desire to "be somebody." Sports have long served as a magic passageway that can transform an anonymous teenager into an American hero. Anyone can attempt the journey. The trip is not easy, and few will emerge victorious. Success will require talent, discipline, confidence, and the stamina to keep striving for the elusive goal. We admire athletes for their physical abilities, but sports are not only about strength or speed. Our modern-day gladiators remind us about the power of the human spirit, as well as our own dreams about achievement and heroism.

The arts offer a similar calling, and present a similar dream: to sing an aria at the Metropolitan Opera, to write a screenplay for a Hollywood film, to hang your pictures on the walls of the Museum of Modern Art, or to dance on a Broadway stage. The nature of the talent may be different, but the discipline, the long struggle, the desire for success, and the need for unwavering self-belief make the artist and the athlete very similar.

The artist also brings something unique to the public arena. To be an artist is to have a voice, a message, a vision. The artist understands some small essence of our world, and communicates that knowledge with his or her work. The artist can touch our souls and help us to experience the universal human drama. Art can transport us from our everyday lives to a more spiritual plane, where we willingly give up control of our senses and feelings, and in the process gain a richer knowledge of our place in the cosmos.

Like Sparta of ancient Greece, our society has been quick to praise the heroes of sport but slow to reward the artists. All too often, while we worship in awe before great works of art in our museums and concert halls, we treat the artist in our neighborhoods with suspicion. Artists are often seen as subversive, unproductive, and peripheral members of society, and these negative attitudes go back hundreds of years. Colonial and nineteenth-century America usually looked abroad for artistic excel-

lence, and our Puritan forebears questioned the need for art altogether.

Yet as our nation has become more confident, and our culture has broadened its influence around the globe, we have begun to take the first small steps toward recognizing the importance of the artistic talent that our great democracy has nurtured. We at the Michener Art Museum believe that this book and the related commemorative exhibition, installed in the Mari Sabusawa Michener Wing, represent one of those small steps.

While there have been many fertile gardens for artists in America's rural heartland, it's clear that one of the most significant exists in Bucks County, Pennsylvania. Bordered on the east by the Delaware River and located within two hours' driving distance of both Philadelphia and New York City, Bucks County has been the home of thousands of artists whose influence extends far beyond the county's borders. Offering a unique mixture of natural beauty, Quaker tolerance, colonial history, and the sophisticated influence of two great cities, the County of Bucks has been a quiet sanctuary for artists for more than 200 years—a place where some of our nation's best creative minds have lived and worked as accepted members of the community.

The Genius Belt tells the story of Bucks County's artistic heritage. And what a colorful and exciting tale it is! Our hope is that this book will not only serve to celebrate our own rich creative history, but will draw attention to the much larger story of the importance of the arts in America, a story that still needs to be told.

This book would never have come to fruition without the help of many dedicated people. Members of the museum staff contributed in a variety of ways. Our able curator, Brian Peterson, offered intellectual leadership and administrative skill throughout the project. My partnership with Brian has helped me to move both the book and exhibition project forward with professionalism and grace. Erika Smith did a yeoman's job securing the rights for a diverse group of photographs that help to tell the story in pictures. My neighbor and friend George Bush brought his many years of editing talent to the project. Jim Michener served as a hands-off counselor who willingly shared his knowledge and memories about the artists from our county. Michener's gentle manner and honorable soul have served as an inspiration for many of us in this community.

Dorothy Herrmann particularly wishes to thank Bucks County historian Francis M. Curley and Janet Holbrook of Rivergate Books in Lambertville, New Jersey, for their kind assistance in the preparation of her article.

Phil Ruth extends his gratitude to Francis M. Curley, St. John Terrell, W. Lester Trauch, the New Hope-Solebury Free Library, and the Spruance Library of the Bucks County Historical Society.

Cleota Reed is extremely grateful to Roy Pedersen for his valuable assistance in locating artifacts and other primary sources. For assistance in research, she also wishes to thank Betsy Smith, Librarian, and her staff at the Spruance Library, as well as Laurie Landers, Vance Koehler, Terry Keenan, and Shawn and Eleanor Miller.

Patricia Sydney wishes to thank her students from "History of Art in Bucks County" for their enthusiasm and Birgitta Bond and Arlene Frimark for research assistance. Special gratitude goes to Sarah, Johanna, and Eliza for their patience, and to David Sydney for his support and invaluable help with editing.

General research assistance was provided by Helen Mirkil, who was assisted by Evelyn Fairstone, Charles Hollerith, Jr., Thomas R. James, W. W. Keen James, Wynne James III, Frank Key, Nicholas S. Molloy, James A. Peterson, and W. Lester Trauch.

Finally, we wish to thank the creative people whose lives and accomplishments are the subject of this book. Without the artists, we would have nothing to celebrate, and both Bucks County and the world would be the poorer.

The Genius Belt

Introduction
The Golden
Years

I was fortunate to live in central Bucks County during the golden years when it enjoyed a widespread reputation as a center of artistic excellence. Two types of workers in the arts accounted for its good name: a group of skilled painters residing in and around the lovely canal village of New Hope, and, coincidentally, an assemblage of nationally known writers who lived on farms throughout the area.

Painters congregated in New Hope and its immediate environs for several intertwining reasons. The village, then still almost somnolent in its nineteenth-century garb, provided an exceptionally appealing setting for homes and studios. Once a few painters, enchanted by the hamlet's charm, began to move in, more painters followed until the artistic community itself became the magnet—a mutually supportive colony inhabited by men and women of remarkable productiveness.

The county as a whole offered writers no central focus of like talent such as New Hope provided for its painters, but it did present writers with a beguiling choice of old, often historic, homes in a woodsy, softly undulating countryside sprinkled with streams, small ponds, and colorful villages—and these houses were available at amazingly low prices and modest tax assessments.

One major attraction of Bucks County was its proximity to both Philadelphia and New York. Because of the manner in which the colonial road system had developed in the eighteenth century, the principal highways led south to Philadelphia, a distance of about forty miles from Doylestown, the county seat. To reach New York entailed meandering more than twice that far on a confusing straggle of roads. Even so, the respective characters of the two big cities were such that Manhattan, with its tremendous centripetal force of theaters, publishing houses, and general intellectual bustle, seemed no farther than sedate Philadelphia. The writers and theater people usually came to Bucks from New York, of course. Most of the painters had roots in Philadelphia, as did a gaggle of commuting Curtis Publishing Company editors and art directors, like the *Ladies' Home Journal's* Laura Brookman, who opened a bookstore in New Hope as a sideline, and *Holiday's* Frank Zachary, who once was harassed by liquor control agents for importing his booze from New Jersey instead of patronizing the more expensive Pennsylvania state store in Doylestown.

I had known since the age of three that I lived in an area that was particularly blessed, for our Sunday school teacher taught us that William Penn himself, the Quaker founder of our state and the finest of the colo-

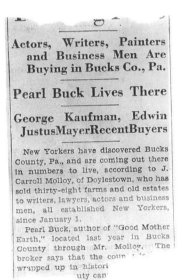

Actors, Writers, Painters and Business Men Are Buying in Bucks Co., Pa.

Pearl Buck Lives There

George Kaufman, Edwin Justus Mayer Recent Buyers

New Yorkers have discovered Bucks County, Pa., and are coming out there in numbers to live, according to J. Carroll Molloy, of Doylestown, who has sold thirty-eight farms and old estates to writers, lawyers, actors and business men, all established New Yorkers, since January 1.

Pearl Buck, author of "Good Mother Earth," located last year in Bucks County through Mr. Molloy. The broker says that the coun'... wrapped up in histori... uty can...

A fragment of an article from a 1930s New York newspaper describing the influx of prominent New Yorkers to Bucks County. Courtesy of J. Carroll Molloy, Realtor.

nial governors, had chosen our Bucks as his favorite. He had, indeed, built his home here. "Since he owned everything," our teacher said, "he could have built wherever he wanted, but he chose us. And don't you forget it." So I was born, as she might have phrased it, into greatness, and I revered our special land.

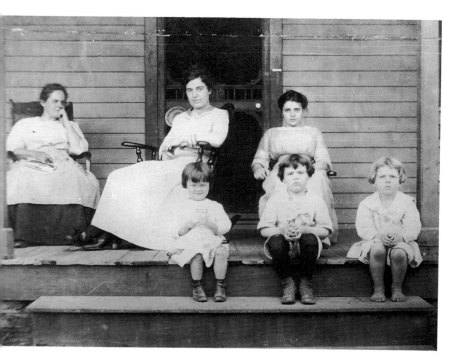

James A. Michener (bottom right) on the porch of one of his many boyhood residences in Doylestown. Courtesy of the Texas Center for Writers.

Right outside my door I had dramatic proof that my town was no ordinary settlement. Our small rented house at the extreme eastern end of Doylestown faced a gigantic medieval castle!

Dr. Henry Mercer, the great man, then and now, of Doylestown, who was a learned man as well as a gifted designer of artistic tiles that he baked in his own kiln, had been awed by the castles he'd seen when he traveled in Europe. "No reason," he must have said to himself, "why a man shouldn't have his own castle in Bucks County." And since the United States was hardly a hotbed of medieval architecture, he decided he was just as well off building the castle himself and recruited a crew of local laborers whom he taught to mix concrete and pour it in the forms he devised for the walls.

I was only a year old when construction on what he would call Fonthill began, and not quite three when the gargantuan (in my baby eyes) edifice was finished, and so remember nothing about that ambitious enterprise except a vague feeling that the castle was growing even as I was and that thus, in some mysterious way, I must have contributed to its completion.

What I do remember—how could I forget?—was the celebration Dr. Mercer staged on his birthday after moving in.

The castle had, of course, a tower, a parapet really, topped by a small flat roof of concrete on which he deposited an immense pile of cedar branches and doused it with gasoline and pitch. At midnight, when I was fast asleep, he ignited the pyre, flames shooting high into the sky, and I

was hauled out of bed to witness this amazing sight not far from where I stood in our upstairs window. It was a spectacle I have never forgotten, a candle in the night that has never dimmed.

It was when his castle was finished that Dr. Mercer proved that he was not only a dreamer but a very practical man. He now had on his hands a work crew that knew how to do only one thing: build castles. So he moved this contingent across town to its southwest end, where he proceeded to build a second concrete castle, even bigger than the first.

I was in primary school when the second castle was completed and my teacher explained what the great man had in mind—a museum in

Fonthill, the castle home of Henry Chapman Mercer, in Doylestown. Courtesy of Urban Archives, Temple University, Philadelphia.

which all the tools that man lived by would be collected and put on display. Sometimes I had the fortune to be present when Dr. Mercer moved his purchases into one of the many chambers in his museum, an entire carpentry shop perhaps, and another time the complete office of an old-time dentist—its intimidating chairs, the grinding wheel worked by pedal power, an array of drills and small hammers, but no hypodermic needles, I am sure, because painkillers of that type had not yet been invented.

He also bought, at farm sales about the countryside, Conestoga wagons used by Bucks County farmers who had contemplated moving west and then decided to stay; rowboats used by shad fishermen on the Delaware River; a planing mill; and many different kinds of plows and even more cast iron fronts from German bake ovens, each showing some Biblical scene. In time the Mercer Museum, just opposite of what was then the jail, became the most encyclopedic of its kind in America and perhaps the world. I was in high school when Henry Ford, an insatiable collector of Americana himself, visited the museum. Rumor had it that he wanted to buy the Mercer treasures, down to every single handmade nail, for his own museum in Dearborn, Michigan. But Dr. Mercer refused to sell, so the story went.

No matter where I might travel in America, I could look at the people around me and think: I'll bet I'm the only one who grew up in a town with *two* castles! In Bucks, we didn't fool around.

Wondrous as the castles were, I was always more impressed by the land itself. It was defined, curiously enough, by two parallel ribbons of water that hemmed Bucks County's entire eastern border, one created by nature, the other by man.

The natural waterway was the Delaware River, which separates Pennsylvania from New Jersey, and farther north, some fifty miles above Bucks County, from New York State. It always astounded me that the Delaware was only a minor river, a mere 310 miles long as compared to the Mississippi's 2,348 miles, or even the Colorado's 1,450, for it manifested the dual personality of hypnotic tranquillity and ruthless power shared by all the great streams that move the waters of the world about.

Its relatively clean water was a breeding ground for shad, a bone-riddled fish that produced roe in such abundance that shad roe and bacon could be featured in country restaurants as its own dish, and forget the meat around those nasty bones. But, from time to time, the placid

river would receive in its upland catch basin some monstrous cloudburst, or a heavy sustained rain for several days, and then the lower reaches of the river, those in our county, were transformed into a devastating torrent. It swept away iron bridges and in some places spread into a lake two miles wide, and where hills or low cliffs pinched its course, rose as much as thirty feet, inundating the settlements along its bank. The flood years were named and remembered: "That dreadful flood of 1841." "The flood of 1903 that carried away the bridge at Point Pleasant three-quarters of a mile downstream." Of the floods in my time, I remember most vividly the monster flood of 1936 that submerged every single remaining bridge and knocked some loose.

The Delaware's man-made companion, which runs beside the river on the Pennsylvania side, was a rural delight born of industrial planning.

During the Delaware River flood of 1936, Annie Shank of Lambertville, New Jersey, could not be coaxed from her home. Courtesy of Urban Archives, Temple University, Philadelphia.

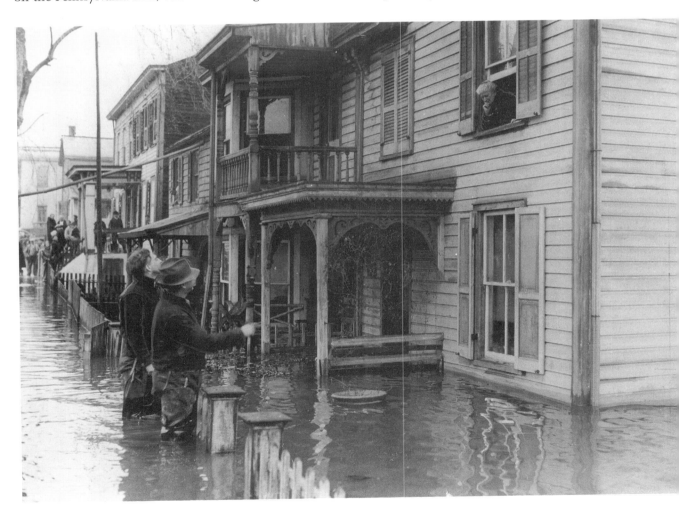

In 1814, the city of Philadelphia, which touches the southern end of our county, realized that its need for coal was so great that railway delivery from the coals mines of northeastern Pennsylvania was going to prove exorbitant. A daring consortium of interests proceeded to dig a barge canal, the Lehigh Canal, along the Lehigh River from the coal fields to Easton, on the Delaware just north of Bucks County, and from there down to Philadelphia. That second section, sixty miles long and mostly in our county, was named the Delaware Canal.

One aspect that made it a precious feature of our life was its towpath, the requisite companion of any canal in those days, for there had to be a level trail for the mules to walk on as they pulled the barges. The towpath was, of course, no less useful to horseback riders and pedestrians, and some of my most pleasant memories are of walking on the towpath from one village to another through an ever-changing landscape. Sometimes the towpath perched on the berm, no more than perhaps ten feet wide

A barge is towed down the Delaware Canal near New Hope. Courtesy of the Spruance Library, Bucks County Historical Society.

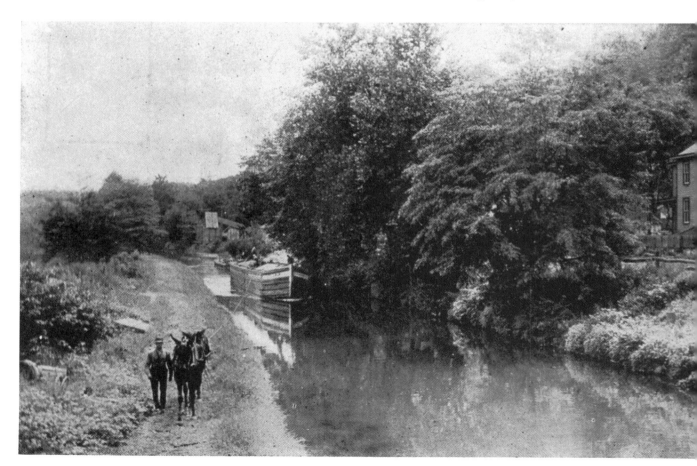

along its crest, which separated the river from the canal. On these magic stretches the river and canal seemed as one, and you almost felt as if you were walking on water. A little farther along the canal might veer inland from the river, and you found yourself among fragrant woods and fields.

Because small streams, and some larger ones, too, debauched into the Delaware, aqueducts were devised to lift the canal over them. These marvelous troughs of wood and metal were great for swimming parties. Doylestown lay some nine miles west of the especially high aqueduct that bridged Tohickon Creek at Point Pleasant. Despite this distance, our townspeople flocked there every summer to swim in the aqueduct's lofty pool of swiftly flowing water and to picnic on the grassy canal banks nearby. Especially thrilling were those moments when the warning horn would sound from an approaching barge. Then everyone would clamber out of the water and watch the barge edge its prow into the aqueduct, which being only about eight feet wide, allowed the barge but a few inches of clearance on either side. The barge men, often with their families, smiled at us and called out greetings as they passed. At those moments we felt in touch with the great world beyond, even if our momentary vision encompassed only Philadelphia and the coal fields.

Canal life offered constant excitement. There were mysterious camps where horses and humans spent winters when the canal froze. There were alluring girls who traveled on the barges with their parents, and handsome young men who were in training to become bargemen. There were the attractive villages, sometimes no more than a dozen houses, that grew up along the canal. And on the canal itself, where sizable communities like New Hope had developed, there could be evening barge rides if local entrepreneurs had acquired either an outdated coal barge or a boat built especially for the trade. The operators provided picnic suppers and perhaps some entertainment with a banjo, so that the canal became a festive place of good food accompanied by the sound of the mules' bells as they trod the towpath, and of songs in the starlight. There was also the constant reminder, voiced by parents and police, "The bargemen are a different lot. Stay clear of them." And we would hear of crimes or savage divorces or sometimes even murders that occurred at one of the winter layover camps.

I often traveled the canal from one end of Bucks County to the other, hitchhiking barge rides, getting to know the bargemen and their families. I was allowed to sound the horn to alert the traffic that we were coming at them, and admired how deftly the downstream and upstream barges

maneuvered their passing. I believe it was the mules of the upstream barge that had right of way on the towpath, while the tow rope of the downstream barge had to be hauled in to allow the barges to pass without stopping. In later years, I often wondered why I never wrote a novel about our canal which I had known so well and loved so much. Perhaps these adventures came too early in my life, before I had a chance to digest them.

I stress the land and its accompaniments because it was always a major player in the legend of Bucks County. Its sylvan beauty was not unlike that of England's Buckinghamshire, for which it had been named when Penn opened the territory in 1680 under Charles II's land grant. And as the original Buckinghamshire had London as a neighboring metropolis, so Bucks County had New York and Philadelphia. Given this proximity, it could not have escaped fame had it so wished. Two men in central Bucks helped make sure that it didn't.

They were real estate men, but not your ordinary salesmen, or for that matter, saleswomen; the latter were then only beginning to break into this occupation. These two men, rivals I suppose, were geniuses in creating and spreading the illusion that Bucks County was a paradise to which any sensible couple living in cramped New York or Philadelphia could logically aspire—if they had the money. I believed then, and I am now even more convinced, that the fame of Bucks County was due in large part to their inspired shenanigans.

J. Carroll Molloy was an avuncular gentlemen of impeccable dress and manner. He took his big-city customers to his heart, convincing them that in him they had a trustworthy friend who knew just about all there was to know about the local real estate. From his tidy colonial-style office on Doylestown's South Main Street, he conducted a first-class operation with two or three assistants who quickly came to know of any farmland for sale or any inquisitive buyer who might be interested in it. When their spadework was completed, J. Carroll moved in to assure the would-be buyer that he, Molloy, could get the best deal, arrange for the most reasonable mortgage, and introduce the stranger to local society. He was a master salesman, relying on his charm and warmth rather than upon trickery or mere fast talk. Through his skills and energy he built an enviable business.

But he did not preempt the field. A few blocks away stood the office of Wynne James, as ingenious a real estate salesman as ever plied his

trade. A gangling Ichabod Crane some six feet five inches tall, he moved about town in a kind of Groucho Marx lope. Erudite, charming, and outgoing, he was notable in our community for two preoccupations. In a staunchly Republican county he insisted upon running every two years for Congress as a Democrat. Invariably he was humiliated, but he did fight the good fight and kept the

WYNNE JAMES, JR.
of DOYLESTOWN
YOUR Democratic Candidate
for Congress

PRIMARY: TUESDAY, APRIL 27th
Your support will be appreciated.
— PULL LEVER 6A —
7:00 A.M. to 8:00 P.M.

Democratic credo at least partly alive. Years later, when I succeeded him as the Democratic candidate for Congress, I too was humiliated, but he consoled me: "One of these days, Jim, we'll win that damned seat," and, indeed, three or four elections later the Democrats did, but not with either Wynne or me.

A calling card from one of the congressional campaigns of Wynne James, Jr., Realtor. Courtesy of Thomas R. James, Elizabeth James Country Real Estate, Lahaska.

His other penchant was marriage, or perhaps simply weddings. Rumor had it that he had been married seven times, but that was, I fear, overexaggeration. I knew three of his wives, including a delightful Irish lass he invited over from the Auld Sod, but his wedding exploits reached their apex the night he invited scores of us to attend his latest marriage, this time to an adorable teenager, he being in his sixties. The marriage was to be celebrated in the dining room of the popular Doylestown Inn, with a gala wedding feast to follow. All of us eager to grab a free meal arrived early and were somewhat distressed when the ceremonies were delayed well beyond the scheduled hour. We could see Wynne and his best man and the clergyman but not the bride nor any of her entourage. The word circulated that *she* was in a different hotel, having dinner with friends.

Wynne was equal to the occasion. Calling us to attention, he announced, "She has cold feet and decided not to go ahead with it. But we have this gorgeous food waiting, so let's have a celebration!" And with the help of the inn staff, we gorged on one of the finest wedding feasts in memory.

What the inspired real estate men, Molloy and James, did to imprint—indeed emboss—the name "Bucks County" in the national consciousness was to run in *The New York Times* and sometimes, I believe, in *The Herald Tribune*, the most enticing and cleverly worded advertisements for

properties that were for sale in Bucks County. The world couldn't miss what a splendid place Bucks County was, thanks to these almost weekly ads.

There must also have been able real estate agents in New Hope, but I was not aware of them because they sold primarily to artists who sought homes in this artistic enclave. Such sales did not attract much attention in the big cities, but when a bevy of nationally famous writers began moving to Bucks, the country was bound to pay attention. I am not sure of the order of their arrival, but suddenly and in short order we had Pearl S. Buck, Dorothy Parker, George S. Kaufman, Oscar Hammerstein, and S. J. Perelman as our neighbors. With them came an inevitable notoriety and aficionados of the written word on both coasts soon shared Bucks County gossip.

Notice the curious symbiotic relationship between the local painters and the international wordsmiths. The artists were not widely known, but the quietly determined manner in which they converted New Hope into their retreat, and the fact that their work was congenial and yet honest and pure, made Bucks County respectable and desirable. They set the tone

George S. Kaufman and Moss Hart, hard at work writing the 1939 play The Man Who Came to Dinner, *in Kaufman's Bucks County home. Photograph by Maynard Clark. Courtesy of the James A. Michener Art Museum. Gift of Philip A. and Dianna T. Betsch.*

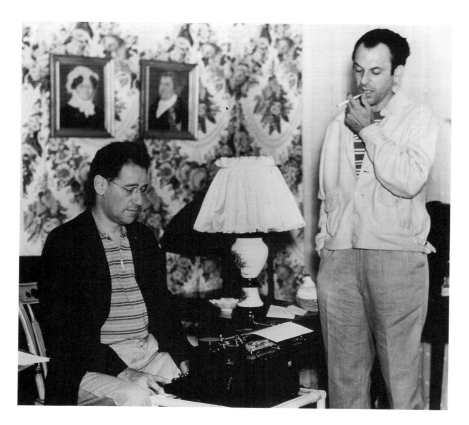

for the golden years. The writers, in turn, were that era's adornment. Already famous when they came, they brought their glamour and attainments with them. Bucks did little to excite their imaginations or encourage them to produce bold new works. But they didn't waste their time here. Oscar Hammerstein wrote some of his most successful lyrics on his farm. Pearl Buck was incredibly productive. S. J. Perelman used Bucks County scenes for some of his wriest wit, and Kaufman and Hart, drawing on their experience here more than the others, collaborated on *George Washington Slept Here*, a rowdy spoof about outsiders who buy an old Bucks County home that had possible historic connections.

As it worked out, our immigrant writers blended easily with our long-settled painters, although I do not know of any instance where a writer bought a local painting. Nor is there any record of a New Hope painter rushing to a bookstore to pick up the latest Pearl Buck, or to a magazine stand to delight in Sid Perelman's newest assault on the English language. Each group seemed content to ignore the other.

The artistic reputation of the area was enhanced by three New Hope institutions of high merit and wide appeal. The oldest, which dated back to my adolescence, was an informal art gallery at Phillips Mill, an isolated cluster of very old buildings of pointed fieldstone on the canal about one mile north of the center of New Hope. The largest of these, formerly a gristmill built in 1756, somehow developed into a gathering place of local artists and eventually became their primary venue for shows. It was here that art first became real to me, where I came to understand that paintings were not just

A 1963 drawing of Phillips Mill by William F. Taylor. Courtesy of Phyllis Taylor Euler.

decorative objects hung on walls but the work of flesh-and-blood people who transmuted what they saw into their own visions. I am sure that many other visitors to this rustic and, as I recall, not especially well lit exhibition room came away with the same insight.

While Phillips Mill, with its shows of largely local scenes, introduced Bucks County to the outside world whenever a visitor bought—or simply remembered—a painting, the second pivotal institution brought the outside world to Bucks. This was the Bucks County Playhouse, a small theater launched in 1939 in yet another historic gristmill, in fact the county's oldest, around which the town of New Hope had grown over the decades. Where once a ponderous waterwheel, green with algae and moss, had turned the millstone, there were now laughter, thrills, and sometimes surreptitious tears. Henry Chapin, a college buddy of F. Scott Fitzgerald's at Princeton, headed the gaggle of local theater lovers who endeavored to bring the best of the American stage to our rural community. Students like me haunted the place to see for the first time Broadway hits like *Springtime for Henry* and *The Man Who Came to Dinner* and famous performers like Edward Everett Horton, Bert Lahr, and Hermione Gingold. Some actors returned summer after summer, so that we began to think of the Playhouse as our own permanent stock company.

The third institution of renown lay across the river in New Jersey, but it was so convenient to New Hope that it became an unofficial annex of Bucks County. That was the Music Circus, a circus tent pitched every summer on a low hillside at Lambertville. Under its cavernous canvas, an imaginative producer-promoter, St. John Terrell, created one of the earliest theaters-in-the-round by ranging his audience around a circular stage so intimate that the performers were almost in your lap. St. John, who pronounced his first name "Sinjen" in the British manner and expected everyone else to do the same, was an experienced theater hand with a sure sense of what an audience wanted. Each season he offered a mix of "golden oldies," like *The Desert Song* and *The Student Prince*, along with recent hits, such as *Oklahoma!*, *Kiss Me, Kate* and, to my particular joy, *South Pacific*. There were name-band concerts as well. St. John imported so many famous actors, entertainers, and musicians that New Hope sometimes resembled a medieval fair town where the mountebanks gathered. I remember one delightful performance by Liberace who minced about in his blinding-white costume before our largely rural audience, asking the farmers' wives, as he flashed his dozens of jewels, "Madam, do you think this might be just a little much?" When they screamed "No!" he thanked them, dispensed little kisses, and sashayed on.

St. John's Music Circus succumbed to the violent eruption of TV in 1970 but he remained a pillar of the county's artistic establishment. One of his perennial contributions, always covered by the press, was the reen-

actment of George Washington's famed crossing of the Delaware on the Christmas night of 1776 to defeat King George III's hung-over Hessians in Trenton the next morning. It was strange that the first weeks of December seemed to be Indian summer all through the golden years and for some years after, but almost every Christmas Eve snow would blow and ice form on the river just when St. John, looking very much like Washington in colonial uniform and cockaded hat, climbed into his authentic longboat as hordes of watchers shivered on the bank.

Two other colorful men, both high school classmates of mine, enriched the county's ambiance and spread its reputation. One of them

The Bucks County Playhouse under construction in 1939. Photograph by Maynard Clark. Courtesy of the James A. Michener Art Museum. Gift of Philip A. and Dianna T. Betsch.

was W. Lester Trauch, who hailed from the upcountry region where the Pennsylvania Dutch predominated. He spoke "Dutch" at home, as did about half my class, and said "wery" for "very," "chust" for "just," and pronounced "ain't" in two syllables so it ended up "aind't." Although from the country and of it, he somehow acquired a lust for literature and an absolute passion for the theater. Even in high school he could tell you in what Shakespeare plays Maurice Evans had appeared, and when Helen Hayes had played opposite one leading man or another.

With two theaters flourishing along the Delaware, Trauch was in an earthly heaven, besotted by the worship of its stars. As drama reporter on our local newspaper, he had access to the greenrooms of both establishments, putting him in intimate contact with the actors and actresses. Many a Broadway luminary appearing at the Playhouse or Music Circus would be astounded to hear this hick reporter deliver himself of long and incisive lectures on the American theater. His widely read reviews, often more erudite than those in the big-city dailies, helped lift the caliber of theatrical performance on our stages to an unprecedented high.

My favorite Trauch story, although its setting was not Bucks County but the South Pacific, deserves telling here. He was stationed on some lonely World War II island near the equator when a USO troupe reached the outpost to perform *Hamlet*, with Maurice Evans and Judith Anderson in the leading roles. Trauch was beside himself with excitement; perhaps he'd even find the chance to talk theater with them. As his company was about to march off to see the performance, the commanding officer announced: "Corporal Trauch will stay here to man the phones. He's already seen the play and knows how it comes out."

Bob Brugger, the other schoolmate who enhanced Bucks County, was also Pennsylvania Dutch, or at least his father was. His mother had been one of three Bavarian girls who immigrated to America early in the century and married Bucks County boys. As fate would have it, all three were soon widowed and ended up running restaurants. The girl who married the Zettler boy wound up with a lovely white colonial inn, since gone, on the canal at Washington Crossing. Rudolph Hein's widow inherited his prosperous Doylestown Inn smack in the middle of town. And Mrs. Brugger, the mother of my friend, was left with three sons and the Pipersville Inn in the upper reaches of the county. All three establishments were spectacularly successful, none more so than the Pipersville Inn, where Bob Brugger's mother prepared sturdy German meals while he held sway in the bar. The inn became one of the most famous watering

spots in all eastern Pennsylvania. Here, visitors from New York and Philadelphia mingled with locals, famous writers would drop in with Hollywood guests in tow, and actors presented scenes from their plays.

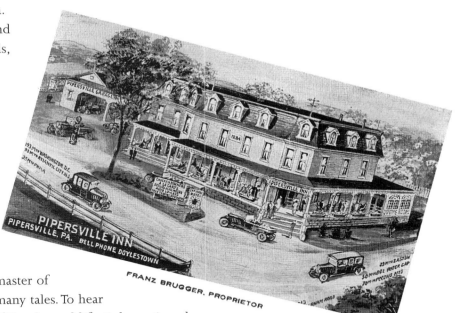

The highlight of any evening's revelry was Bob Brugger's own act when he slipped on a shawl and a woman's hat to transform himself into a Pennsylvania Dutch biddy with a salty tongue. He was a master of the dialect and a custodian of many tales. To hear him was to catch the essence of Dutch rural life. Bob continued with his repertoire so long as the customers kept drinking. He always got up in time to open the bar and restaurant and then go to Doylestown, and in later years Philadelphia, for his daily radio show. Every week he had a glittering array of guests who told about their work or discussed national issues. Needless to say, Bob never missed the opportunity to sneak in good words about Bucks County and his Pipersville Inn.

A postcard of the Pipersville Inn, one of Bucks County's best-known watering holes. Courtesy of the Spruance Library, Bucks County Historical Society.

When I extol a garland of years which I recall as golden—years that were more memorable than those that went before, more radiant than those that followed—just what am I talking about? The period of the painters, but not yet their golden years, started around 1910, when some, like thirty-year-old Daniel Garber, had already moved to the New Hope area (in his case nearby Lumberville) and others were dropping in for trial summers. Edward Redfield, forty-two that year, was going strong, but Robert Spencer, then thirty-one, was still waiting to be recognized for his industrial scenes. Fern Coppedge, twenty-seven, was just beginning to define her distinctive palette. John Folinsbee, who had been crippled by polio four years earlier, was only eighteen. The superb work he would produce even as he battled the ravages of the disease was still some years off.

Thus I would peg the beginning of my golden years at around 1920, when the painters had made New Hope their own, their talents had

matured, and the public increasingly acknowledged them as serious artists.

The writers were a generation behind them. None had yet appeared in print in our century's second decade: they were still much too young. Perelman turned six in 1920; Buck, Parker, and Hammerstein were in their teens. Kaufman, the eldest of the future Bucks contingent, was twenty-one. Not until the late 1920s did they come trickling in one by one, and it was the mid-1930s before the county's renaissance reached full bloom.

And the sunburst ended when? Inevitably, the artists would depart the scene first. By 1958, with the death of Daniel Garber, all the major painters except Folinsbee, who carried on until 1972, were gone. The writers, although much younger, soon followed. Hammerstein died in 1960; Kaufman, the following year. One by one, as they had come, they left us. Only Pearl Buck lived into her eighties. She died in 1973.

I would say then that the golden years spanned roughly the period from 1920 to 1965, a dazzling four decades filled with good work, gratifying recognition and, for some of the writers, worldwide fame. But I must stress that without the pioneering by the painters, central Bucks would not have become, however briefly, the wonderland my generation knew. It would have been attractive farmland awaiting the onslaught of suburbia.

All of us who lived here in those dazzling days felt part of the parade. We cheered when *our* Pearl Buck won the Nobel Prize and *our* Oscar Hammerstein the Pulitzer. We relished Perelman's latest books, and roared at his scripts for the Marx Brothers' movies. I was stunned by the brilliance of how our neighbors, Samuel and Bella Spewack, produced the musical gem, *Kiss Me, Kate*. I memorized the song of its vaudevillians, "Brush Up Your Shakespeare," and performed a soft-shoe as I sang it. The bonds that tied me to that time and place never parted. Long after I moved away, my wife and I returned year after year to the Phillips Mill to reassure ourselves that Bucks County painters were still at their easels.

There was another aspect of our county that moved me profoundly, so much so that I frequently left the Delaware River as it slept to gather its thunder for the next flood, and the canal with its precious memories, and New Hope where the artists thrived, and Central Bucks where so much good writing was done, and plunged alone into the rocky, twisted woodlands just north of where the famous people lived, into a realm obscured from everyone except oddballs like me.

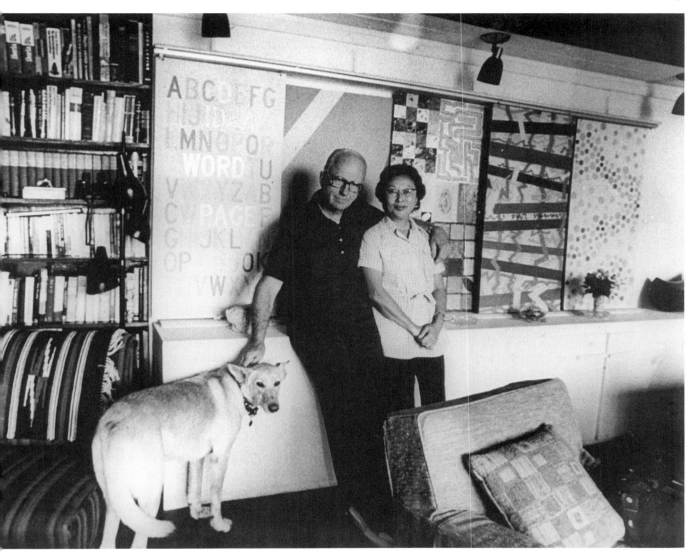

Where was I headed on these forays? Into the borderline where good farmland collided with a no-man's-land of twisted trees, turbulent creeks, granite boulders, and strange clearings as if elves had saved those spots for their ball games. It was here that the great glaciers had stopped after creeping from their polar lair to cover much of North America. My hidden wilderness, only about two miles north of where I lived, was the edge of a terminal moraine, the detritus of sand, grit, pebbles, stones, and mammoth rocks that had been pushed along by the glacier's snout. How wonderful to think that the ice marched one-third of the way

*J*ames A. Michener with his wife, Mari, and friend in the living room of their home in Pipersville, Bucks County, in 1974. The Micheners owned two dogs, named Java and Burma. Courtesy of Urban Archives, Temple University, Philadelphia.

through Bucks County, saw the meadowlands ahead, and miraculously stopped! At least it did that time.

But I must not leave my memories of Bucks on that portentous note. The elves' glades were rich in minerals, great for growing things. There, in the last century, farmers discovered that they could raise superb crops of ginseng root, which was much sought after in China as the ultimate aphrodisiac. If a man, no matter how old or enfeebled, consumed a prescribed amount of the powdered root, his powers would be restored and infinitely sustained. It has always amused me to think that the stolid, conservative Lutheran and Mennonite farmers of my county supplemented their income by growing ginseng for aging mandarins. Perhaps this unorthodox pursuit helped prepare them to accept those strange painters and writers in their midst.

The Writers

In the summer of 1932, an impoverished young novelist was bamboozled into believing that he had discovered Shangri-La in a backwater called Bucks County, Pennsylvania. During a weekend visit to friends in Erwinna, he went for a stroll, passing by a farm that was for sale. A mimeographed sheet, extolling the glories of the place, was nailed to a telephone pole. Since he had nothing better to do, he stopped and read it:

> The farm consists of 83 acres of tillable farm land, twelve being in excellent timber.... There is a large dwelling house, five out-buildings, three studios and a large stone barn.... It is two miles from Frenchtown, New Jersey, where there are chain stores and shopping at cheaper than city prices. Erwinna is an old canal town on the Lehigh Canal, one mile from the farm. This is fine, hilly country, inhabited by old Pennsylvania Dutch farmers and a colony of well-known New York writers and artists....

The price of all this land and literary inspiration was $6,000.

It so happened that the mouth-watering real estate ad had been written by the farm's owner, a man who didn't know a hoe from a wheelbarrow. He was Michael Gold, the editor of *The Masses* and *The New Masses* and the author of an intensely emotional memoir that had been published two years before about growing up poor on New York's teeming lower East Side. Entitled *Jews without Money*, it was considered a masterpiece of proletarian literature.

Although Gold may have been a Marxist, in this instance he was a crafty capitalist. The passerby, who believed every word of his hyped description of the property and the nonexistent writers' colony, was Nathanael West. This not yet famous novelist was then working as a night clerk in a seedy New York hotel to support his literary ambitions, which were stalled at the moment; he was having trouble finishing his second book. That was one of the reasons why his writer friends, Josephine Herbst and her husband, John Herrmann, had invited him to Bucks County—they wanted him to discover for himself that this remote rural area was a good place to write. In 1928, they had moved to Erwinna, buying a ramshackle seventeenth-century farmhouse where they lived cheaply and wrote. Their gamble had paid off. In that year Josie, as she was called, published her first novel, *Nothing Is Sacred*. In the thirties, she would become well-known not only for her trenchant social and political journalism, but also for the Trexler Trilogy, a remarkable series of novels

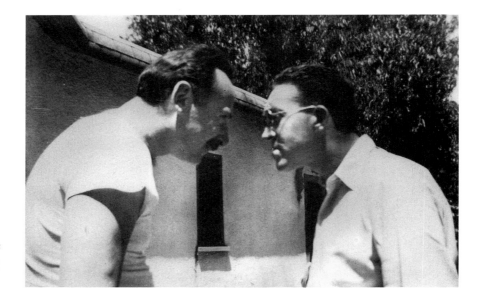

Nathanael West with his best friend, S. J. Perelman, ca. 1930. Courtesy of the James A. Michener Art Museum. Gift of Dorothy Herrmann.

(Pity Is Not Enough, The Executioner Waits, and Rope of Gold), which comprised a wonderful portrait of an everyday American family's struggle for the American dream. Critics of the period frequently compared her work to Dos Passos's U.S.A.

"It was a delicious autumn," Josephine Herbst later remembered, also taking note that her young houseguest was a very attractive man, six feet tall, with marvelously alive eyes and a witty, intelligent face. "We walked through fields of tall grass, plucked the antlered horns of red sumac, talked of Pushkin for whom autumn had been the creative season. We drank Pennsylvania bootleg rye and homemade red wine; read aloud Carl Sternheim's A Pair of Underdrawers, recited poems by Hans Arp...."

West was so impressed by the "literary vibrations" of the Delaware Valley that in mid-October he took an extended vacation from his dead-end job at the Hotel Sutton and rented a room for six weeks at the Warford House, across the river in Frenchtown, New Jersey. It was there that he at last managed to complete his novel, entitled Miss Lonelyhearts, which is perhaps the most compelling—and chilling—novel ever written about modern man's isolation and loneliness.

By this time West had convinced his brother-in-law, S. J. Perelman, a humorist and cartoonist, to come to Bucks County to look at Michael Gold's farm. After Perelman, a cynical man whose business it was to make fun of everything, saw the property with his wife, Laura, he also became convinced that West had discovered a real writer's paradise. He later

wrote: "Their voices shook as they described the stone house on a hill-side circumscribed by a tumbling creek, the monumental barn above larger than the cathedral at Chartres.... I grudgingly went out with them to see the place, and in a trice also fell for it. The autumn foliage was at its height, and the woods and fields blazed with color. In contrast to the bedlam of New York, the only sound that disturbed the sylvan hush was the distant chatter of crows in the north forty. There was an air of permanence, of solidity, about the house and outbuildings that captivated and reassured."

Shortly after West completed *Miss Lonelyhearts*, he and Perelman scraped up enough money to buy Michael Gold's farm. It was only then that they discovered the true nature of its former owner's genius, which was to hoodwink other New Yorkers. Surveying his dilapidated property, West prayed for the commercial success of his novel. The royalties would help pay for needed renovations, which included painting over the garish colors of the main house's interior. In keeping with his political sympathies, Michael Gold had painted most of the rooms a violent shade of red or pink. But to West's disappointment, *Miss Lonelyhearts*, although well received by critics, was not popular, and soon the disheartened author was christening his run-down farm "Eight Ball." Although he would not often live there, he converted a small white building that had been a pigpen into a writing studio. It was there in 1934 that he finished *A Cool Million*, an uproariously funny, savagely satirical creation that dismantled, piece by piece, both its hero and the Horatio Alger myth. He also collaborated with Perelman on a play *Even Stephen* and with his Erwinna neighbor, writer Joseph Schrank (who had a hit play in *Page Miss Glory* but would be best remembered for his book *Cabin in the Sky*), on an antiwar play *Gentlemen, the War!* (later entitled *Good Hunting*). Although another Bucks County neighbor, George S. Kaufman, dean of successful American playwrights and an astute prognosticator of Broadway hits and flops, told West that the play would be a triumph, it was a failure—on the eve of World War II, its antiwar sentiments were outmoded.

Still, Kaufman remained West's champion. "I consider him a writer of great promise, with a viewpoint and style of his own that are quite likely to elevate him to significance," he once wrote. This was an astute judgment of West's ability as the four books of genius (*The Dream Life of Balso Snell*, *Miss Lonelyhearts*, *A Cool Million*, and *The Day of the Locust*) that he wrote during his brief life remain unsurpassed in raging wit, brutal satire, and social comment. For critics, the surrealistic fantasy of *The Dream Life of Balso*

Snell, his first novel (1931), and the antic anger of *A Cool Million* (1934) were sharp revelations of America's literary creativity in the thirties. Edmund Wilson thought that West's novels were "more finished and complete as works of art than almost anything else produced by his generation." West's slender body of work set a standard by which new novels of originality and invention are often judged today.

According to West's biographer, Jay Martin, "West looked upon the farm chiefly as a place where he might be free to write, by living what he believed to be the artist's style of life. Among other things this would include friendly converse with the 'colony of ... writers and artists,' which Michael Gold had noted. As it turned out, Miss Herbst and John Herrmann were the only genuine writers around. The poet Isidore Schneider gave up his house at about the time West moved in. Gold never returned. John Coffey, though a fascinating character and an anarchist fur thief, was a subject for writers rather than a writer.... New Hope, where George S. Kaufman and Moss Hart lived, was some distance away. Only somewhat later would Dorothy Parker, the novelist and playwright Melvin Levy, the dramatist Joseph Schrank, and the novelist Daniel Fuchs live in the Erwinna area."

Although neither West nor Herbst was aware of their existence, there were two other "genuine" writers in the area. One was Agnes Sligh Turnbull, whose novels about the inhabitants of rural Pennsylvania (*Remember the End, The Day Must Dawn,* and *The Bishop's Mantle*) were best-sellers in their day. Born in the late Victorian period, Turnbull stressed optimism and puritanical values in her writing, and some critics have dismissed her work as old-fashioned.

The other, more contemporary, novelist was Margaret Widdemer, the daughter of a Doylestown minister. Widdemer's eyes, unlike her father's, seemed to have been directed perpetually downward, at her typewriter, as she was something of a writing machine. Nine of her novels—she eventually wrote thirty-two—were published while she was still in her twenties. The first, *The Rose Garden Husband,* was a best-seller when it was published in 1915, when she was only twenty-one years old. Her last novel, *Red Castle Women,* was published in 1968 when she was eighty-four (she would live to be ninety-three). During her long and distinguished career, Widdemer won numerous prizes for her work. Her volume of poetry, *The Old Road to Paradise,* won the American Poetry Society's prize for the best book of poems published in 1918, sharing top honors with Carl

Sandburg's Cornhuskers. In 1922, *The Saturday Review of Literature* gave her an award for best satire for her book, *Tree with a Bird in It*; in 1960, she received the Lyric Award for distinguished services to poetry.

By then, West was long dead. He and his beautiful bride, Eileen McKenney, were killed in an automobile accident in California in 1940, the very day after West's friend, F. Scott Fitzgerald, had died of a heart attack. West was only thirty-seven years old; Eileen, twenty-seven. They had been married nine months.

Most people in Bucks County weren't surprised when they learned of West's fatal crash. A notoriously careless driver, he had so many accidents that he frequently had to be towed out of ditches. Some of his neighbors refused to ride with him. Once, when Joseph Schrank was driving with West, and West "shot out of a side road like a bat out of hell," Schrank yelled at him, "This is the last time I ride with you—some day you are going to get killed driving like that!"

For S. J. and Laura Perelman, nothing would ever be the same after West's death. Laura never fully recovered from her brother's death, and Perelman, perhaps as a way of finding solace, began writing in the study where West had written *A Cool Million*. One of West's wooden duck decoys, of which he had a sizable collection, rested on the desk. Outside the window he could see the tulip tree that he and West had planted years before, when they had first bought the farm.

S. J. Perelman, a brilliant stylist, was a very different type of writer than his brother-in-law. Although both authors had been influenced by the Dadaist and Surrealist movements in the twenties and thirties, Perelman's forte was satire. For forty years his zany wit and outrageous fantasies embellished the pages of *The New Yorker* and other magazines. His specialty was the short comic essay, and his writing was so original that in a sense he created his own genre. For one thing, his titles were inimitable: "Boy Meets Girl Meets Foot," "Beat Me, Post-Impressionist Daddy," and "I'll Always Call You Schnorrer, My African Explorer"—that one was about Groucho Marx. But whatever piece you read, you were guaranteed a verbal roller-coaster ride through a world of puns, double entendres, flashes of slang, and dashes of Yiddish, all put together in a matchless style that almost concealed the bitterness beneath.

Here's an excerpt from the parody Perelman wrote of Raymond Chandler's hard-boiled detective novels. It was entitled "Farewell, My

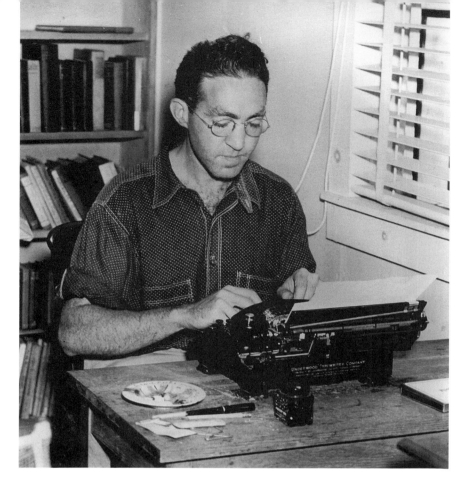

Lovely Appetizer." In this scene, Mike Noonan, a sleazy private detective, comes into his office and growls good morning to his secretary, Birdie Claflin:

> "Well, you certainly look like something the cat dragged in," she said. She had a quick tongue. She also had eyes like dusty lapis lazuli, taffy hair, and a figure that did things to me. I kicked open the bottom drawer of her desk, let two inches of rye trickle down my craw, kissed Birdie square on her lush, red mouth, and set fire to a cigarette.
>
> "I could go for you, sugar," I said slowly. Her face was veiled, watchful. I stared at her ears, liking the way they were joined to her head. There was something complete about them; you knew they were there for keeps. When you're a private eye, you want things to stay put.

Perelman's inspired parodies and satires were inhabited by such people as Urban Sprawl, architect; Whitelipped and Trembling, brokers; Howells and Imprecation, lawyers; and Garish Cooper, an actor. But my

favorite Perelman character, I think, was Fern Replevin, whom he described as "an utterly lovely character of twenty-four whose mouth wanders at will over her features."

Perelman addicts memorized favorite lines: "She had a complexion like leeches and cream." "Don't mind us, Verna, we just dropped in to sneer at your towels." "Skins, you know, are divided into three types—cameo, butterscotch and mock nutria." "Great fatuous booby that I was, I imagined advertising would be destroyed from the outside. It won't. It's going to bubble and heave and finally expire in the arms of two nuns, like Oscar Wilde." And: "A hush fell over the audience and was removed by an usher."

Perelman, who died at age seventy-five in 1979, was a small, dapper man with a neatly trimmed mustache, a soft hesitant voice, and sad quizzical eyes behind steel-rimmed spectacles. The S. J. stood for Sidney Joseph, but his friends called him Sid. He was a man of vast contradictions. He was capable of great charisma, civility, and wit—a wonderful raconteur when he chose to be—but he could also be moody, self-absorbed, and cantankerous. In short, he was a charming curmudgeon.

Sid wrote twenty-one books and co-authored several stage plays, including the hit 1943 musical *One Touch of Venus*, starring Mary Martin as a statue of Venus that came to life. His play *The Beauty Part*, starring Bert Lahr in a virtuoso performance in which he played six parts, had its tryout at the Bucks County Playhouse in 1961. It was produced by his friend, the playhouse's director, Michael Ellis, who had encouraged him to write it. In 1956, Sid won an Oscar for his screenplay of *Around the World in Eighty Days*. It was said that he was responsible for creating Groucho Marx's comic image, and although he denied this, as did Groucho, there is an echo in *Monkey Business* and *Horse Feathers* of Sid's very special literate frenzy. Sid's feelings about Bucks County were complex. Although he loved its special beauty, there was nothing that he liked better than to poke fun at the trials of country life. In his book *Acres and Pains*, which was published in 1947, he described a farm as "an irregular patch of nettles, bounded by short-term notes, containing a fool and his wife who didn't know enough to stay in the city." When he was in the city, he longed to be in the country, and vice versa. "For the money I have spent on blueprints alone," he once said, "I could have razed the house, erected a replica of the Taj Mahal, and retired to Sun Valley. If I ever adopt a coat of arms, it will show a ravenous draftsman sighting through a transit, over a shield marked 'Soft Pickings.'"

The intense summer heat, even the gnats seemed to conspire against him. He wrote to a friend, "This is a sweltering night in the opinion of one who has spent many of them in a lot of distant corners; when Pennsylvania sets its mind to it, Bangkok and Washington, D.C. seem almost like spas. It's Sunday night about 10:30 p.m., and other than a few billion bugs and rodents, snakes and rabbits, I'm alone in the middle of these eighty-three acres."

Although he had frequent visitors from New York, including Dashiell Hammett, Lillian Hellman, and Edmund Wilson, the monotony of country life often got on Sid's nerves. He complained to another friend, "It's two months now since we returned to the country, where almost nothing happens—as Chekhov so eloquently demonstrated. The high excitement each week is the Wednesday arrival of the laundry truck."

After Laura died in 1970, he abruptly sold his farm, as well as most of the family's possessions, moved to England and then back to New York. Giving up Eight Ball Farm was a decision that he always regretted. In "A Farewell to Bucks," published in *The New York Times* shortly before he departed for England, he wrote with a special note of poignancy about the deer and other wildlife on his former country estate:

> The other morning in Philadelphia I recalled those many evenings when my wife and I used to skim off the horrors of the day's news and the deer moved silently through the dusk. A little group of us— the seller, the buyer, our respective real estate agents and lawyers— were gathered at a title company's office to conclude the formalities of the change of ownership, and as our pens scratched away at the countless documents, I began thinking about the permanent residents—the quadrupeds, the winged ones, the blind burrowing irrigators of the soil, and the myriad, scaly, antennaed insects and reptiles whose claim to these fields and hills so far predated ours. Did they suspect, in their unimaginable dreams, that five faceless folk had met in a glassed-in partition to accomplish this world-shaking agreement? The longer I thought about it the less likely it seemed and the more unreal the whole exercise became....

An intensely private, reclusive man, Sid did not socialize with many of his neighbors, but there was one woman of whom he was enormously fond. She was a small, fragile brunette with thick brown bangs and an air of disarming helplessness. He called her "Dotty," but she was, of course, better known to the world as Dorothy Parker. Dorothy, who lived in

Dorothy Parker, with one of her many canine friends, in a signature portrait by famed photographer Edward Steichen. Courtesy of George Eastman House. Reprinted with permission of Joanna T. Steichen.

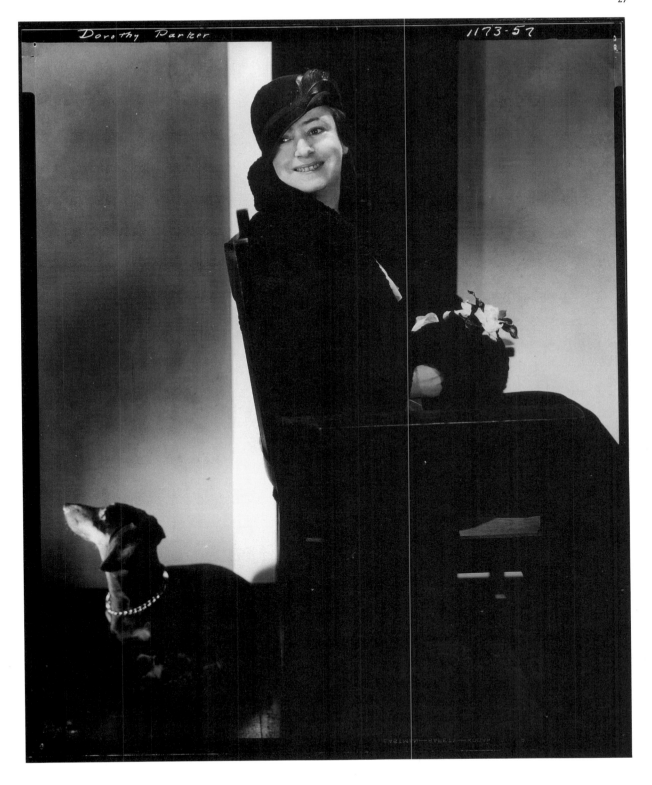

Pipersville, Pennsylvania, from 1939 to 1947, was one of the most talked-about women of her time. Her short stories appeared at regular intervals in *The New Yorker* and *Bookman*, and her collections of verse, which ranged from poetic lyrics to short humorous rhymes, were best-sellers. In 1927, under the pseudonym "Constant Reader," she began to write a book review column for *The New Yorker*. Two years later, she was awarded the O. Henry Prize for "Big Blonde," a corrosive story about a former party girl who sinks into alcoholism and suicidal despair after separating from her husband.

The queen bee of the Algonquin Round Table, a celebrated circle of quipsters who lunched regularly at New York's Algonquin Hotel, Dorothy was a master of the wisecrack, or ad-lib jest. Hearing that a well-known English actress, famous for her love affairs with members of the legal profession, had broken her leg, she cracked, "She must have done it sliding down a barrister." Of Katharine Hepburn, who was appearing in the play *The Lake*, she said that she ran "the whole gamut of emotions

The Algonquin Round Table. Starting with Dorothy Parker on the left and moving counterclockwise around the table: Robert Sherwood, George S. Kaufman, Edna Ferber, Franklin P. Adams, Marc Connelly, Heywood Broun, Alexander Woollcott, and Robert Benchley. © Al Hirschfeld. Drawing reproduced by special arrangement with Hirschfeld's exclusive representative, the Margo Feiden Galleries Ltd., New York.

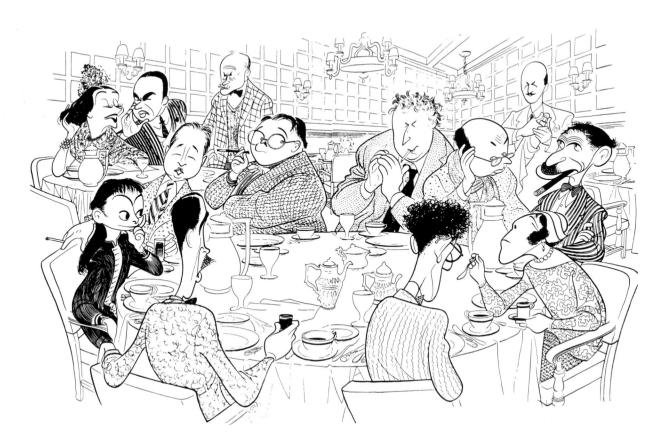

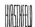

from A to B." Another of Dorothy's favorite targets was the writer Clare Boothe Luce, wife of *Time* and *Life* publisher Henry Luce. Told that Mrs. Luce was always kind to her inferiors, Dorothy asked, "But where does she find them?"

In 1936, the woman whom Alexander Woollcott once summed up as "a combination of Little Nell and Lady Macbeth" bought Fox House Farm, a colonial farmstead off Mt. Airy Road, near Pipersville. The 111-acre farm cost only $4,500, and shortly after they purchased it, Dorothy and her young husband, actor and writer Alan Campbell, learned why it was so inexpensive. Occupied by squatters, the house was a ruin, and the entire first floor was littered with chicken carcasses. But the prospect of a total restoration did not faze Dorothy. By this time, she had abandoned her literary career, and she and Alan were working in Hollywood as highly paid screenwriters. During the time they lived in Pennsylvania, the Campbells received screen credit for at least fifteen films, including *Sweethearts* (with Nelson Eddy and Jeanette MacDonald) and *A Star Is Born* (with Janet Gaynor and Fredric March). One of the reasons they wrote so many films was that they needed the money to renovate their Bucks County property. Spending $98,000, they transformed the farmhouse into a showplace that stunned their friends and the locals.

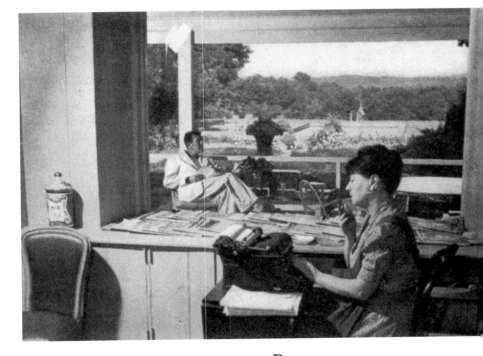

Dorothy Parker and her husband, Alan Campbell, in their Bucks County home, Fox House. Courtesy HG. Copyright © 1942 (renewed 1970) by the Condé Nast Publications, Inc.

Like everything else she did, Dorothy Parker's approach to interior decorating was unconventional. She and Alan redid the living room in nine shades of red. "It was like sitting in a bowl of red jello," one guest quipped.

"We caused talk," Parker later confessed in an article for *House and Garden*. "We even caused hard feelings.... There are no folks so jealous of countryside tradition as those who never before have lived below the

twelfth floor of a New York building. They moved into their beautiful Pennsylvania stone houses, and they keep their magazines in antique cradles.... Their walls are hung with representations of hydrocephalic little girls with scalloped pantalets and idiotic lambs.... Now, they can't really think such things are a delight to live with. Can they? They found us vandals.... Now only the natives speak to us. We feel all right."

While the house was being renovated, the couple lived at the Water Wheel Tavern, north of Doylestown. Dorothy felt that their room was too small and cramped, and so she rented the Cuttalossa Inn, along the Delaware River, in Lumberville. The locals were shocked. It was unheard of for someone to rent an entire hotel during the Depression.

Dorothy's idea of country life was to sleep until mid-afternoon, then spend a few hours reading, knitting, and chain-smoking until it was time to dress for dinner. Meals were served often after 11:00 p.m. because Dorothy liked her martinis. Both she and Alan expected their help to stay up 'til dawn cleaning up, and it was not unusual for weekend guests to come downstairs in the morning and find the cook had quit.

Another wag who added sparkle and gaiety to Bucks County was famed playwright and director George S. Kaufman, leader of the Algonquin Round Table. Kaufman co-wrote the Marx Brothers' plays *The Cocoanuts* and *Animal Crackers*, as well as their film *A Night at the Opera*, and directed many Broadway hits, including *The Front Page* and *Guys and Dolls*.

Known as the "Wit's Wit," Kaufman was famous for his deadpan humor. "The trouble with incest is that it gets you involved with relatives" and "Satire is what closes on Saturday night" were two of his often-quoted witticisms. Kaufman and his wife, Beatrice, a charming fashionable woman who wore slacks long before they became stylish, moved to Bucks County in the mid-thirties. In 1936 they paid $45,000 for a 1740 stone farmhouse on Route 202 in Holicong (today the Barley Sheaf Farm bed-and-breakfast). Its prior owner was Juliana Force, director of the Whitney Museum in New York. Shortly after he bought it, Kaufman collaborated with John Steinbeck to turn *Of Mice and Men* into the prizewinning play of 1937.

The property, which he called Cherchez La Farm (the name, a pun in French, means both "Dear Home: The Farm" and "I Can't Find the Farm"), had an uplifting, almost tranquilizing effect on Kaufman, an intensely shy, nervous, and hypochondriacal man who washed his hands

compulsively and picked pieces of lint from the carpet. "I like Bucks County," he once wrote in *The New Yorker*, "and when I depart for the farm, I am in a gay and emancipated mood, eager for a holiday and the wide countryside."

Despite his quirks, Kaufman was an indefatigable host, and every weekend brought a stream of famous people to his estate, among them playwright Lillian Hellman (when she wasn't the Perelmans' houseguest) and comic Harpo Marx. That irrepressible Harpo liked nothing better than to stand around the Kaufmans' pool, twining leaves into his hair and creating mayhem. Once, when he and Kaufman were playing croquet on the lawn, the game was interrupted by the arrival of two Quakers who had come to talk with Beatrice Kaufman about helping them with some charitable work. Mrs. Kaufman took her guests inside, and when she did not return, Kaufman went to look for her.

Exterior view of Barley Sheaf Farm, George S. Kaufman's Bucks County home. Courtesy of Urban Archives, Temple University, Philadelphia.

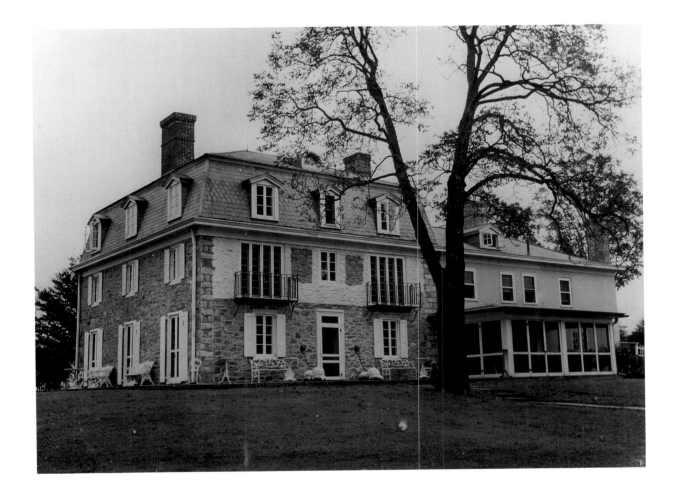

Alexander Woollcott and Harpo Marx, who were frequent visitors at Barley Sheaf Farm, fight the battle of the bulge. Courtesy of Anne Kaufman Schneider.

"Twenty minutes passed. No Beatrice. No George, either," Harpo recalled. "Now I was getting edgy. I looked in the window. There sat both Kaufmans, cozily sipping tea with the ladies from the Society of Friends. I went to the kitchen and dumped a bottle of ketchup down the front of my shirt and pants. I went to the doorway of the living room, where I stood, dripping ketchup.

"'Excuse me, Ma'am,' I said, addressing Beatrice. 'I've killed the one cat, and he'll be ready for dinner, but I still haven't caught the other one. Will one be enough?'

"The visitors departed in haste, and our game resumed. Beatrice couldn't stop laughing, but George was practically reduced to ashes. He couldn't get his ball through another wicket and never did make it to the stake."

Kaufman spent $100,000 to renovate his farm. Moss Hart, the playwright and director with whom he wrote eight plays, including such hits as *Once in a Lifetime* (1930) and *You Can't Take It with You* (1936), was so impressed with the results that he soon purchased a farm of his own, an eighty-seven-acre property several miles away, off Aquetong Road. Obviously trying to outdo Kaufman, he created a forest on a hilltop, transplanting 3,500 pines and spruces and importing 139 twenty-year-old elms. The total cost was $33,000. Unfortunately, the property lacked water, and Hart had to dig seventeen wells before he discovered any.

When Kaufman (or Dorothy Parker or Alexander Woollcott, depending on your source) saw what his colleague had done, he quipped, "It just goes to show what God would do if he had money." Equally impressed, the novelist Edna Ferber signed Hart's guest book, "You know I love you, don't you Mouse, but I would kill you for your house!"

Algonquin wit Alexander Woollcott, however, was not overawed. After visiting Hart's estate, the noted drama critic scribbled acidulously in the guest book, "This is to certify that I had one of the most unpleasant times I ever spent." Hart immediately reported Woollcott's impressions to Kaufman, adding that it would have "been awful if he had broken a leg and been on my hands for the rest of that summer." This unpleasant fantasy of having to cope with the most difficult of houseguests inspired

one of Kaufman and Hart's greatest hits—*The Man Who Came to Dinner* (1939), which, in their own words, was "an unexpurgated version of Alexander Woollcott."

Actress-singer Kitty Carlisle, whom Hart married in New Hope on August 10, 1946, had a different impression of his palatial estate. In her 1988 autobiography, Mrs. Hart recalled with refreshing practicality, "It was a very large establishment, a bit rich for a man who relied on play-wrighting for his income."

Hart was Kaufman's most successful collaborator. According to one of Kaufman's biographers, "As their relationship went on, Moss became closer to George than anyone—even closer than family. The older man smiled on the antics of the talented youth he had made out of a boy on the borscht circuit. When that young man flowered into a charming, extroverted dandy, George was delighted by him, amused, and ultimately as proud as if Moss had been his own son."

Moss Hart and Kitty Carlisle, who were married in New Hope in 1946, seen here in the study of their Bucks County home. Courtesy of Kitty Carlisle Hart.

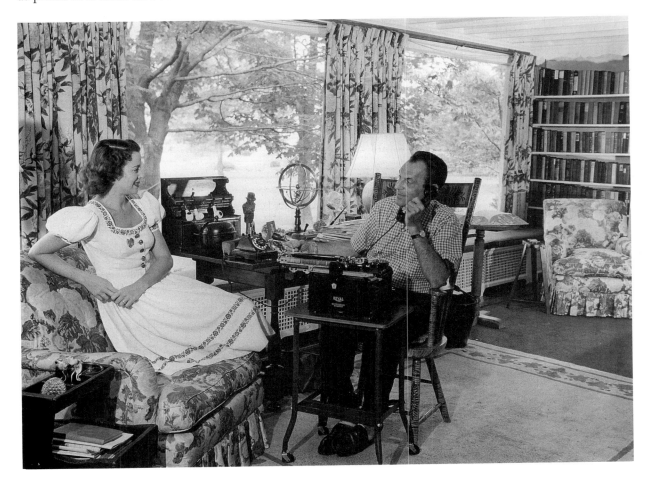

It was Hart who summed up Kaufman's quixotic personality better than anyone. When Kaufman died in 1961 at the age of seventy-two, he delivered the eulogy. "There were many Georges," Hart said. "There was George the cantankerous croquet player, irritable and implacable, a marvelous loser but a poor winner. There was George the terror of head-waiters, taxi drivers, and barbers—yet strangely, almost foolishly senti-mental. There was G. S. K. the wit, certainly one of the wittiest men of his time, always genuinely surprised that his own special way of life should be considered witty. There was a wintry and distant George, but there was also a warm and spring-like George, though not everyone saw this side of him, for he was not always a comfortable man or what we think of as a cozy man. Yet, and this was the contradiction, he was a loving man. It might surprise him to hear me say that, but he was...."

On the other hand, the gregarious, warm and generous Hart was adored by his large circle of friends. For Bennett Cerf, co-owner of Random House, who published Hart's best-selling 1959 memoir, *Act One*, about his poverty-stricken childhood in Brooklyn and his years as a social director at summer camps on the borscht circuit, he "was the most remarkable person I ever knew. To me, Moss represented the theater. Everything he did delighted me. He was such fun to be with.... Moss was the kind of guest a hostess dreams of. No sooner did he appear at a party than he automatically assumed the role of co-host. Immediately, further-more, everybody in the room became a little brighter, a little more assured, just because Moss was there."

P*earl S. Buck at her desk in Bucks County. Courtesy of the Pearl S. Buck Foundation, Inc.*

If Moss Hart represented the theater to most sophisticated Americans, Pearl S. Buck, who lived in Bucks County for much of her long life, represented "a human bridge" between the civilizations of the West and the mysterious East to millions of her devoted readers. An attractive woman with magnetic blue eyes and a radiant smile, Pearl Comfort Sydenstricker was born in Hillsboro, West Virginia, on June 26, 1892. Her parents were Presbyterian missionaries in China, and she grew up in Chinkiang on the Yangtze River. Unlike other foreigners, she and her parents lived in the Chinese community, not in a special compound set aside for them, and Pearl learned to speak Chinese before she could speak English. She was so at home in China that she once wrote, "I had almost ceased to think of myself as different, if indeed I ever thought so, from the Chinese."

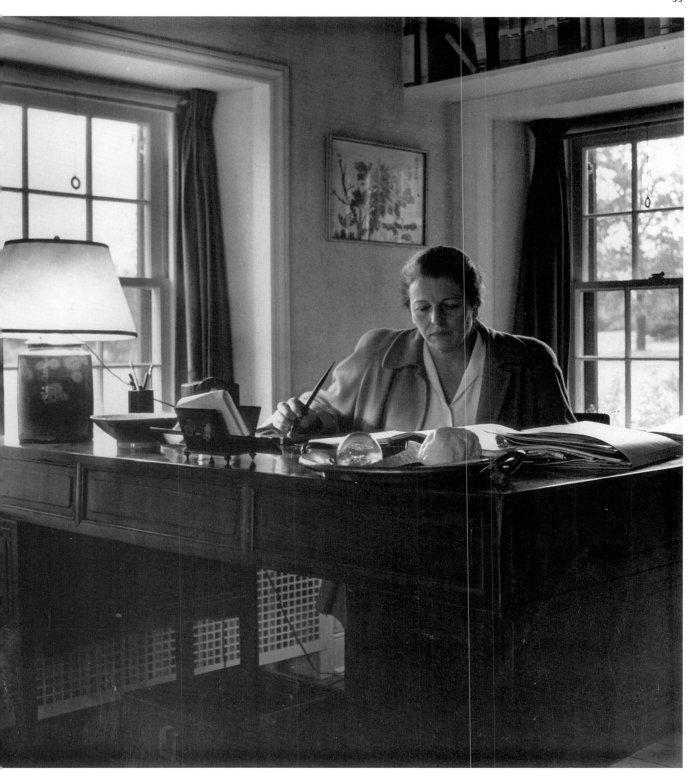

After graduation from Randolph-Macon College in Virginia, she began writing. She published her first novel, *East Wind: West Wind*, in 1930. Her second novel, *The Good Earth*, about a Chinese peasant named Wang Lung and his rise from poverty and ignorance, received the Pulitzer Prize as the best American novel of 1931. It was the first novel of a trilogy about the family of Wang that included *Sons* (1932) and *A House Divided* (1935).

In 1938, she became the first American woman to win a Nobel Prize in literature. According to Nobel's biographer, "The decisive factor in the Academy's judgment was above all, the admirable biographies of her parents [*The Exile* and *Fighting Angel: Portrait of a Soul*, both published in 1936] ... two volumes which seemed to deserve classic rank and to possess the required prospects for permanent interest." The Nobel committee also considered her novels outstanding "for rich and genuine epic portrayals of Chinese peasant life." In accepting the prize, she stated her indebtedness to the tradition of the Chinese novel, whose principal purpose, she stressed, was the entertainment of its readers.

In 1917 Pearl married John Lossing Buck, an agricultural missionary of whom her parents disapproved. "I had to live on my own," she said years later, "and I married a man I saw alone only four times before the ceremony. My parents were right and I was wrong. I married a handsome face, and who wants to live with just a handsome face." During her marriage to Buck, a highly regarded agriculturist, she taught English literature at various Chinese universities. The Bucks were divorced in 1935. That same year she married Richard J. Walsh, president of The John Day Company, her publishers.

After their wedding, Buck and Walsh moved into a Park Avenue apartment in New York. They spent their weekends, however, on a 400-acre estate, Green Hills Farm, in Perkasie, Pennsylvania, which Pearl had bought shortly after she left China for the last time in 1932. The property was in poor condition. The farmhouse was abandoned, without electricity or running water. She paid $4,100 for it.

Shortly after returning from Reno, Nevada, where, in a bizarre coincidence, she shared a hotel room with Richard Walsh's first wife while they both waited to obtain their respective divorces, she invited Doylestown *Intelligencer* reporter and columnist Lester Trauch to Green Hills Farm.

"She told me that the Chinese—I don't know if I believe it—were not interested in the personal lives of writers and actors," Trauch subse-

quently told an interviewer. "She couldn't understand why Americans were so interested. One Christmas Eve she had to close her shades because people were driving up the road that went between her barn and her house and peeking in. She eventually had the road declared private."

Pearl Buck's large family eventually included nine adopted children. Her only natural daughter, Carol, a retarded child, had been reared in a training school in Vineland, New Jersey. One of the reasons that she started writing was to pay for Carol's expensive care.

As talented and generous as she was, Pearl Buck unfortunately lacked judgment when it came to men. Scandal marred her last years, when she became involved with a young dance instructor from a studio in Jenkintown whom she installed as president of her foundation. Reportedly, he manipulated the writer for his own financial profit, although no charges were ever filed against him. In 1973, she died in Danby, Vermont, at age eighty after a long illness. The author of eighty-five novels, plays, children's books, translations, and collections of short stories and essays, she remained active to the end of her life, writing a children's book as well as two novels, including the long-planned sequel to *The Good Earth*, to be entitled *The Red Earth*. More than twenty-five volumes still awaited publication. In her day, she was the most translated of all American authors. Her work tended to enjoy more popular than critical acclaim, although *The Good Earth* and her biographies of her missionary parents continue to be highly praised.

Besides her books, Pearl Buck's legacy includes Welcome House, an adoption agency that has placed 5,000 mixed-race and Asian children with American families since 1949, and the Pearl S. Buck Foundation, which since 1964 has assisted 25,000 Amerasian children overseas.

Pearl Buck is buried at Green Hills Farm, which is open to the public. Fittingly, her headstone, off to one side near a small spring, consists of a flat stone, inscribed in Chinese. "It's the perfect symbolism for her life," Lester Trauch observed to an interviewer. "She was one of the loneliest women I've ever met."

If Pearl Buck's goal was to bridge East and West, Jean Toomer's life-long quest was a search for spiritual fulfillment, which sprang from an intense need to be perfect and whole. The great-grandson of a white planter and a mulatto former slave, Toomer was the author of *Cane*, a brilliantly innovative work that many critics consider a masterpiece of American literature. Published in 1923 when Toomer was only twenty-

eight, it immediately established his literary reputation, and he was hailed, with Richard Wright, Langston Hughes, Countee Cullen, and Zora Neale Hurston, as a leading figure of the Harlem Renaissance. This was a literary and artistic movement in the 1920s, centered in Harlem, in which educated, urbanized African-Americans discovered the beauty and honesty of life in the Harlem ghetto. Alienated from white American society, yet aloof from the experiences of the majority of their own people, they were in search of their own identity and so were forerunners of the revolutionary African-American writers of the 1960s, such as James Baldwin and Imamu Amiri Baraka.

Cane, which is part drama, part poetry, and part fiction, was considered daringly experimental by the literary critics, who raved over its use of interior monologue and other avant-garde techniques. Commented one reviewer: "This extraordinary book is thus a celebration of blackness, which is symbolized by the 'Oracular / Redolent of fermenting syrup, / Purple of the dusk, / Deep-rooted cane.' It is only when he has acknowledged and affirmed the tragedy and the beauty of his heritage, Toomer suggests, that the black can throw off the chains that history has placed upon him, and transcend himself. In style, Cane is lyrical and metaphorical, bordering at times on the mystical, in a way which has suggested comparisons with Hart Crane and Walt Whitman."

Despite the critical acclaim, Cane sold barely five hundred copies and then disappeared into obscurity. After its publication, Toomer continued to write books, essays, and poems, but publishers rejected almost all of his subsequent work.

In the mid-thirties, like many of his contemporaries, Toomer became absorbed in the teaching of George Ivanovich Gurdjieff, an Armenian mystical philosopher who espoused a spiritual-mental-physical system for achieving wholeness, and he led Gurdjieff groups in Harlem and Chicago. By 1924 he rejected art in writing for Gurdjieff's promise of internal harmony. It was through his interest in the Gurdjieff experiment that he met Margery Latimer, a promising young novelist who was a descendant of the early New England poet Anne Bradstreet and the famous New England clergyman John Cotton. They married in 1932, and she died the following year giving birth to their only child. In 1934 Toomer married Marjorie Content, a highly gifted photographer who was the daughter of Henry Content, a member of the New York Stock Exchange, and, like her husband, an intimate friend of Georgia O'Keeffe and Alfred Stieglitz. At

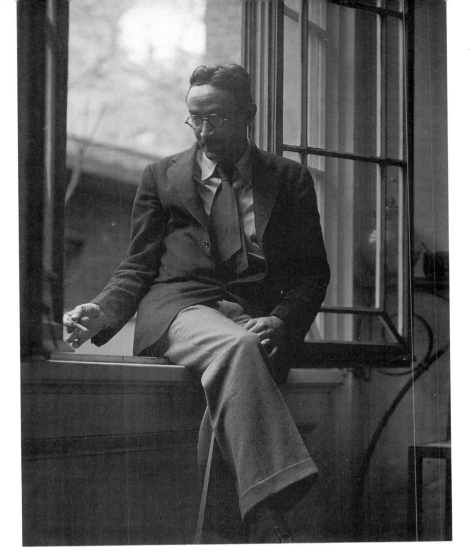

this time he hoped to establish a Gurdjieff-styled institute in Doylestown, with his father-in-law's money, but it was never built.

Toomer instead used Henry Content's funds to buy a Bucks County farm in 1936. According to his biographers, Cynthia Earl Kerman and Richard Eldridge, Marjorie and Jean had become impressed with the area when they visited the home of the sculptor Wharton Esherick, a friend of Marjorie, who lived in Paoli, Pennsylvania:

> Jean had remarked that this part of the country would be a nice place to live. So they returned to the area the following year and found a farm with a good livable house for sale near Doylestown. In April, they hired a local farmer to run the farm and began remodeling the dilapidated gristmill.... The main house, where the family

lived, was given the name Mill House, and Marjorie designed an emblem for the new project....

Walking the rural roads nearby, he cut quite a figure, as one of his neighbors recalled: "I thought when I saw him he must have been from either Ethiopia or India. He was narrow, and tall, and black-haired, and walked rather slowly, pondering as he went, meditating, I should say. He always wore a white leather jacket and a black hat, and generally he had on beautiful, what we called Santa Fe trousers that were creamy whipcord trousers—the luxury pants of a cowboy; and he had a black and white coach dog."

A dark-haired woman with beautiful posture, Marjorie Content was as striking as her husband. She wore brightly colored long skirts and American Indian jewelry even to the market, which brought her to the attention of Dorothy Paxson, who not only became her close friend but invited her and Jean to visit the Quaker meeting nearby, the Buckingham Meeting of the Religious Society of Friends. Finding the quiet worship a deeply satisfying experience, Jean Toomer began spending much of his time writing religious tracts, including his "minor Quaker classic," *Friends Meeting for Worship*. He also continued to lead and attend Gurdjieff groups, starting his own group at his home, where his large group of disciples depended on him for consultation, advice, and emotional support. In increasingly poor health from a variety of ailments, including kidney failure, gall bladder disease, and arthritis, he began experimenting with Jungian analysis, the Alexander technique, dianetics, and nutrition and diet. For the last fifteen years of his life he was an invalid and a recluse, and one friend summed up his life as "a story of a tragedy." After many years of poor health and invalidism, he died in 1967 in a nursing home near Philadelphia. Upon learning of his death, his admirers were stunned. As he had published nothing in the forty-four years since *Cane*, they presumed that he had died years earlier.

Time, however, has restored Jean Toomer's literary reputation. The growing interest in African-American literature that began in the 1960s led to his rediscovery, and today *Cane* is more widely read than it was while its author was alive. After a leading publisher reissued *Cane* in the year following Toomer's death, it was ranked with Richard Wright's *Native Son* and Ralph Ellison's *Invisible Man*. It is considered the principal literary masterpiece of the Harlem Renaissance, and Toomer, one of America's most creative and enigmatic writers.

Jean Toomer had his first—and only—literary success when he was twenty-eight years old. In contrast, another famous—and extraordinarily prolific—Bucks County writer did not publish a book until he was almost forty. His name was James Albert Michener, and he began life as a foundling raised in poverty in Doylestown by Edwin Michener, a farmer, and Mabel Michener, a kindly woman who did laundry for Doylestown's wealthier families to support her two sons and numerous foster children. Michener never knew who his real parents were. "I've never felt in a position to reject anybody," he once confided to an interviewer, "I could be Jewish, part Negro, probably not Oriental, but almost anything else. This has loomed large in my thoughts. Raised in a poorhouse, I missed a whole cycle of childhood, but I've never used it as a device for self-pity."

Michener has said that as a young man, his literary imagination was kindled by his ramblings along the picturesque Bucks County countryside as well as his relationships with some colorful locals. At the same time he honed his writing skills by editing the student paper at Doylestown High School, from which he graduated in 1925. After graduating summa cum laude from Swarthmore College in 1929, he taught English at some Pennsylvania schools, including the George School in Newtown, and at the Colorado State College of Education at Greeley. Then, after becoming disillusioned with academe, Michener became a textbook editor at Macmillan, a New York publishing firm. During World War II, he enlisted in the Navy and journeyed throughout the South Pacific as chief historical officer for the area from Australia to French Oceania. He visited forty-nine islands in eighteen months, becoming thoroughly acquainted with their histories and diverse cultures. Although he had dreamed of writing for years, it was during this trip that he decided to pursue it seriously. Retiring to a small Pacific island during a slack period in his service, he began work on a book. It was a collection of eighteen loosely linked stories told by a naval officer about American Marines, Seabees, nurses, and the inhabitants of the South Pacific islands during the war. These tales formed the core of *Tales of the South Pacific*, which was published without fanfare by Macmillan in 1947.

When he returned from the service, Michener resumed his job as a textbook editor at his old firm. In the meantime, he submitted his second book, a first novel entitled *The Fires of Spring*, to the head of Macmillan, who told him that he really didn't have much of a future as an author and that he should stick with his editorial job and not waste his time on

From left to right: Joshua Logan, Richard Rodgers, Oscar Hammerstein II, Mary Martin, and James A. Michener, around the time of the first production of South Pacific. Courtesy of the Rodgers & Hammerstein Organization.

writing. Michener then approached Random House, and shortly after signing a contract with the publisher, the book of short stories that nobody had paid much attention to won the Pulitzer Prize for 1947. Oscar Hammerstein, who lived in Doylestown and was unaware of the fact that they were neighbors, tried frantically to reach Michener to secure the dramatic rights. Fortunately, he succeeded, and some time later, he and Richard Rodgers created South Pacific, one of the most successful musical productions of the postwar period. Starring Mary Martin and Ezio Pinza in the leading roles, it opened on Broadway in 1949 and ran for five years. The musical was based on two stories from the book, and Michener became a literary success overnight.

Michener followed this success with a series of short novels (The Bridges at Toko-Ri and Sayonara), numerous articles for Reader's Digest on foreign

civilizations, and a series of epic semidocumentary novels, each of which illumined a particular region. They include *Hawaii* (1959), *The Source* (1965), *Chesapeake* (1978), *Space* (1982), *Alaska* (1988), *Mexico* (1992), and *Miracle in Seville* (1995). As one critic pointed out, "His achievement is in spellbinding narration in which he exploits an unerring recognition of fascinating detail, a feeling for adventure, and a gift for re-creating primitive societies, alien cultures, and faraway and colorful lands where Americans enter the larger world. Moreover, whether writing a nonfiction book like *Iberia: Spanish Travels and Reflections* or an epic novel like *Centennial*, he combines a hospitable outlook with the authenticity of a thorough researcher who has been there to see it all for himself."

Michener moved back to Bucks County in 1949, around the time that *South Pacific* opened on Broadway. According to his biographer, John P. Hayes, he never thought of himself as one of the famous writers who were living in the area, although "he was the only member of the literary group to have grown up in Bucks County. He was also the last to buy his property at the bargain price of sixty dollars an acre!" His new home was a ranch-style house with numerous picture windows perched high on a wooded hillside overlooking a seventy-acre tract in Pipersville. His contractor and landscaper was Herman Silverman, and although Michener had originally planned to cut costs by doing much of the finishing work himself, "construction got under way at about the time Michener saw *South Pacific* in dress rehearsals, and as his enthusiasm mounted with each performance, he sent modified plans to Silverman. 'Go ahead and put in the [second] bathroom,' he wrote after watching a rehearsal in Connecticut. Then, after Rodgers and Hammerstein made their generous offer he could afford to add a garage and 'plant some pine and spruce, plus shrubs and rhododendron.'"

The many books Michener wrote at his Pipersville retreat include *Sayonara* (1954), *The Floating World* (1954), *Report of the County Chairman* (1961), *Caravans* (1963), *America vs. America: The Revolution in Middle-Class Values* (1969), *Presidential Lottery: The Reckless Gamble in Our Electoral System* (1969), *The Quality of Life* (1970), and *Sports in America* (1976).

Michener's work—some forty books translated into more than fifty languages, with worldwide sales in the millions—has become one of the great literary properties of the world. It was not by accident, as he is a meticulous craftsman, one who works very closely with editors. In the opinion of the late Bennett Cerf, his publisher at Random House for many years, he "is the ideal author as far as a publisher is concerned—a

man who lets us do the advertising, as Faulkner did, and trusts us. For *Hawaii* he had fifteen books of notes before he started writing. For *The Source* he lived in Haifa and other cities in Israel and Syria for more than year, picking up history and folklore and learning how these people live."

A more revealing insight was offered by the late Helen M. Strauss, his agent for many years at the William Morris Agency: "One must always remember that he is a man of many moods and a loner, and his interests are varied. Some of his Quaker upbringing is apparent in his mode of living. His attitude toward money is baffling. He has a great ambivalence about it. He relishes his success but spends little money on himself. He lives modestly. His personal material needs are simple. He has helped many people in many ways—artists, writers, people with financial problems.... I know of no one who is less interested in status....

"Even when traveling on some company's expense account, he is economical. He is so lacking in ostentation that if one meets him without knowing who he is, the first impression would be that perhaps he is a college professor or a clergyman who has no real interest in wearing apparel other than it's functional, whose income is modest and who lives in some Middle Western university town."

Several Erwinna residents recall another, more flamboyant Michener—the "Mitch the Witch" who told fortunes inside a tent for several years at the annual Tinicum Art Festival in Erwinna. According to one person who had his future revealed by the world-famous author, "Michener gave his imagination free reign in his outrageous fortune-telling sessions, as he told the 'whole truth by the infallible method of an Egyptian princess.'"

In 1955, Michener, who had been married twice before, married Mari Yoriko Sabusawa, an American of Japanese extraction who, along with her parents and thousands of other Japanese-Americans, had been forced to live in internment camps during World War II. A charming and brilliant woman, Mari traveled all over the world with her husband and made life comfortable for him wherever they went, handling the details of their traveling and living arrangements. Like her husband, she was an avid art collector, sharing his enthusiasm for twentieth-century American paintings.

The Micheners were a devoted couple. According to John P. Hayes, "Michener enjoyed Mari's attention as much as she enjoyed sparring with him. They called each other Cookie and they enjoyed each other immensely. He teased Mari about her weakness for buying gimcracks on

James A. Michener at the desk of his Bucks County home. Courtesy of Urban Archives, Temple University, Philadelphia.

each research trip. Michener himself collected souvenirs, but discrimi-
nately.... But Mari possessed 'an insatiable desire to collect nonsense
items,' observed her husband who was powerless to do anything about it.
'The result,' he informed the librarians at the University of Northern

Colorado, where he deposited his *Centennial* papers, 'is this box full of junk.' Among the items were statues, bones, seashells and miniature models of dinosaurs and beavers. As for Mari, she just went on collecting."

Strongly influenced by his Quaker upbringing and his poverty-stricken youth, Michener has quietly donated at least $80 million to universities, with substantial donations to support writing programs, and to libraries and museums, including a $1 million endowment gift to the Michener Art Museum in 1988. This was followed by the establishment of the Michener Art Endowment Challenge in 1992 (a program that tied endowment gifts to the donation of major paintings to the collection).

Mari Michener died after a long battle with cancer in September 1994. A thoughtful, idealistic woman, she believed that "whatever you make, you return to the community. My husband made his money in the arts, so we return it to the arts." One of her last wishes was that a wing be added to the Michener Art Museum, which promotes the arts through its collection of twentieth-century American art, with a special focus on the arts of Bucks County. The most prominent feature of the new Mari Sabusawa Michener Wing is a long-term exhibition space that honors twelve nationally known artists in all media who helped make Bucks County famous, including Pearl S. Buck, Moss Hart, George S. Kaufman, Dorothy Parker, S. J. Perelman, and Jean Toomer.

In the glittering thirties and forties, so many nationally famous literary figures owned country homes in Bucks County that the New York press dubbed the area "the Genius Belt," although for James Michener, a native, it was more like "a poor man's Connecticut." Bucks County was home to many other celebrated writers, however, and who they were may surprise you....

In 1933, James Gould Cozzens, whose many novels generally dealt with the moral dilemmas and compromises of the upper-middle class, bought a farm in Lambertville with his wife, Sylvia Baumgarten, a literary agent. Several years later, Cozzens, a man who liked to spend his spare time farming and gardening, told an interviewer that "this summer I intend to spend many pleasant mornings hanging around courtrooms because I plan to write a novel about a lawyer. My book will be about a lawyer who must make a choice between an ideal and what might be called a selfish, practical consideration." As it turned out, those court-

rooms were located in the Court House at Doylestown, and the result of Cozzens's research was *The Just and the Unjust*, which was published in 1942 and considered one of the best legal novels ever written.

Cozzens's eleventh novel, *Guard of Honor*, was the story of the Army's youngest major general's efforts to hold a Florida air base together in World War II. It won the 1948 Pulitzer Prize in fiction, and in the opinion of one critic, "gave added recognition to a novelist who has worked consistently with respect for his craft, with an artistic integrity which is not too common in our time."

Budd Schulberg, American novelist and short-story writer, was another famous writer who chose a Bucks County farm as the place to write his memorable books. The son of B. P. Schulberg, the legendary film producer and head of Paramount Pictures, Schulberg first attracted notice in 1941 with his first novel, *What Makes Sammy Run?*, a satire of the rise of a Hollywood mogul, which many critics consider the best book about Hollywood ever written. Among his other well-known works were *The Harder They Fall* (1947), about the prize-fight racket, and *The Disenchanted* (1950), whose alcoholic central character was based on F. Scott Fitzgerald in his declining years. It was a best-seller and a Book-of-the-Month Club selection. In 1954, Schulberg, whose explosive and direct prose has been described by one friend as at odds with his charmingly vague manner, wrote one of the most successful movies that has ever been made—*On the Waterfront*, starring Marlon Brando—and then rewrote the screenplay as a novel, entitled *Waterfront*. His autobiography, *Moving Pictures: Memories of a Hollywood Prince*, was published in 1981. In the 1950s, when he was living on his farm near New Hope, Schulberg used to write in a little stone house that had been used as a root cellar or a springhouse.

In the early years of that decade the world-renowned Arthur Koestler lived on an island in the Delaware River near New Hope. Koestler had gained recognition with the publication of his novel *Darkness at Noon* (1941), a fictionalized account of the Moscow trials of 1938 in which many Bolshevik revolutionaries were put to death by the Soviet government.

An equally talented writer, although his subject matter was completely different from Koestler's, was Glenway Wescott, who lived across the river in Rosemont, New Jersey. A writer of uncompromising taste and discipline, Wescott was considered "a writer's writer," admired by his peers since the publication of his first book of poems, *The Bitterns*,

in 1920, when he was just nineteen. However, the Wisconsin-born Wescott was better known to the reading public for his fiction. His second novel, *The Grandmothers*, which was published in 1927, was an unsentimental portrait of a sprawling three-generation Wisconsin family. It won the Harper Prize and is still considered a minor classic. Wescott, who served as vice-president of the National Institute of Arts and Letters, wrote several other novels before his death in 1987, including *Apartment in Athens*, which was published after World War II and was a psychological study of the Occupation and its stresses upon a once well-to-do Greek family and a guilt-obsessed Nazi.

Hugh Ford, formerly of Lambertville, who now lives in England, is presently working on a biography of Wescott. Ford, formerly a professor of English at Trenton State College in New Jersey, is the author of numerous articles, reviews, and books on the expatriate period, including *Four Lives in Paris, Published in Paris, The Left Bank Revisited, Women of Montparnasse*, and several works on the life and work of Nancy Cunard.

An eighty-acre farm near Quakertown was the home and writing studio of George Papashvily. A Russian immigrant who fled to Turkey and then to the United States soon after Stalin came to power, Papashvily soared to literary prominence in 1945. With the help of his American-born wife, Helen, he wrote a book, *Anything Can Happen*, a hilarious account of his first fifteen years in the United States that conveyed an enormous affection and belief in his new country. Observed one critic: "It commits the most delightful mayhem upon the English language since Hyman Kaplan got his funny education." George and his wife later collaborated on five other books. *Anything Can Happen* was made into a film in 1952, with Jose Ferrer playing the author. Then the multitalented Papashvily became a successful—and nationally acclaimed—sculptor.

Besides Kaufman and Hart, prominent playwrights who chose to make their homes in the area include Kenyon Nicholson of Stockton, New Jersey (he wrote *Sailor, Beware!* and *Out West of Eighth*), and Jerome Chodorov of New Hope, co-author of the play *My Sister Eileen* (which was based on Ruth McKenney's idealized stories in *The New Yorker* about her doomed sister Eileen, who married Nathanael West). Interestingly, the play, which was produced on Broadway in 1940, was directed by George S. Kaufman.

Then there were Ruth and Augustus Goetz, whose most famous work was *The Heiress*, an absorbing psychological drama inspired by Henry James's *Washington Square*, a novel about an heiress who is dominated by

her unloving father and a fortune hunter who wants to marry her. Starring Wendy Hiller and Basil Rathbone, and staged by the legendary Jed Harris, it was produced on Broadway in 1947 and ran for 410 performances. As Ruth Goetz later recalled, she and Gus, a former stockbroker, were struggling to come up with an idea for a second play when she stumbled on the James novel. What drew her to the story was that the heiress reminded her of "a lost maiden like dozens I had watched." In 1949, Olivia de Havilland received an Oscar for best actress for her role as the plain, shy Catherine Sloper in the movie version, which co-starred Ralph Richardson and Montgomery Clift, and was directed by William Wyler.

In 1994 *The Heiress*, starring Cherry Jones and Frances Sternhagen and directed by Gerald Gutierrez, was revived on Broadway. It was a phenomenal success, receiving four 1995 Tony Awards, including Best Revival of a Play.

Samuel and Bella Spewack were another highly successful Bucks County husband-and-wife writing team. The Spewacks wrote many Broadway comedies, including the hit musical *Kiss Me, Kate*. Year after year the names of Spewack productions went up in lights along Broadway. In addition, the versatile Sam wrote novels, short stories, television adaptations, and films. According to one critic, "The torrent of comedy froth that the Spewacks created for Broadway was often fast-paced, madcap, verging on slapstick and knockabout farce. Their plays were typically peopled by the harassed, the rattle-brained, the blunder-prone, the insupportably pompous, among other cartoon figures."

Spewack and Bella Cohen were married in 1922, having met while he was a reporter for the *World* and she for the *New York Call*, a Socialist paper. "Sam really fell in love with my writing," Mrs. Spewack later recalled. After spending several years together as correspondents in Moscow, they launched a writing collaboration that eventually spanned four decades.

Clear All Wires!, based on their experiences as reporters in Moscow, was the Spewacks' first big break on Broadway, opening in 1932. Six years later, it was turned into a musical with the title *Leave It to Me!*, with a score by Cole Porter. The show, which included the song, "My Heart Belongs to Daddy," introduced a new young star to Broadway. Her name was Mary Martin.

In *Boy Meets Girl*, which was directed by George Abbott and opened in New York in November of 1935, the Spewacks wrote about a fictional

writing team, Benson and Law. The script included an exchange that has slipped into common usage: "Listen," Benson says, "I've been writing stories for eleven years. Boy meets girl. Boy loses girl. Boy gets girl."

Kiss Me, Kate, a take-off of Shakespeare's *The Taming of the Shrew*, with a score by Cole Porter, ran for 1,077 performances in New York and won a Tony Award as well as a Page One Award for the Spewacks in 1949. The critic Brooks Atkinson wrote that *Kiss Me, Kate* had "the best musical comedy book of the year."

John Wexley of Ottsville was another prolific playwright, author, and Hollywood screenwriter. Wexley's most famous work was *The Last Mile*, a taut, searing prison drama that was first produced on Broadway in 1930 and made Spencer Tracy a star. Clark Gable subsequently played on stage the role of Killer Mears, the ferocious mutineer of Death Row; in the two movie versions, Preston Foster and Mickey Rooney played the part. Wexley followed this triumph with *They Shall Not Die*, a controversial dramatization of the Scottsboro case that Brooks Atkinson, drama critic of *The New York Times*, called "a play of terrifying and courageous bluntness of statement." In the thirties, Wexley became a Hollywood screenwriter, writing movies for James Cagney, Humphrey Bogart, and Edward G. Robinson, among other stars. Wexley's films included *The Amazing Dr. Clitterhouse*, *Angels with Dirty Faces*, *Confessions of a Nazi Spy*, and *The Long Night*. He was also the author of the book *The Judgment of Julius and Ethel Rosenberg*, published in 1955.

Two writers who hold a special place in Bucks County's literary pantheon are librettists Oscar Hammerstein II and his protégé, Stephen Sondheim. Both were native New Yorkers, albeit born a generation apart.

Hammerstein was the son of a famous vaudeville theater manager and grandson of a German-born opera impresario. In 1920, at age twenty-five, he wrote the book and lyrics for his first Broadway musical, *Always You*, which instantly brought him to the forefront of the movement to breathe new life into the moribund art of operetta. He soon rose to the top of this field on a tour de force of wildly successful collaborations with composers Rudolf Friml (*Rose Marie*, 1924), Sigmund Romberg (*The Desert Song*, 1926), and Jerome Kern (*Show Boat*, 1927). But then, as the Great Depression gripped the country, he fell on hard times. By 1940, he could look back on nine years without a single Broadway or Hollywood hit. His wife, Dorothy, was making more money as an interior decorator.

Ready for a change of scenery and already familiar with Bucks through visits to friends, the Hammersteins went househunting in the vicinity of Doylestown. One day (so the story goes), they saw a rainbow hovering over a three-story, white-porticoed residence on East Road, which happened to be for sale. Regarding the rainbow as an omen, they purchased the house and its surrounding forty acres, named the place Highland Farms, and moved in with their five children, two each from previous marriages and a fifth from their own.

As if in obeisance to the Bucks County rainbow, Hammerstein's fortunes now took a dramatic turn for the better. In 1941, he won an Oscar for his lyrics in *The Last Time I Saw Paris*, with music by Jerome Kern. Next, the renowned musical comedy composer Richard Rodgers asked him to write the book and lyrics for the show that would make Rodgers and Hammerstein the most famous tandem in American musical theater.

Oscar Hammerstein II at his writing desk on his Bucks County farm. Courtesy of the Rodgers & Hammerstein Organization.

This was *Oklahoma!* (1943), whose unprecedented combination of a serious, rather than lighthearted, story line with fetching melodies and robust ballet created a new genre, the musical play. Hammerstein said that the words for "Oh, What a Beautiful Mornin,'" *Oklahoma!*'s memorable opening number, came to him as he sat on his porch, watching cows grazing on a distant hill. Other Rodgers-Hammerstein hits followed over the next seventeen years, among them *Carousel* (1945), *The King and I* (1951), and *The Sound of Music* (1960).

Oscar and Dorothy Hammerstein hosted a steady stream of showbiz folks on their spread, where they eventually raised Angus cattle. Actress Mary Martin, director Joshua Logan, and young Henry Fonda (who would marry Dorothy's daughter, Susan) were frequent visitors. But the most regular summer guest was a neighbor boy from a troubled family.

Stephen Sondheim was the son of one of Dorothy's New York clients who moved to Bucks after her divorce. Beginning in 1942, when "Stevie" was twelve, he escaped his apparently greatly troubled home life by spending so much time with the Hammersteins, twenty minutes up the road by bike, that he became almost a member of the family, with Oscar a sort of surrogate dad. According to one of Hammerstein's biographers, Sondheim would say later that "Oscar and Dorothy saved my life, on a personal level. I don't know where I would be if I hadn't met them."

It was Oscar who steered Sondheim along the path to theatrical stardom as well. When, in 1946, the youngster wrote a full-blown musical on his life at George School in nearby Newtown, Oscar took it apart piece by piece, subjecting each element to brutally frank examination. Sondheim would give full credit to his mentor: "Hammerstein taught me everything I know about the theater and songs."

Ten years later, with a degree from Williams College and after studying advanced musical composition, Sondheim graduated to the big time. He wrote the lyrics for Leonard Bernstein's *West Side Story* (1957), then collaborated with Jule Styne in the creation of *Gypsy* (1959). These successes reflected only part of his brilliance. In 1962, he wrote both the words and the music for *A Funny Thing Happened on the Way to the Forum*, which ran on Broadway for 964 performances.

Many Sondheim hits have since followed, including *Sweeney Todd, the Demon Barber of Fleet Street* (1979), the Pulitzer Prize-winner *Sunday in the Park with George* (1986), and *Into the Woods* (1987). In the process, he collected more than twenty Tony, Grammy, and Academy Awards for his sophisticated, often cynical lyrics and his talent for making songs propel a plot.

Hammerstein didn't live long enough to experience his protégé's most mature work. He died of stomach cancer in his beloved Bucks County in October 1959, shortly before the opening of *The Sound of Music*.

Not all writers found it necessary to live on farms or large estates to obtain the necessary solitude to create their works. The tiny, bustling, artistic town of New Hope offered much in the way of literary stimulation. It was home for Sheldon Warren Cheney, a well-known art historian and theater critic, who founded the magazine *Theatre Arts* in 1916 and whose definition of American theater influenced playwright Eugene O'Neill.

Stanley Kunitz, who was regarded early in his career as one of America's best metaphysical poets, lived outside of town, on Lurgan Road, near Bowman Hill Tower. In 1959, his *Selected Poems 1928-1958* won the Pulitzer Prize for Poetry.

After World War II, Millen Brand, another highly regarded poet, moved with his poet wife to North Main Street. A slender, good-natured man, Brand was a writer and editor known for his novels and screenwriting about mental illness and psychiatry. His best-selling first novel, *The Outward Room*, won him instant fame in 1937 for its frank depiction of a woman's mental illness, which was a topic then not commonly discussed in American fiction. Reportedly, Brand invented the psychiatric novel form. As a result of this success, he became co-author of the 1948 film *The Snake Pit*, starring Olivia de Havilland, which was also about the struggle of a psychotic woman to achieve sanity. His script, as well as the picture, received an Academy Award nomination and won an award from the Screen Writers Guild. Other works include *Savage Sleep*, a novel published in 1968, and *Local Lives*, a book of long narrative poems about life in the Pennsylvania countryside that was published in 1975 and called by *Publisher's Weekly*, "an enduring testament ... one of the tenderest and most firmly grounded works by a poet of our time."

Another delightful book was Walter Teller's *Area Code 215: A Private Line in Bucks County*, a series of short essays on Bucks County published by Atheneum in 1963. It was Teller, a prolific nonfiction writer, who in 1948 co-founded the *New Hope Gazette* with Charles Evans.

Perhaps the writer who was the most stimulated by the experience of living in New Hope was Patricia Highsmith, who published twenty novels, including one set in Lambertville entitled *The Cry of the Owl*, as well as seven short-story collections. Her best known character was Tom

Ripley, an intelligent, cultivated murderer who appeared as the central character in five of her novels. Highsmith's first novel, *Strangers on a Train*, was published in 1950 after being rejected by six publishers. She had the last laugh when, the following year, Alfred Hitchcock made it into a movie starring Robert Walker and Farley Granger. According to the *New Hope Gazette*, Highsmith lived in a cottage that overlooked the ruins of the mill on Sugan Road. Her drawing of the mill graced the cover of the June 1961 issue of *Bucks County Life*. Although she later moved to Locarno, Switzerland, she evidently never lost her love for the little town on the Delaware. A short time before her death she sent a donation of several hundred dollars to the New Hope-Solebury Free Library.

If New Hope represented a place of tranquillity and inspiration to Highsmith, it signified something entirely different for Edmund Schiddel, a resident of Center Bridge and the author of *The Devil in Bucks County*, which was published by Simon and Schuster in 1959. *The New York Times* called this roman à clef "Shocking, vivid, valid," while the *Philadelphia Bulletin* pronounced it "The last word on Bucks County." To give you an idea of its steamy plot, let me quote from the teasers on the paperback edition:

> The natives stood around nudging each other, snickering, gossiping about what went behind the austere facades of the old stone farmhouses they had recently unloaded on the Madison Avenue yokels. "City folks," they said, "too much money and not enough sense to pound sand into a rathole ... drinking, whoring, wife-swapping, more than likely ... the kids no better than their parents—wild, irresponsible, spoiled."

> A slice of HELL ... They came flocking into Bucks County like locusts—artists and writers and the flannel-suited execs from Madison Avenue and Radio City. All were looking for a paradise away from the rat race. What they found was something a lot different ... For example, take Bill Barksdale, who came to set up a quiet home. What would happen to Bill's wife when he was away at the TV studio? How long could she deny her wild and desperate longings?... And these are just two of the big-city refugees who came—frustrated people in search of high jinks and low taxes, bringing with them all the tensions they thought they were leaving behind. No wonder that in such a grab bag, violence and scandal lay smoldering....

Even though Schiddel maintained in a disclaimer that "there is no town of Olympia in Bucks County … and no character in this book is intended as a portrayal of a real person. The situations and institutions depicted have their basis only in the author's imagination," everyone in Bucks County knew that Olympia was based on New Hope, and they knew the real people he was writing about, too. Apart from its torrid plot, the book makes for oddly reassuring reading—evidently the good old days in Bucks County were not as halcyon as we imagine. The traffic situation in New Hope on a weekend in the late fifties was almost as horrific as it is today. So for a titillating—and informative—book about the lurid Bucks County of yesteryear, pick up a copy at the library or a used-book dealer. Then search out an old-timer who will fill you in on the real people on whom the fictional characters are based.

The Devil in Bucks County was the first book in Schiddel's Bucks County trilogy. The other two were *Scandal's Child* (1963) and *The Good and Bad Weather* (1965), also published by Simon and Schuster. The first two books were best-sellers and published in at least six or seven languages, so that, without even setting foot on the canal, readers from many other countries came to know New Hope as possibly the most scandal-ridden small town in the United States.

The 1930s and 1940s were, as James Michener has pointed out in his introduction, the golden years of literary endeavor in Bucks County. Not only did many eminent writers live in the area, but their works moved and inspired readers all over the world. Pearl Buck was the recipient of both the Nobel and Pulitzer Prize. Other Pulitzer Prize-winners included novelists James A. Michener and James Gould Cozzens, lyricist Oscar Hammerstein, playwrights George S. Kaufman and Moss Hart, and poet Stanley Kunitz. (Kaufman won the Pulitzer twice—for *Of Thee I Sing*, written with Morrie Ryskind and Ira Gershwin and produced in 1931, and for *You Can't Take It with You*, written with Moss Hart in 1936.)

In 1995, an eighth Bucks County writer's name was proudly added to the list when Jonathan Weiner, a Buckingham resident, won the Pulitzer Prize for general nonfiction. Weiner's prizewinning work was *The Beak of the Finch*, the story of two Princeton University scientists who have spent more than twenty years in the Galapagos Islands measuring variations in beak size in some thirteen varieties of finch that live on a small

island, not far from where Darwin himself did his pioneering research. In his book, Weiner, whose previous work includes two other books on ecological science, *Planet Earth* and *The Next One Hundred Years*, concludes that "life is always poised for flight." Evolution, he writes, takes place "daily and hourly, all around us, and we can watch."

"We moved here because we heard Bucks County was the literary capital of the country," the jubilant author recently told a reporter. "This is a distinguished area. I'm proud to be a part of it."

Happily, the rich artistic tradition of the golden years are continuing in Bucks County, as Jonathan Weiner and many other prominent writers and poets, such as Christopher Bursk, enhance our reputation as a literary mecca. An English professor at Bucks County Community College for the past twenty-four years and a resident of Langhorne Manor, Bursk was named Poet Laureate of Bucks County in 1978. The author of four published collections of poetry, he recently has been awarded a $50,000 Pew Fellowship in the Arts.

Stan and Jan Berenstain, creators of the world-famous Berenstain Bears, live north of New Hope in Solebury Township; their son Michael, author of many acclaimed children's books, in Doylestown. Other writers who currently make their homes in Bucks include J. P. Miller, author of the Emmy Award-winners *Days of Wine and Roses* and *The People Next Door*; playwrights John D. Hess of Solebury and Robert Griffiths of New Hope; writer-illustrator Karen Greene; suspense novelist Eric Sauter; and romance novelists Jim and Nikoo McGoldrick, Patrice Garfield, Christine Bush Mattera, Gwendolyn Pemberton, and Gimone Hall, whose husband, Larry Hall, a former editor and columnist for the Doylestown paper, writes detective stories.

Rachel Simon, a graduate of Buck County's Solebury School, writes fiction. Neil Samuels, of Warrington, does screenplays. Deborah Heiligman, the wife of Jonathan Weiner, specializes in children's books. John Edward Pfeiffer, formerly of New Hope and more recently of Newtown, has written numerous books and articles on astronomy, archeology, and anthropology. Derek Fell, who lives in Tinicum Township, is the winner of many awards for his writing and photography on gardening.

There are poets as well, among them River Huston, Bucks County's 1995 Poet Laureate; Judith and Philip Toy of Solebury; and Stan Heleva, who organizes weekly poetry slams at Karla's Restaurant in New Hope.

And although they live on the New Jersey side of the Delaware, John

Schoenherr of Stockton and Richard Egielski of Milford, both Caldecott Medalists in children's literature, are part of Bucks County's literary community, as is mystery writer Kate Gallison of Lambertville.

If a novelist or poet moved to Bucks County today with the hope of becoming part of a colony of writers, he or she would not be disappointed as Nathanael West was in the early thirties. No longer a backwater, the region is bustling with all types of talented literary people.

Select Bibliography

Cerf, Bennett. *At Random: The Reminiscences of Bennett Cerf.* New York: Random House, 1977.

Crowther, Prudence, ed. *Don't Tread on Me: The Selected Letters of S. J. Perelman.* New York: Viking, 1987.

Hayes, John P. *James A. Michener: A Biography.* Indianapolis: Bobbs-Merrill Co., 1984.

Herrmann, Dorothy. *S. J. Perelman: A Life.* New York: G.P. Putnam's Sons, 1986.

————. *With Malice Toward All.* New York: G.P. Putnam's Sons, 1982.

Kerman, Cynthia Earl, and Eldridge, Richard. *The Lives of Jean Toomer: A Hunger for Wholeness.* Baton Rouge: Louisiana State University Press, 1987.

Martin, Jay. *Nathanael West: The Art of His Life.* New York: Farrar, Straus & Giroux, 1970.

Meade, Marion. *Dorothy Parker: What Fresh Hell Is This?* New York: Viking Penguin, 1989.

Quasha, Jill. *Marjorie Content: Photographs.* New York: W.W. Norton & Co., 1994.

Strauss, Helen M. *A Talent for Luck.* New York: Random House, 1979.

Stirling, Nora. *Pearl Buck: A Woman in Conflict.* Piscataway, New Jersey: New Century Publishers, 1983.

Teichmann, Howard. *George S. Kaufman: An Intimate Portrait.* New York: Atheneum, 1972.

"The Genius Belt Revisited," *Mid-Atlantic Country,* March 1992.

Footlights and Fireflies The Bucks County Theater Tradition

W—hile vacationing in Sydney, Australia, in 1972, New Hope Borough Councilman Dr. D. K. Leiby was asked where he lived. "New Hope, Pennsylvania," Leiby answered. "New Hope!" his Australian inquirer exclaimed. "Isn't that where the Bucks County Playhouse is?"

Half a century earlier, no one would have dreamed of this pastoral county as the site of a playhouse. Bucks had become a haven for visual artists, and painters were enchanted with its bucolic seclusion. But it held no attraction for theater folk who needed to be close to the action on Broadway. There was nothing to suggest that Bucks would ever earn renown as the "country seat" of the American stage.

As in any other rural backwater, dramatic productions were largely limited to school and church performances by amateurs, often as part of seasonal or civic celebrations. Not until the 1920s were there stirrings of interest in more sophistication. A group of aspiring thespians organized a Doylestown Theater Guild and "put on some pretty good quality plays," according to W. Lester Trauch, a theater enthusiast who worked as a reporter and columnist on the Doylestown paper, *The Intelligencer*. "They would get an actor from Philadelphia up here, and he would serve as director," Trauch remembers. "The casts were made up of people from the area. I got to know one director. He got $100 per production and couldn't pay for a hotel room, so he asked to stay in a Guild member's house."

The Guild mounted its productions in the County Theater, the town's only movie house. During those years before the advent of the talkies, stage performances often enjoyed a distinct advantage over silent films. This edge, however, could be lost in controversies over avant-garde plays. Trauch recalls one that almost "broke up" the Guild:

> They put on a play [by English playwright Sutton Vale] called *Outward Bound*. The director had seen it in New York. As the play develops, you learn about all these passengers, and all about their mistakes and loves and everything. Then, near the end, you find out that all the characters are dead. They're outward bound, you see. Well, the poor people from Doylestown who had never been to the theater before, when they found out that these people up on the stage were all dead, well they were just beside themselves! There was a local judge who was in the cast, and some of those people never forgave him. They just couldn't imagine why he would want to be in a play like that!

Whether weakened by scandals, the development of "talkies," or the stultifying Great Depression, the Doylestown Theater Guild vanished from the region's cultural stage. Bucks County's climb toward the top of America's theatrical heap would be launched from another base camp. This turned out to be Broadway itself. The import of what W. Lester Trauch calls "legitimate theater" would be the work of foreign forces. Bucks County only happened to be in the right place at the right time.

The "right time" was the 1930s. Real estate values had plummeted. Farms held by families for generations were suddenly up for grabs, no longer supportable by their strapped owners. Among the first New Yorkers to recognize and take advantage of this phenomenon were writers and brothers-in-law S. J. Perelman and Nathanael West. The latter had just concluded a stay at a resort on the New Jersey side of the Delaware in late 1932 when he convinced Perelman to go in with him on the purchase of an old farmstead across the river.

It was an inspirational transaction for Bucks County real estate agents. They eagerly widened their scope to include New York City's wealthier inhabitants. According to Trauch, the pitch they developed went something like this: "Look, Bucks County is a lovely place! You can get yourself a beautiful old stone farmhouse here for pennies on the dollar. You don't have to go all the way over to Connecticut to get a summer retreat, and then pay an arm and a leg to outbid some other New Yorker for it. We're only an hour-and-a-half from Manhattan, an hour from Philadelphia. There are already some artists who have set up shop here, but we're relatively undiscovered. We're the new Connecticut, only more convenient and a better bargain."

In 1936, the spectacularly successful playwright and stage director George S. Kaufman and his wife, Beatrice, were among those who came down from Gotham, looking for a summer home and curious about this "new Connecticut." Bucks County turned out to be attractive indeed, and the Kaufmans plunked down $45,000 on a 200-year-old plantation along Route 202 in Holicong. The purchase didn't line any local pockets, however. The Kaufmans bought their spread—which they named Cherchez La Farm—from a fellow New Yorker, Juliana Force, the director of the Whitney Museum. She had discovered Bucks County in 1914 during an art-collecting expedition.

Within months of their purchase, the Kaufmans (and Beatrice in particular) persuaded other Broadway luminaries to join them. Among the first to arrive was Moss Hart, a young playwright and director with

whom George Kaufman had begun collaborating in 1930. Hart bought an old farmstead on eighty-seven acres in Aquetong, Solebury Township. Neighbors now in both New York and Bucks County, Hart and Kaufman completed their work on a comedic play called *You Can't Take It with You*, which won them a Pulitzer Prize.

The trickling migration of New York glitterati to Bucks County impressed a twenty-two-year-old struggling actor-producer by the name of St. John Terrell. "Sin'-jun," as the Chicago native pronounced his first name in the British manner, had graduated from Columbia University in 1938 and that summer joined two actor friends in starting a summer stock theater in Clinton, Connecticut. When their season's lone musical produced a rare sellout—and his own acting career refused to take off as he thought it should—Terrell made two decisions: he would start up his own summer theater the following year, and "only do musicals."

He was on the lookout for potential sites when Bucks County hove into view. It so happened that one of his New York neighbors, a play-wright by the name of Kenyon Nicholson, was among the new Bucks Countians. When told of Terrell's ambitions he invited him to come down. Nicholson said he knew some people there who might be interested in backing a summer theater.

The people Nicholson had in mind were a handful of citizens that had recently banded together to save a local landmark from demolition. The endangered structure was a historic gristmill for which the village of New Hope had been named. When its most recent owner, Louis Brown, decided to retire from milling and sell the building, "the prospect of one of the finest river-front sites along the Delaware suddenly being thrown open to development" stirred a number of leading lights into action. Among these was a sometime author, Henry Chapin, who would later write:

> What happened to this property in the very center of New Hope could have seriously affected the welfare of the community both from an economic and, even more important, a social point of view. Realizing that the town itself was in no financial position to attack this problem, a few people organized a partnership to purchase and hold this property until ideas for its use could be thoroughly considered.

The owners saw that New Hope was entering a slow phase of growth as center to a surrounding part of Bucks County, which itself

was changing and growing as a community. We knew that the town itself had no adequate center for meetings and entertainments and were determined that the gristmill must in some way be used to meet this want. On the other hand it had to carry itself as a business and not as a charity.

It was while Chapin and his Hope Mill Association partners— Fredericka Child, George Dyer, and Ruth B. Folinsbee—were considering options for their mill property that Kenyon Nicholson saw his chance to play matchmaker. His invitation to Terrell led to an autumn 1938 meeting with the Association people, their spouses, and a few other Bucks Countians picked up along the way, including Bertha and Marshall Cole, the Morris Llewellyn Cookes, and John and Olivia Kuser. "As martinis and Manhattans flowed," the host, Don Walker, would say of the occasion later, "the famous Terrell charm started to work. For several hours, the names of Moss Hart, Burgess Meredith, Richard Bennett, Dorothy Parker, George S. Kaufman, Margaret Webster, Edmund Lowe, and other stage and literary figures bounced back and forth between the rafters of our living room and the assorted characters below."

By the time the meeting broke, there was a general understanding— perhaps even a giddy expectation—that New Hope would have itself, in Walker's words, "a real live summer theater with real live actors and a real lively impresario."

And so it did. A combination dedication-and-groundbreaking ceremony was staged at the Hope Mill on Sunday, March 26, 1939, and little more than three months later, on Saturday, July 1, an overflow crowd estimated at seven hundred assembled to be a part of the Bucks County Playhouse's opening night.

Among the 292 attendees who actually held tickets for the performance were several dozen stockholders in Bucks County Playhouse, Inc., who had, in fact, been working feverishly throughout the past weeks, days, hours, and even minutes to transform the former mill into a viable theater in time for the premiere performance.

Nothing had come easy. Shares in the Playhouse proved almost impossible to sell, and even investors who took the plunge often did so grudgingly. One well-to-do resident of Newtown summarized the public skepticism when he responded to the stock offer:

A cold analysis of the Bucks County Playhouse, Inc ... as an investment of any size does not appeal to me. I do not know whether there

is a real need for a summer stock company in New Hope, but inasmuch as I want to be identified with any real forward movement in the countryside, I am willing to go along and subscribe for one share ($100), in light of a community donation.... There is a broader aspect. I doubt if it is a wish of any entrepreneurs to change the character of New Hope, but after talking to people who have lived through a summer stock company invasion, I am fearful.

Selling shares had not been the only challenge during the hectic months of preparation. The revamp of the Hope Mill into a playhouse had to be not only adequate to its needs and affordable, but in compliance with the building code for theaters (local architect Donald Hedges could claim most of the credit for accomplishing all that). Moreover, coming to an agreement that assured the tempestuous Terrell's services for two years wasn't all that easy either. And there were sundry disasters, such as the near-bankruptcy of the general contractor before he finished the job. To top things off, a dollop of solder accidentally set fire to the theater's shingle roof on the night of June 30, almost bringing the whole operation down in flames.

But the Playhouse's champions prevailed, and here they were, after a final crisis-filled day of sweeping out the auditorium and bolting the seats into place, rubbing shoulders with George S. Kaufman, Moss Hart, Burgess Meredith, Orson Welles, Florence McGee, dramatist-producer Jack Kirkland, and theater caricaturist Al Hirschfeld who had buzzed in from New York to immortalize the evening in a cartoon.

Hirschfeld drawing of the opening night at the Bucks County Playhouse in July 1939. In the foreground, from left to right, are Moss Hart, Beatrice Kaufman, George S. Kaufman, and Richard Bennett. © Al Hirschfeld. Drawing reproduced by special arrangement with Hirschfeld's exclusive representative, the Margo Feiden Galleries Ltd., New York.

The audience was already seated when the building inspector finally gave his high sign. The last-minute hammering behind the curtain ceased, and a flushed Terrell strode out onto the proscenium with the

promise that the Playhouse undertaking would be "no neighborhood drama league but a real theater—it's just that the air is a little fresher and the grass is a little greener." That said, the curtain went up.

The first season was, by most yardsticks, a rousing success. From the opening run of the British comedy *Springtime for Henry*, starring Edward Everett Horton who would make a career out of playing the eponymous

role, through eleven more productions concluding with Eugene O'Neill's
Ah, Wilderness!, the theater was nearly always full. Over the course of more
than seventy performances during 1939, only twenty-eight tickets went
unsold, and all of the initial stock-offerings in the theater were snapped
up by the end of the year.

Terrell, it turned out, was able to pack them in without proffering a
steady diet of musicals. In fact, more than a hundred additional seats were
soon installed. Not that he had given up on the idea. "Musicals were just
too expensive," he remembers. "We only had the money to do one or
two." Some of the stockholders might have argued that there wasn't even
enough money for *that*, inasmuch as the virtually sold-out season had
yielded almost no profit. Terrell, they had come to see, was more inter-
ested in artistry than the bottom line. "He was the type of producer that
if his costume designer needed something from the 1870s, he would go
to New York or Philadelphia and buy it," Trauch says of his longtime
friend. "Of course, he could have let the designer use almost *any* old piece
of clothing and the audience would never have known the difference. But
that's just the way St. John was." Despite Terrell's contribution to getting
the theater off to a gangbusters start, he parted company with Bucks
County Playhouse, Inc., after fulfilling only one year. Trauch believes "St.
John was not asked back because he didn't make enough money for the
Playhouse."

There were also townsfolk who were less than thrilled with the
theater's swift ascent to prominence. From the get-go, influential *New Hope
News* editor Gordon Cooper had given the Playhouse a cold shoulder.
Town historian Francis Curley reports that "Cooper didn't even mention
the theater in his paper until two weeks after it opened. And then he
referred to its patrons as 'those scatter-brained Playhouse-goers.' Of
course, it didn't help that the theater operators didn't give him any of
their printing or advertising business. Maybe they thought they were too
big for a small-town paper."

The Borough Council proved no more sympathetic. "From late spring
to early fall," Curley points out, "this town of fewer than one thousand
inhabitants was visited by 400 play-goers every night, and 800 on two-
performance days. As you can imagine, traffic was a huge problem. The
congestion was compounded by hundreds of other people who came
here to catch glimpses of the actors—many of whom were big stars of
the stage and screen." In an attempt to bring some order to this mayhem,
the Council hired an officer assigned full-time to traffic control. He saw

E dward Everett Horton and Julie
Haydon between rehearsals at the Bucks
County Playhouse in July 1939.
Courtesy of Urban Archives, Temple
University, Philadelphia.

to it that parking meters were placed around the town to systematize parking patterns and raise money to defray the additional municipal costs. Councilmen even began tossing around the idea of enacting an amusement tax that would force the Playhouse to help foot the bill.

While some New Hope residents had reason to lament recurrent invasions of "scatter-brained Playhouse-goers," others put themselves in a position to profit from all the excitement. Prior to the theater's opening, New Hope was no different than many small riverside towns. It had a newsstand that served as a coffee shop, a drugstore, a hardware store, a couple of restaurants and grocery stores. There were only two gift shops: the New Hope Craft Shop, catering to the area's artists, and the Tony Sarg Shop, which sold clothing and women's things. There were no shops on South Main Street at all, only trees.

But then came the Playhouse, and suddenly New Hope was up to its towpath in the tourist trade. "More and more shops sprang up to accommodate the visitors," recalls Francis Curley. "They developed to sell a tremendous conglomeration of stuff. New restaurants and antique businesses opened. Eventually it got to the point where it is today, that you could get ten thousand people to come to New Hope for almost no reason at all. They came to shop, to walk around, to look at each other."

With St. John Terrell moving on to become a speech advisor for Presidential candidate Wendell Wilkie, the Playhouse directors named a pair of co-producers for the 1940 season—Kenyon Nicholson, who was already familiar with the theater's operations, and Theron Bamberger, a former Philadelphian, who had arrived via White Plains, New York, and Bridgeport, Connecticut, where he had served several seasons as a producer of summer stock theater. Before that he had made his name as a reporter and theater critic in Manhattan. Bamberger and his wife, Phyllis, a former press agent for the Jewish Philanthropic Society, moved into a house near New Hope rented from playwrights Sam and Bella Spewack, co-authors of the 1935 Broadway hit *Boy Meets Girl*.

In tandem with Nicholson, Bamberger used his connections to continue Terrell's practice of importing a steady stream of Broadway luminaries. This took some doing, considering that the top pay was $1,000 a week, no matter how famous the actor or actress. This limit was necessary because the theater simply didn't have the capacity to generate proceeds that would support higher salaries. It speaks well of the Playhouse that for the first few decades of its existence it was nonetheless able to attract to

New Hope the likes of Hume Cronyn, Joe E. Brown, Louis Calhern, Mildred Natwick, Charles Butterworth, and Katherine Locke.

　　To complement major stars who seemed particularly suited to particular parts in particular plays, Bamberger and Nicholson assembled a resident acting company that was itself peopled with notable performers. Among the resident players during the 1941 season was the Austrian-born character actor Walter Slezak, a portly, mustachioed, impish pounder of the stage who had recently purchased an old farm in the county.

The crowds have gathered for a fund-raising auction at the Bucks County Playhouse, September 1940. Courtesy of Urban Archives, Temple University, Philadelphia.

Slezak and his fellow thespians spent that summer keeping up a grueling schedule of eight performances per week, with rehearsals for the following week's shows crammed into their remaining hours. Altogether, seventy-two members of Actors Equity Association worked in New Hope during the 1941 season, accounting for what Theron Bamberger estimated to be 170 working weeks.

Then world events intruded into the Playhouse's steady climb to prominence. Soon after the Japanese attack on Pearl Harbor, Kenyon Nicholson went off to Australia to take over Red Cross Theatre Productions in the Pacific, leaving Bamberger to steer the Playhouse through the upcoming lean seasons. Tire and gasoline rationing meant there would be few visitors from Philadelphia's Main Line and New York's affluent suburbs. Faced with the loss of this critical portion of his clientele, Bamberger resolved to take his mountain to Mohammed. He rented the ballroom of Philadelphia's Bellevue-Stratford Hotel and transformed it into a functioning theater. Not everyone knew what to make of the move. One chuckling reporter for a Philadelphia newspaper wrote, "There's a blitz going on in the ballroom of the Bellevue-Stratford and it took a bunch of country slickers from Bucks County to take that venerable hostelry for a sophisticated hayride." Bamberger countered, "We're going to announce curtain time with a cowbell. That ought to make any Bucks County theater goers feel at home. And it'll get these city slickers, too!"

Through a dozen shows in the summer of 1942 and eleven more in each of the next two seasons, Bamberger made a lot of believers. "They're calling me a genius, now," the gruff impresario remarked to a reporter. Despite flourishing in a venue where a decent turnout generated nearly twice the take of a New Hope performance, Bamberger was stymied when the Bellevue-Stratford raised his rent after the 1944 season. Reluctantly he canceled 1945. His patrons were left with fond memories of a performance of Kaufman and Hart's *The Man Who Came to Dinner*, the last of thirty-four Bucks County Playhouse productions in Philadelphia. It had featured an elegant actress named Diana who would go on to stardom after adopting the name Dina Merrill.

In the months following World War II, Bamberger and the Playhouse directors tried to pick up where they had left off in New Hope four years earlier. By that time, the Playhouse had become part of a popular movement in American entertainment. A *Philadelphia Inquirer* reporter noted in

Actress Valerie Cossart on the threshold of her dressing room, learning her lines. Courtesy of Urban Archives, Temple University, Philadelphia.

Backstage at the Bucks County Playhouse, two aspiring actresses learn the lines of George S. Kaufman's play Stage Door. Courtesy of Urban Archives, Temple University, Philadelphia.

the spring of 1946 that there were no fewer than eighty-five "straw-hat theaters" poised to raise their curtains in the eastern United States. Why so many? "Summer theater is different," the journalist opined. "It's a mixture, perhaps, of an odd and intriguing setting together with a more tolerant attitude on the part of the audiences. Everyone is more relaxed, even the critics. They expect less and are better pleased with what they get." At the Bucks County Playhouse in particular, where the reporter judged that "visitors often are more impressed with the surroundings than with the offering," the intriguing qualities included "a revolving stage that contrasts sharply with the general ruggedness of the building and with the quiet beauty of New Hope."

Quickly regaining its momentum following the wartime hiatus, the Playhouse enjoyed its most prosperous season to date in its first year back. Record attendance in 1946 was boosted by the extension of the season to fifteen weeks, from a June 7 opening to a September 21 finale, while most summer theaters hewed to the more traditional July 1-through-Labor Day schedule. The crowning event of 1946 was the mid-summer appearance of America's "First Lady of the Stage," Helen Hayes, in James M. Barrie's *Alice Sit-by-the-Fire*. If the Playhouse hadn't yet sealed its reputation as a leading theater on what *Variety* magazine called "the silo circuit," Hayes's performance took care of that. When she further honored the theater by choosing it as the site for her sixteen-year-old daughter's debut, that was icing on the cake.

For Theron and Phyllis Bamberger, who had bought an old farm-house of their own on Solebury Road during the war and were now virtual co-producers at the Playhouse, the popularity of the theater didn't make their jobs any easier. "No form of theatrical activity is quite so onerous as running a country playhouse," Bamberger told a visiting writer. "The straw-hat impresario not only must produce a different play every Monday night, but he also must act as house manager, in which capacity he has a far harder job than his colleague on Broadway." As one summer theater observer noted, "the manager is responsible for every detail. There are programs to be printed, copy to be written, advertising to be managed, parking places to be arranged. Between such chores the manager must dally with cleaning arrangements, with electricity and tele-phone service, refreshments, tickets and the box office, make-up, costumes, and the gentle art of pacifying stars." Bamberger's "gentle art" was exercised during the 1947 and 1948 seasons on behalf of such Broadway and Hollywood heavyweights as Bela Lugosi, Lillian Gish,

Perched over the Delaware Canal, an apprentice prop girl looks over a script and dreams of glory. Courtesy of Urban Archives, Temple University, Philadelphia.

Shirley Booth, Buddy Ebsen, and even Thornton Wilder, who in 1948 appeared in one of his own plays, *The Skin of Our Teeth.*

As if the Bambergers didn't have enough to occupy them, the Playhouse faced what some observers believed would be their biggest challenge yet: a local competitor. The source of the perceived threat was none other than New Hope's old friend, St. John Terrell, returning after a decade's absence with grand plans to establish a performing arts venue somewhere in the area. Terrell had been developing his scheme at least since the summer of 1938, when his success producing a musical in Connecticut led to discussions with actor Richard Bennett, who advised St. John to "get musicals. Most Americans can't follow a long story. They can't sit still that long. Musicals are what amuse people. They don't have to concentrate as much. There's song and dance and a little story that goes with it. That's all they need."

Terrell's notion of establishing a "musical-only theater" clicked into sharper focus five years later on—of all places—a Pacific island. While

flying transport planes across the South Seas as part of his Army Air Force duties in 1943, the stage-struck pilot was assigned to help mount a production of Irving Berlin's smash-hit Broadway comedy, *This Is the Army*. Finding actors among his military colleagues was no problem for the well-connected former producer. Coming up with a venue for the musical took a lot more doing. In searching about for a solution, Terrell flashed back to a high school field trip he had made to a Chicago museum. There he and his classmates wandered through a primitive man exhibit that included a life-size three-dimensional depiction of cave dwellers squatting or sitting in a circle, watching their leader draw in the dirt with a stick while telling a story. "That is man's original theater," Terrell remembered hearing his teacher comment. "They're sitting in a circle so they can keep on the lookout and protect themselves against any threat coming at them from any side."

With this "original theater" scenario in mind—and some knowledge of the "theater-in-the-round" design employed by William Shakespeare in his Globe Theater—Terrell asked Army engineers to bulldoze a giant bowl-shaped pit into the earth. In the center of this bowl he had a low platform built, and, voilà, the Army had itself a spacious yet simple sunken amphitheater.

With lighting provided by Jeep headlights, the actors took to the stage for the first of several performances. "It turned out to be the best show they ever had," Terrell recalls. "The guys screamed and yelled, and they fell in love with the actors overnight. Everybody said, 'My God, this is a *hell* of an idea!'"

Now it was 1949, and St. John was returning to New Hope with his idea polished to a commercial sheen. Somewhere in these favorable environs he would dig a theater-bowl, raise a tent over it (he didn't have the financing to afford anything more permanent), and there he would put on musicals guaranteed to pack them in night after night. The term he had coined for his novel venue was "Music Circus." With encouragement from the mayor of Lambertville (New Hope's municipal counterpart on the New Jersey side of the Delaware River), St. John selected a site for his project just north of the little town. Limited funds forced him to rent the property for a single season, and when he began lining up his first musicals, he had to stick with those that were in the public domain and thus free of royalty costs.

As he had with other ventures, Terrell faced his share of detractors in trying to pitch his musical big-top. "Who'll come to see plays in a tent?"

some folks sniffed. Still other critics pointed out that "You can hardly use any scenery in theater-in-the-round, so how can you put on successful productions without scenery?" On the heels of such questions followed warnings that if the Music Circus succeeded at all, it would steal customers from the Playhouse, dividing the regional customer base and making it tough for both establishments to survive.

Amid a blizzard of speculation, Terrell lifted the flaps on his Lambertville Music Circus with a production of Franz Lehár's popular operetta *The Merry Widow* on July 2, 1949. "It was a success almost from the minute it opened," he claims. "The phones were ringing constantly. Of course, during the first couple of weeks we had very sparse audiences. We had no advance publicity. But then it started to roll, and by the end of

St. John Terrell, founder of the Lambertville Music Circus, is framed by his famous tent. Courtesy of St. John Terrell.

the third week, we'd done $10,000 gross business. Well, that was more than any summer theater in the whole area had ever done. By the end of the summer you couldn't get a ticket, and we had expanded the capacity of the tent from 700 to 1,200 persons."

As he had with the debut of the Bucks County Playhouse ten years earlier, caricaturist Al Hirschfeld once again descended from New York to attend the premiere performance and do a little sketching. His depiction of a moment from *The Merry Widow* showed newlywed stars Wilber Evans and Susanna Foster striking poses alone on the unadorned circular stage, while Terrell's "brilliant little conductor" Bobby Zeller grandly waved his baton at them. Attending one of the early performances was the renowned Broadway composer Sigmund Romberg, who had arrived unannounced as someone's guest. After the show, Romberg learned that St. John was having a hard time convincing disdainful agents—including those representing Jerome Kern and Rodgers and Hammerstein—that the Music Circus was worthy of hosting recent Broadway hits. Romberg assured the musical ringmaster that, on the basis of what he had seen, the Circus was certainly welcome to anything he had composed, and he would let his colleagues know they had nothing to fear from letting their work be presented in this unconventional forum. Romberg's timely endorsement helped get the Music Circus off to an especially robust start.

Terrell's theatrical experiment whetted the region's appetite for theater. Playhouse producer Bamberger reported at the end of his 1949 season that fifteen plays had attracted 50,000 ticket-buyers to his theater that summer, slightly increasing his receipts over the previous year. The steady progress of the theater had allowed him to continue providing seasonal apprenticeships for one male and one female graduate of the American Academy of Dramatic Arts. The young lady who earned this honor for the 1949 season, during which she made her professional debut in a production of her uncle George Kelly's *The Torch Bearers,* was a beautiful twenty-one-year-old Philadelphian by the name of Grace Kelly.

New Hope officials pricked up their ears when they heard the Playhouse increased its seasonal take during 1949. Hoping to share in the profits, Councilmen moved to enact a five-percent amusement tax in the Borough. As the theater was virtually the only enterprise in town affected by this tax, Bamberger and the Playhouse directors complained that they were being singled out unfairly. The theater might be responsible for some additional municipal costs, they admitted, but it also generated a *lot*

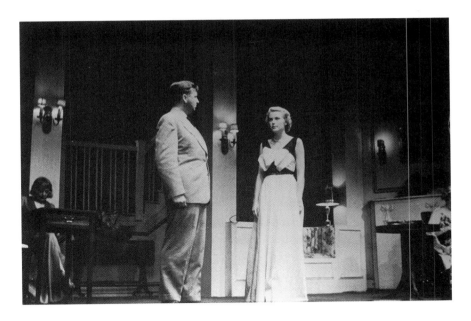

*G*race Kelly during her first professional stage appearance, July 25, 1949, at the Bucks County Playhouse. Photograph by Richard W. Cauffman, from the collection of Jeff Cadman, stage photographer, Bucks County Playhouse, New Hope, Pennsylvania.

of spin-off business for other New Hope merchants. Beyond that, the Playhouse was operating at such a narrow margin of profit that its stockholders had yet to receive any dividends on their investments. Discussions between Playhouse and Borough representatives went on for months, then stretched into years. When the tariff was finally imposed in 1953, the stage was set for two decades of tax-related wrangling.

Following the 1949 season, Bucks County Playhouse, Inc.'s president Donald Walker, in partnership with a pair of struggling Broadway producers named James Russo and Michael Ellis, purchased Henry Chapin's 272 shares of Playhouse stock and thus acquired a controlling interest in the theater. Walker had come to feel that the Playhouse should be owned and operated by a single party. As it was, stockholders and officials of his BCP, Inc., had little say in how the theater was run, and so long as the corporation received only rent payments, it didn't stand to make much profit. Walker's plan was to help the entrepreneurial Ellis set up a subsidiary corporation that would step in when Theron Bamberger's lease ran out after the 1953 season and begin producing shows more in the interest of the parent company. Specifically, Walker dreamed of having the Playhouse serve as a testing ground for plays that might hit it big on Broadway.

From the quality of Bamberger's productions in the early 1950s, one could not have guessed that he was a lame duck producer, fulfilling the final years of his contract with BCP, Inc. The summer skies over New

Hope remained spangled with stars of stage and screen: Ilka Chase and Brian Aherne in 1950; Leslie Nielsen, June Lockhart, Lillian Gish, Kitty Carlisle, Hume Cronyn, and Jessica Tandy in 1951; Jack Klugman, John Carradine, and Angela Lansbury in 1952. Bamberger's thirteenth and final season kicked off with an extremely successful production of the Broadway hit *Mister Roberts* and concluded with a well-received presentation of *Our Town*. As the summer progressed, however, Bamberger felt the weight of his impending loss of the theater more and more acutely. Bruises inflicted during a car accident weakened him further. By September, with only one week left in the season, Bamberger was in the hospital diagnosed with hypertension aggravated by injuries sustained in an automobile accident. He died two days after that summer's final performance.

Bamberger's successor was himself no stranger to theatrical heartbreak. Thirty-five-year-old producer Michael Ellis had just presided over a string of five Broadway flops, concluding with a 1953 production of *Two's Company* that folded when its star, Bette Davis, fell ill. The Bucks County Playhouse seemed just the venue for a retooled career, and he had big plans for how he and it would succeed. In an article penned for the May 1954 edition of *The Bucks County Traveler*, he described the dream he had formulated with Playhouse directors:

> We believe the Playhouse should be more than a summer theatre. We see no reason why the doors should close as soon as Labor Day week-end is over. After all, the roads are clear and the county is at its most beautiful during the fall. And so this year we plan to run at least until Thanksgiving—and perhaps longer if the audiences find our programs entertaining. That will give us time for new plays, revivals, try-outs of Broadway-bound shows, ballets, monologues, and all the myriad exciting evenings the theatre can afford.
>
> The coming season opens May 29th with *The Moon is Blue*, the really great Broadway comedy. This will be showcased in a theatre with new air-conditioning, a newly-redecorated interior—and a new attitude, which will include flowers for the ladies on opening nights and free iced tea at matinee intermissions.

Soon after Ellis took up the Playhouse reins, he disbanded Theron Bamberger's resident acting company. He would need to bring in a new cast for each production, and casting would be done entirely in New

York. Even local actors who wanted to be in one of Ellis's productions would have to go to Broadway to audition.

There would also be plenty of fresh faces *behind* the scenes at the Playhouse, as Ellis assembled a production company staffed by a score of apprentices. He retained, however, one important role-player from the Bamberger years. John Crowley had been with the Playhouse since the spring of 1951, and was now firmly entrenched in the position of "irre-placeable workhorse."

With Crowley at his side, Ellis launched into his first season, ambi-tiously extended to run from late May to the end of October. During this period the Playhouse presented a staggering twenty-one plays, eight of which had never been performed anywhere before. Ellis would be forced to scale back this breathtaking schedule by several productions each of the next four seasons, but he maintained his practice of mounting at least one original play for every two hits he imported from New York. His fellow summer theater producers were impressed. Said one, "Since most companies would not dare to try more than one original a season, it stands to reason Mike has four times as much guts as anybody else. Or maybe he's just four times more crazy."

Ellis saw it another way. "With Broadway production costs growing so exorbitant, an author doesn't have a chance to be seen in New York unless he's got a sure-fire hit," he explained. "I give new authors a chance." He was also keeping his fingers crossed that one of his discov-eries would graduate from New Hope to New York and make every-body—including himself—a lot of money. It was a dream that heartened him through the reading of 175 new scripts each year. But even at that rate, it would be years before lightning struck.

Ellis's recipe for success—which one reporter described as generous "interlardings of safe old hits"—appealed especially to the Delaware Valley's "matinee ladies," as they were called by New Hope residents. "The women take the town over completely every Wednesday and Saturday afternoon when the Playhouse is open," wrote one bemused observer of the scene, "filling the air with their high-pitched chatter and the local tills with their long-suffering husbands' money. They are easily distinguished by their little flowered hats and the spike heels which they insist on wearing while tottering up and down our quaintly uneven brick sidewalks. The minute they begin arriving (often by the busload), the Solebury natives take to the hills. Competing with this horde for parking

space or a table in a restaurant is always a losing game. But, God bless them, they keep New Hope green with their compulsive spending, so long may they rave!"

An inundation of a less-desirable sort occurred during Michael Ellis's second season at the Playhouse. He called it "The Great Flood" when he wrote about it in a twenty-fifth anniversary playbill. It was, he said, "the single event of the last 25 years that could be picked out and marked as the most unusual or startling or most disastrous" to befall the Playhouse:

> It was bright and sunny all day on the 19th [of August, 1955], but the waters [of the Delaware River] kept rising after the torrential downpours of the previous day and the previous weekend. At 7:00 A.M. on the morning [of the 20th] the great flood crested at a height that found water two inches above the level of the stage.
>
> A great debate raged as to whether the Playhouse should try to reopen in September or wait until the 1956 season. It was finally decided that the best means of informing the public that New Hope was alive and not a ghost town to be shunned was to reopen the Playhouse at whatever cost.
>
> The staff and many volunteer workers went to work to repair some of the $27,000 worth of damage and to make the building clean and safe once more. In two weeks and one day the Playhouse reopened. The flood is now merely a pungent memory.

Safely up out of the Delaware River's reach, St. John Terrell's Lambertville Music Circus had only to contend with torrents of customers. By the latter 1950s it had become a drawing card of national proportions. W. Lester Trauch remembers out-of-staters telephoning the offices of Doylestown's *Intelligencer*, looking for information about the Music Circus. "This is pretty much the way the calls would go," he recalls. "They'd say, 'We're planning a vacation. We're taking an automobile trip. We'll be coming through Pennsylvania, and we want to see the Music Circus in Lambertville.' And I used to say, 'You certainly *do*!' So I would give them the Music Circus telephone number, and they would try to make a reservation. It was almost impossible to get tickets."

Despite healthy patronage, Terrell's cash cow was being hobbled by competition—not from the Playhouse, as some people had anticipated, but from the Circus's next-door neighbors. "I had a nightmare of a problem," he recalls, "because the people that owned properties on the

St. John Terrell in a rare peaceful moment at the Lambertville Music Circus. Courtesy of St. John Terrell.

edge of the Music Circus grounds were all selling ice cream and candy and everything else to my customers. They even sold quick-exit parking spaces for a dollar!" Unable to staunch the bleeding off of his profits, St. John resolved to move "somewhere where it's all ours and we can put a fence around it." As luck would have it, a farm about two miles northeast of Lambertville came up for sale in 1960. Here, for a few more years, Terrell would ride a wave of success that sent ripples far beyond the Delaware.

Soon after pitching his revolutionary big-top in 1949, he had set up four affiliated "canvas theaters" around the country—in Hyannis and Cohasset, Massachusetts; Sacramento, California; Neptune, New Jersey; and Miami Beach. Other impresarios quickly unfurled their sails in St. John's brainstorm. To avoid infringing on St. John's patented label, the other venues had been given variant labels such as "music fair," "music theater," "melody fair," "lyric circus," "melody tent," and "musicarnival." As of 1964, the number of musical big-tops across the country had grown to thirty-one, and between them they were attracting an audience of seven million people for a gross of $20 million.

On what one reviewer dubbed "Music Mountain, the Mount Parnassus of Hunterdon County," Terrell was by this time packing them in to the tune of 18,000 persons per week. He managed this largely without the benefit of star-power, noted a *Ford Times* reporter in the spring of 1964: "Instead he finds new, young voices and puts emphasis on the quality of the musical production, which in every case is original with the Music Circus. Each season there is some of the old mixed with the new—the old being operettas such as *Naughty Marietta* or *The Chocolate Soldier*. Capacity houses attest to the public's affection for these classics and to its appreciation of the careful, straightforward production they receive. As to atmosphere, there is a real circus gaiety about the tent and grounds."

Although successful in booking "new, young voices" in the Music Circus's early years, Terrell was not against rolling out the red carpet when bigger names agreed to grace his stage. Few names were bigger than bandleader Paul Whiteman, the "King of Jazz" of the 1920s and 1930s, who was both a friend of Terrell's and a Delaware Valley neighbor. Since 1940, the rotund fifty-year-old jazzman had lived on a 500-acre country retreat at Rosemont, near Stockton, New Jersey, with his fourth wife, actress Margaret Livingstone, and his children. Between ever rarer commutes to New York City as his career wound down, he raised Angus

cattle and enjoyed duck hunting with baseball legend Babe Ruth. Whiteman was apparently an excellent shot. As soon as the Sultan of Swat brought down one bird, the King of Jazz would bag the next. Through his teenage daughter, he became involved in the Lambertville Recreation Association, and was inspired in the fall of 1947 to form the Paul Whiteman Teen Club, which met on Saturday evenings for dancing, entertainment, and refreshments—a veritable crash course in popular American music taught painlessly by stage and radio musicians he imported as houseguests.

In 1961, Whiteman, now seventy, built a home in Solebury Township, outside New Hope. He called the house Coda Cottage, indicating that here he meant to conduct the final movement of his life. One of his last appearances had been the Music Circus's seasonal kickoff in May of the previous year. On this occasion, still adorned by his trademark

Paul Whiteman leading a local band in the 1940s. Photograph by Maynard Clark. Courtesy of the James A. Michener Art Museum. Gift of Philip A. and Dianna T. Betsch.

pencil-thin black mustache (dyed by then, one must assume), he led his band through a lushly orchestrated program of Gershwin tunes, concluding with his theme song, "Rhapsody in Blue," which he had commissioned from Gershwin four decades earlier. Reviewers were not kind. "Looking like a Dutch miller," one of them noted, "he flicked a small baton, twitched an elbow or crooked an eyebrow. Virtually his only movement was to wag his head."

Whiteman's 1960 gig at the Music Circus was part of Terrell's growing effort to diversify his offerings and attract stars of a greater magnitude. By the middle of that decade, he had added weekly jazz concerts, folk music festivals, and children's theater shows to his schedule. Under his big-top, careers were born for the likes of Shirley MacLaine, Shari Lewis, Robert Goulet, Audrey Meadows, and Jack Cassidy. Superstars swooping in for one-night stands shook the Lambertville heights with their music. Through one typical stretch from late June to mid-July 1966, the procession of musical dignitaries included José Greco with Nana Lorca, Ella Fitzgerald with the Oscar Peterson Trio, Ramsey Lewis and his Gentlemen of Jazz, Stan Getz, The Supremes and the Copacabana Show with Red Buttons and Stevie Wonder, Louis Armstrong, Duke Ellington, Judy Collins, and the Stan Kenton Orchestra.

Beyond the glow of its star-studded lineups, however, the Music Circus was falling on hard times. Back taxes began mounting up in 1968, and climbed even higher the following year. The 1970 season—its twenty-second—turned out to be its last. West Amwell Township, no longer willing to wait for arrears, seized the property that September and put it on the auction block. No bidders came forward, so the Music Circus grounds—once bustling with activity and reverberating with song—sank into the ghostly limbo it inhabits to this day.

The New Hope Playhouse, too, struggled under a growing burden of back taxes and other debt. But somehow it managed to survive—if often just barely. With a mere 432 seats, it had to play to capacity crowds every night to make a buck, and that sort of run doesn't happen often in any theater. Not that the Music Circus, even in its heyday, cut into the Playhouse audience to any measurable degree. It was the area's only proscenium theater and, as Terrell put it, appealed to a "much more cerebral group" than the Circus, albeit a smaller group, since "musicals appeal to a more fundamental instinct than plays."

Undeterred by such considerations, the Playhouse's Michael Ellis bravely invaded uncharted territory. During his first years as a co-producer, he had lived on unemployment checks. Not until 1958, when he instituted two-week runs for each production, did he show a profit, and then only because he took a gamble on a new play, *Boston Love Story*, which set a house record by grossing $8,000 in its second week. It was a welcome victory not only for him but for all theater lovers who disdained the normal summer stock fare described by one critic as "mostly rewarmings of Broadway successes, hastily mounted, often brilliantly miscast."

But the following year, the Playhouse's twentieth anniversary season, the theater sank once again into the red. Ellis's sole triumph was having the legislature designate it as "The State Theater of Pennsylvania." This was a purely honorary title, but a little extra honor never hurt.

No doubt Ellis would have been happy to swap this honor for a single Broadway hit. As it turned out, he didn't have to. In 1960 he mounted a new show called *Come Blow Your Horn* by the up-and-coming playwright Neil Simon. It seemed to have all the right qualities, so following the close of New Hope's season, Ellis packed up his production and moved it to New York. Simon's farce drew mixed reviews at first, but then caught hold for a nineteen-month Broadway run. "I made more money from *Come Blow Your Horn* than I did in ten years of operating the Playhouse," Ellis marveled to a reporter.

Thanks to Neil Simon, lightning struck again for Ellis in 1963—though it would only be a glancing blow. He kicked off the season with Simon's newest play, *Nobody Loves Me*. In the cast, along with veterans Mildred Natwick and George Voskovec, were a couple of young unknowns, Robert Redford and Elizabeth Ashley. Like *Come Blow Your Horn*, *Nobody Loves Me* seemed to have all the right ingredients, except, perhaps, for a winsome title. Following a good showing at New Hope, the play and its principals (excluding Voskovec) relocated to New York's Biltmore Theater for an October opening. Under the new name *Barefoot in the Park*, the play took off on an incredible 1,502-performance run that led all the way to Hollywood for Redford and Ashley. Unfortunately for Michael Ellis, he wasn't along for the ride. He had tried to buy the rights to *Barefoot* from Simon, but the playwright had promised them to another producer.

In the course of the 1964 season, it became apparent to Ellis that in orchestrating productions in both New Hope and New York—sometimes

simultaneously—he was spreading himself too thin. Needing more time to concentrate on business and family, he quit New Hope that fall, selling most of his Playhouse stock to Walter Perner, Jr., his associate producer for the past two seasons, and Herb Barness, a businessman who was happy to let Perner run the show. Ellis's departure opened the door on an era of near-fatal financial and managerial instability at the Playhouse, a result less of the people involved than of changing times and tastes. Unfortunately, questions of economic viability would overshadow considerations of artistic achievement during the next chapter in the theater's history.

When thirty-one-year-old Walter Perner took over the helm in the spring of 1965, he believed he had inherited "the best summer playhouse in America." His primary goal—beyond surviving six months of sixteen-hour days—was to maintain the theater's distinguished tradition. It was no surprise, then, that the unassuming producer (who "looks and talks more like a high school English teacher than a theatrical entrepreneur," according to one observer) chose to stick with Ellis's Playhouse formula, described by a reviewer as "name stars, original productions, a mixed diet of new and tested plays, high production standards, 432 good seats, and rampant atmosphere." Some of that atmosphere, wrote yet another visitor, derived from the fact that the Playhouse "hangs over a rushing stream, smells of pine, and usually has half-a-dozen fireflies in the audience."

Despite mounting what some reviewers considered "the most lavish and brilliant productions audiences had ever seen at the Playhouse," Perner lasted only three seasons as producer. He was unable to solve the riddle that had plagued his predecessors: how does one put on plays of reasonable—let alone glorious—quality in a small theater without losing one's shirt? After another flirtation with bankruptcy in 1967, he took his talents into the friendlier field of college theater, though he stayed on for a while as president of the Playhouse board.

The Playhouse's state of flux moved along two channels in the wake of his departure. Inspired by the recent formation of a Bucks County Arts Foundation dedicated to fostering the development of fine arts in the County, Lee Yopp, the director of the Bucks County Community College Theater, set up shop at the Playhouse in the fall of 1967 and oversaw an ambitious fall-spring season. Six Broadway hits were performed for large audiences of students on weekday mornings and the general public on weekends.

As the 1968 summer season approached, the scrambling Playhouse board of directors broke with the theater's tradition of independence and

signed a five-year agreement with the Producing Managers Company (PMC) of New York. PMC's point men Spofford J. Beadle, James B. McKenzie, and Ralph Roseman explained that they wanted to bring their packaged productions to New Hope not only because they thought the company had a profitable formula, but because "the most famous summer stock house around can't be allowed to go under."

For a couple of seasons, the PMC solution did indeed help the Playhouse stay afloat. In 1968 and 1969, PMC even managed to earn a modest profit in New Hope. Meanwhile, Lee Yopp and his resident acting company continued to brave the frosty off-peak seasons along the Delaware, introducing hundreds of students from schools on both sides of the river to a caliber of theatrical production they would otherwise never have enjoyed. Following the 1970 spring season, Yopp accepted the invitation to preside over the upcoming summer season as well. It was hoped that the theater could function more smoothly with a single tenant handling year-round production.

As a first step toward making the theater viable, Yopp tried to solve its perennial tax problem by reconstituting the Playhouse as a nonprofit organization. This, however, proved of little help. With no financial breathing room, he found himself having to make "embarrassing aesthetic compromises" in order to keep the theater going. It was a grating reality, especially given the success of its Theater in Education program, which drew 90,000 students each year. "I've got to have new actors," Yopp remarked wistfully to a visiting writer. "Better actors, directors that are specialists, a resident designer to give continuity to our work. It's a shame that it all boils down to money."

He eventually found the demons too oppressive. Joining an exodus of Playhouse employees, some of whom left with several paychecks still due them, Yopp submitted his resignation, effective after the final performance of 1973. A reporter from the *Bucks County Courier Times* attended this performance of *The Glass Menagerie*, believing like Yopp that this could be the last production ever mounted at the Playhouse. He filed the following haunted impressions of the occasion under the headline "Playhouse dies—not with a bang, but with a whimper":

> I had the sensation I had been summoned as an official witness at the deathbed of a friendless indigent in a nondescript charity ward.
>
> The walls of the house were stripped bare of identity. The proscenium arch, once blackened for artistic enhancement of the strutting

players, seemed to form a funereal mourning band for the stage that was about to go dark.

But it wasn't a funeral. Or even a wake. No decent burial has been planned for this debauched and spent pauper. Then who were these strangers who scarcely filled the center section of seats; strangers barely mumbling in the cold gloomy light? Were they the morbidly curious who had come merely to gape at the death rattle?...

This was a final-forever performance. It was a relief when the house lights dimmed and *The Glass Menagerie* distracted us from reality....

Perhaps the Playhouse is only in a coma; the theater is, after all, irresponsibly capricious. Outside the Playhouse [after the show], the streets of New Hope were dark and empty and silent. I don't know why I went. I'm sorry I did.

As it turned out, the Playhouse was only lapsing into a five-month coma. Spofford Beadle and James McKenzie returned with the Managing Producers Company to bring the Playhouse back to consciousness with six productions during the summer 1974 season. Then the impresarios Saul Novick and Jane Friedlander of Theatrix, Inc., threw their weight into further resuscitation beginning in May 1975. When their elaborate plans for "re-establishing the credibility of the Playhouse" and operating it "for the next twenty years" deflated after a single summer season, a twenty-five-year-old law school graduate by the name of Mark Edleman arrived in the fall of 1975 to take a shot at transforming the Playhouse into a full-time regional arts center. He had no more luck than his predecessors.

Finally, out of this managerial maelstrom, some pieces started to fall in place. It began in an almost unrecognizable way with the phenomenal showing of a new rock opera called *Jesus Christ Superstar*, mounted in the spring of 1975 by a Doylestown-based company known as the Now Time Singers. Fresh off this success, young director Ralph Miller signed the Singers up for a reprise of *Superstar* at the Playhouse. A few months before the 1976 season was to start, however, the directors of Bucks County Playhouse, Inc., had still not awarded a summer contract to a production company. Miller could hear opportunity knocking. He convinced a couple of his colleagues on the Now Time Singers, salesmen Bert Daikeler and Mitchell Graff, to join him in forming a production company called RAM III, Ltd. (RAM standing for "Ralph A. Miller"). The trio came up with a

budget and program proposal, and to their delight were selected over several New York companies to produce the 1976 season.

What RAM III did between June 1 and September 5 was pull off the most successful season at the Playhouse in recent history—without the benefit of Actors Equity Union actors. After ticket prices were lowered by a dollar, more than 42,000 people came to see *Godspell, Jesus Christ Superstar* (with Ralph Miller in the title role), *Fiddler on the Roof, Man of La Mancha, South Pacific,* and *George Washington Slept Here.* On the heels of this boffo summer, the Playhouse directors lined up a twelve-week, six-show fall season and a spring season of similar scope, independent of RAM III. Their efforts were quickly rewarded when the opening two-week September run of *The House of Blue Leaves,* starring Eli Wallach and Anne Jackson, broke the Playhouse's attendance record. It was enough to convince the BCP directors that they had the wherewithal to run the theater year-round themselves. Ralph Miller and his RAM III partners were advised that their lease would not be renewed the following summer.

But as the weather cooled and audiences thinned during the fall 1976 season, Playhouse directors reconsidered their decision: operating a theater had turned out to be a lot of hard work and they didn't have the time, manpower, and energy to do the job properly. Miller was quick to seize this chance. He submitted a bid not merely to *lease* the Playhouse but to buy it outright. Although it pained some of the Playhouse directors to turn their beloved theater over to a company employing amateur actors, they could not resist the $200,000 offer, and RAM III took possession in January 1977.

Beginning that March, the new Playhouse owners held by-appoint-ment-only auditions for actors, singers, dancers, instrumentalists, and stagehands. Out of about 400 hopefuls, RAM III assembled a company which the *Bucks County Panorama* described as "23 talented, exuberant, regional actors and actresses who will form the nucleus of all casting." Thus armed, RAM III launched the 1977 season with a production of *Godspell,* which had sold out for seven of nine Playhouse performances the previous summer. Once again it proved a powerful drawing card, on par with emerging Playhouse fixtures *Jesus Christ Superstar* and *Man of La Mancha.* Subscription sales jumped from 390 to 720; theater parties increased from 104 to 154. A new era had dawned.

With Ralph Miller and his associates at the reins, the Playhouse has sailed a relatively steady course through nearly two decades of down-

scaled Broadway staples. Recent seasons have featured such sure-fire hits as *The Phantom of the Opera*, *The Sound of Music*, *Man of La Mancha*, *Guys and Dolls*, *South Pacific*, *The Music Man*, *Hair*, *A Funny Thing Happened on the Way to the Forum*, and *A Chorus Line*. The theater's steadiness appears all the more remarkable when viewed against the backdrop of summer stock's general decline. The number of summer theaters in the northeastern United States has dropped from seventy-five to eleven since 1977. "They died," one critic wrote, "because the financial return on a theater cannot compare with the possibilities of development, either in condominiums or shopping areas."

New Hope, meanwhile, has landed on the National Register of Historic Places and experienced what a writer for *Pleasure Hunt Magazine* described as "a fantastic renaissance" and "new business boom."

The resurgence occurred just in time to provide a bustling backdrop for the Playhouse's fiftieth anniversary, celebrated in 1989. Looking back over a rollercoaster half-century of drama and music, chroniclers found themselves sorting through an amazing collection of names. Wrote one impressed journalist, "Big names who have performed at the New Hope theater have collected at least eleven Oscars (Shirley Booth, Bob Fosse, Lillian Gish, Helen Hayes, Grace Kelly, Walter Matthau, Liza Minnelli, Luise Rainer, and George C. Scott), ten Tonys (Tammy Grimes, Moss Hart, Richard Kiley, and Jessica Tandy, as well as Booth, Fosse, and Minnelli), three Pulitzer Prizes (Thornton Wilder), and one induction into the Pro Football Hall of Fame (Terry Bradshaw, who appeared in *Damn Yankees* in 1983)."

New Hope has also been a busy stop on the road to television fame. Household names who have graced the Playhouse stage include Merv Griffin, Larry Hagman, Leonard Nimoy, and Dick Van Dyke.

Stars flashing in and out of Bucks County put the Playhouse on the map, but hundreds of supporting talents have helped keep it there. Perhaps the greatest Playhouse achievement has been collective: the interplay of talent and patronage that has kept the theater viable well into its sixth decade. As actors alone do not a theater make, the Playhouse owes as much to Bucks County as the county owes the theater.

Henry Chapman Mercer and the Crafts Tradition

Browsing in a rural Bucks County junkyard in 1897, Henry Chapman Mercer's ever-inquisitive mind took a highly original turn. He suddenly saw in the jumble of "masses of obsolete utensils and useless objects" nothing less than "the history of Pennsylvania, profusely illustrated." Inspired by this vision, he set out to forage the "bake-ovens, wagon-houses, cellars, haylofts, smoke-houses, garrets, and chimney-corners" of the county to find the cast-off remains of the nation's great handicraft traditions—traditions that had shaped the lives of generations of Americans only to be swept away in his own lifetime by the Industrial Revolution.

As fortune had it, he was endowed with ample funds. He assembled relics of every trade, craft, and calling: implements for making barrels, wallpaper, cheese, tinware, sausages, shoes, pottery, hats, books, baskets, shingles; tools of the gunsmith, weaver, fisher, housewife, miner, sign painter, barber, blacksmith, teacher, doctor, musician, farmer. And he gathered together the products of many of these trades and professions, from a whale boat to darning needles, from a cigar store Indian to a printing press. He called his vast collection the "Tools of the Nation Maker."

Mercer (1856–1930), a native of Bucks County, descended on one side from settlers who had bought land from William Penn and on the other from Scots-Irish pioneers in Virginia and Maryland. As the first grandson of Doylestown's Judge Henry Chapman, he was expected to follow a career in the legal profession. His exposure to the ideas of design reform at Harvard University in the late 1870s changed his direction. In particular, he was intrigued by the teachings of Charles Eliot Norton that the arts of an era offered a coherent summary of the spirit of that age and the genius of its people. Increasingly enchanted by art and archaeology, Mercer set his sober pursuits aside

Portrait of Henry Chapman Mercer, ca. 1890. Courtesy of the Spruance Library, Bucks County Historical Society.

89

after a couple of dutiful years studying law at the University of Pennsylvania, and instead embarked on a series of fanciful adventures.

He had developed a taste for travel when, at age fourteen, he toured Europe with his mother and her two sisters, one of whom, his widowed aunt Elizabeth "Lela" Lawrence, later became his great benefactor. In 1882, after his law studies, he returned to Europe on his own and explored Egypt as well. In 1886, he built a commodious raft and sailed down the Danube for two years, visiting castles and entertaining friends along the way. In 1889, he undertook a 700-mile houseboat journey on the Loire, taking photographs and keeping a journal to satisfy his penchant for historical accuracy.

His interest in history grew steadily. Earlier, in 1880, he had helped found the Bucks County Historical Society. By 1890, his river journeys behind him, he approached history differently by beginning a career as a self-taught gentleman archaeologist. He soon distinguished himself in this field through his investigations of prehistoric man in the Americas for the University of Pennsylvania Museum. But the politics of museum life did not agree with his essentially artistic temperament. Soon after he left the museum in 1897 came his revelation in the Bucks County junkyard.

The ceaseless collecting of early American implements that Mercer then began culminated in the nation's preeminent collection of such artifacts. To house the collection, he designed and built a remarkable structure that after his death was named the Mercer Museum. In homage to the implements it would house, he "hand-crafted" the building. Though he constructed it of a state-of-the-art fireproof material—reinforced concrete—he limited his work force to local men using traditional hand tools. His only sources of power were a gasoline-powered cement mixer and a horse.

Ever since its public opening in 1916, the Mercer Museum has stunned visitors with its iconoclastic, rough-hewn grandeur. Arriving from the out-of-doors, one passes briefly through a low, dark hallway to emerge into the building's central atrium, which rises five stories to the vaulted concrete roof. A seeming hodgepodge of exhibits crowds this dusky well from floor to ceiling—some standing, some suspended, some jutting into space: the whaling boat, a Conestoga wagon, fire engine, sleigh, more wagons, all seeming to defy gravity. Tools of every kind are attached to the supporting columns and the balcony rail. At eye level stands a huge cider press and other objects so large they had to be placed

in the building before walls enclosed them. A spiraling staircase houses cell-like rooms, each devoted to a specific craft or trade.

For most of the twentieth century, the Mercer Museum's stark, oddly fenestrated facade on Doylestown's Pine Street faced the stone walls and entry tower of the Bucks County Prison. More than a few times over the years, callers at the museum's Pine Street door asked for the warden, while tourists seeking to view the museum's collections rang the penitentiary's bell. Most of the prison was pulled down in the 1980s; its handsome gatehouse and a remnant of its walls survive as a part of the James A. Michener Art Museum. Across the way, Mercer's original facade

The Mercer Museum under construction, ca. 1915, one of three poured concrete structures designed and built by Mercer in Doylestown. Courtesy of the Spruance Library, Bucks County Historical Society.

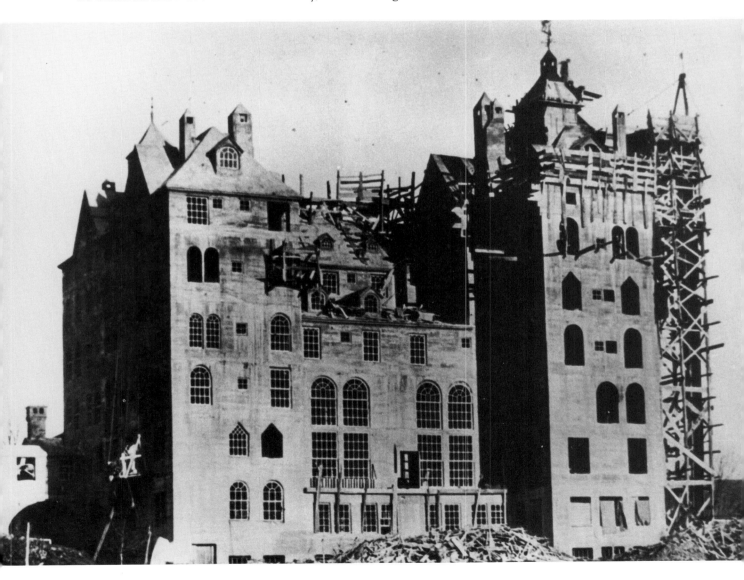

remains virtually unchanged, though the museum now greets the public not on Pine Street but in a spacious entrance pavilion added on the other side of the building.

In his museum, Mercer linked the material culture of preindustrial American society to its predecessors through the ages around the globe. He saw his collection as a kind of anthropology based on common implements for near-universal human endeavors. "Here," he said, "we look from the present backward to the past. Beginning at the doorstep of our grandfathers, we go back to Roman and Egyptian times. This therefore is archaeology turned upside down, reversed, revolutionized." He said that his collection offered "a new presentation of America from the point of view of the work of human hands." The crafted everyday objects of anonymous people provided a tangible glimpse into the past.

In all of this, Mercer reflected in highly original ways the influence of William Morris (1834–1896), the English design reformer and the major figure of the Arts and Crafts Movement whose credo was "art should be by the people and for the people, a pleasure to its maker and its user." Despairing of both the aesthetic and social ills brought about by industrial manufacturing, Morris had looked to the past for inspiration, especially to medieval handicrafts.

Mercer became an exponent of the Arts and Crafts Movement in America. Like Morris, he was determined to revive old crafts, and soon settled on ceramics. While collecting Bucks County potters' tools as archaeological specimens in 1897, he became interested in the ceramic redware tradition of the Pennsylvania-German potters who had settled in and around Bucks County. Inspired to put their tools to use, he decided to "resuscitate" the art of making their ware. He apprenticed himself to one of the last remaining potters, David Herstine of Kintnersville, hoping to learn from him the nearly lost skills of the craft. Mercer never quite mastered it but working in clay fascinated him. In the end he coupled a little modern ingenuity with his archaeological interests to develop hand methods that allowed the manufacture of decorative ceramic tiles in sufficient quantities to constitute a going business.

Like his tool museum, Mercer's tile factory was an architectural adventure in concrete. The first such structure he had built, back in 1908, was his own Doylestown house, a capricious fortresslike mansion that he called Fonthill (Plate 1). For his tile works next door, completed four years later, he decided on the Spanish mission style. Both Fonthill and the Tile Works are now visitor attractions.

Interior of the Mercer Museum, showing a few of the thousands of objects collected by Mercer. Courtesy of the Spruance Library, Bucks County Historical Society.

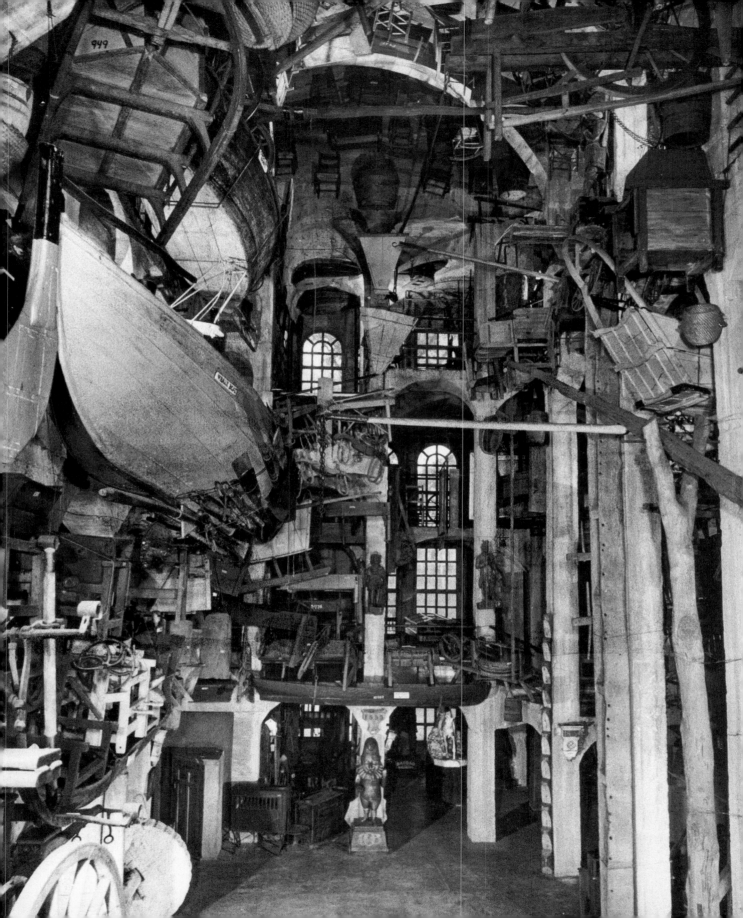

*M*ercer's preliminary sketch of a tile design (above), with the finished work of art (opposite). Courtesy of the Spruance Library, Bucks County Historical Society.

*T*he nearly completed Moravian Pottery and Tile Works in 1912. Courtesy of Urban Archives, Temple University, Philadelphia.

Mercer drew his designs for tiles from many sources, first from Pennsylvania-German stove plates made by local ironworkers, then from medieval tiles he found in the British Museum, and also from objects he had collected on his travels. He moved from conventional four-square tiles to an original mosaic style that he patented, and then to a sculptural relief style that he called "brocade," each style in response to specific architectural requirements. Many large decorative pavements, countless small houses in the Arts and Crafts style, the Pennsylvania State Capitol, Isabella Stewart Gardner's Fenway Court, and his own home, all became showcases for his tiles. He translated to his tiles much of the imagery of the Tools of the Nation Maker, creating an original iconography of American history. He offered over 500 tile designs in a series of catalogues and they ended up on the floors and walls and fireplaces of schools, libraries, churches, hospitals, and private residences across the country.

His architect friends in Philadelphia and Boston who wanted such tiles for their new Arts and Crafts-oriented architecture encouraged him when, in 1898, he opened his Moravian Pottery and Tile Works on the grounds of Aldie, the Mercer family estate in Doylestown. The first true Arts and Crafts Movement tile maker in America, he had not revived an old craft but invented a new one for his own time.

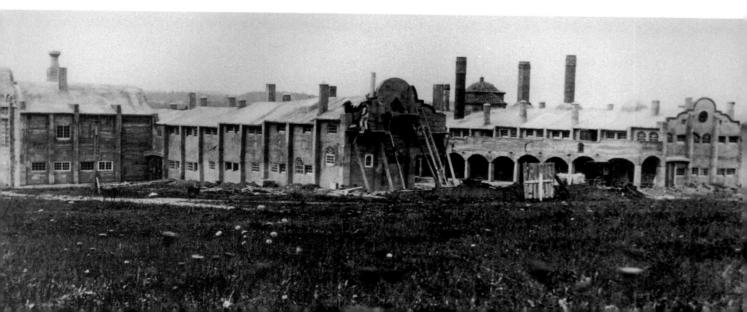

In January 1922, Mercer received a letter from the New York architect Richard Henry Dana, Jr., who had recently visited Doylestown. Dana wrote that he was "so much stirred by the hand-crafts of Pennsylvania" that he wanted a complete list of those still in operation. "I personally favor encouraging this hand-work in America," he wrote, "rather than importing antiques from Europe." In replying, Mercer identified those makers of fine crafts whose work he knew at the time. His list included several craftspeople in Bucks County: Morgan Colt of New Hope, who worked in wrought iron and carved in wood; the Davenports of New Hope, who wove rugs; and his own brother, William R. Mercer, Jr., of Doylestown, who made stained glass and also cast urns, plaques, and other objects in concrete. Mercer said that he otherwise knew of nothing of artistic importance being done in brass, copper, lead, or glass and least of all in cast iron, although, in fact, work was under way in some of these crafts in and near Bucks County.

And then he emphasized an important distinction. He pointed out that the products of the traditional artisans of the past, which Dana had seen in the Mercer Museum, were unconscious survivals of old European industries and were not to be confused with the modern products made by himself and others. The new works had sprung up, Mercer wrote, "under an entirely different condition, rather as luxuries to the rich than as growing out of the life of the everyday common world." He added that "the last of the old crafts, [such as] slip decorated pottery, painted chairs and settles, and hand made Windsor chairs, died in the 1890s."

Mercer had recognized that in the early decades of the twentieth century, the crafts had become fine art, and this, too, was part of the heritage of Morris and the Arts and Crafts Movement. The latter-day

crafters Mercer referred to in his letter were people of considerable sophistication, who had responded to the modern world's love affair with the machine by turning to handicraft. They had done so not so much in protest against an age of mass production as in an attempt to broaden and enrich their own lives and the arts of their times. They did not imitate the work of the artisans of the past but strived instead to create a new voice for the crafts, one that spoke to modern times. In this they succeeded, each in a distinctly individual way.

One of the most interesting of these Bucks County craftspersons was Mercer's brother, William, who died in 1939. Six years younger than his adventurous sibling, the talented William did not try to follow in Henry's obsessive footsteps, though he too traveled in Europe, sometimes with his brother. After boarding school, private tutoring in Cuba, and a few years at Harvard, he studied in Philadelphia with the distinguished figural sculptor Charles Grafly (1862–1929). In 1892 he built a studio behind the family home in Doylestown, though he chose to work in it not primarily as a modeler or carver of figures but as a maker of objects allied to the crafts.

Inspired perhaps by the Mercer home's then-famous Italian gardens, William began to carve and to cast in concrete sculptural ornaments for landscaping. He also created on a small scale decorative panels of stained glass and mosaics, sometimes incorporating them into his concrete work. He adapted motifs and forms from historic Greek, Roman, and Byzantine sources, and used them to make fountains, benches, columns, pedestals, and arches in stone and concrete. He cast elaborately decorated garden planters with relief designs, one after a Byzantine sarcophagus, and another with Roman figures, which he offered in a trade catalogue. He exhibited his work in Paris, Munich, and Berlin, as well as closer to home at the Pennsylvania Academy of the Fine Arts.

In 1902, the prestigious Society of Arts and Crafts in Boston honored William's sensitive use of historical motifs in a new medium by electing him a Craftsman member. In 1913, the Society made him a Master, and in that same year, awarded Henry its greatest honor, the Society's medal.

It is ironic that, despite the durability of William Mercer's medium and the popularity of his work at the time, very little of it survives. Some of it seems to have been cast off as styles in garden design changed. Other items fell prey to the elements. Some of his best works—a loggia, a fountain, fireplaces, and other pieces—adorn New Aldie and its garden, now a

The fountain designed by Henry Mercer's brother, William Mercer, at William's home, Aldie Mansion. Courtesy of Heritage Conservancy.

historic site in Doylestown. Several of his molds, found abandoned in an old barn, are preserved at the Moravian Pottery.

The Mercer brothers worked (separately) in their ancestral Doylestown, the busy county seat. Each in his own way drew upon the

past to create objects for the modern world. In their originality, commitment, and work ethic, they set examples for their mostly younger colleagues in the burgeoning realm of the crafts in Bucks County. Those craftspersons congregated not in Doylestown, however, but about a dozen miles to the east, in and around New Hope, which had already attracted a number of painters.

Neither the painters nor the craftspersons of New Hope have been so celebrated as their New York counterparts who, summering at Woodstock, Ogonquit, or Provincetown, never quite escaped the spotlight of the New York press. Just as Philadelphia was a much quieter art center than New York, so too was New Hope a less publicized crafts colony. And New Hope had none of the exotic quality of Taos in New Mexico with its blend of Native American and modern influences.

The "big" names of the New Hope colony were its painters, William Lathrop, Daniel Garber, and Edward Redfield, who, with their followers, constituted the New Hope School. The craftspersons who worked among them were often equally distinguished. Some were more sympathetic to the modern spirit of the times than the painters. Painter and craftsperson were sometimes one and the same, which was not surprising, since almost without exception those who worked in the crafts at New Hope had been trained in the fine arts.

The senior member of the New Hope crafts group was Morgan Colt. He had trained as a painter, studied architecture at Columbia University, and practiced as

*G*othic stool made by Bucks County painter and craftsperson Morgan Colt. Courtesy of New Jersey State Museum: Museum Purchase.

an architect before he discovered the idyllic landscape and hamlets of Bucks. In 1908, he and his wife settled next door to the Lathrops at Phillips Mill, two miles north of the center of the village. He put his architectural skills to work to make a handsome home, studio, and garden out of a nucleus of old structures and a pig yard. Probably with the advice of Henry Mercer, he built his studio and the gateway to his grounds in reinforced concrete. Then, wanting to furnish his buildings entirely with the products of his own hands— in the spirit of William Morris who said, "Have nothing in your house which you do not know to be useful or believe to be beautiful"—he built and decorated chairs, tables, chests, and all else needed to make his home a work of art. Having done that, Colt, in 1914, opened the Gothic Shop, housed in a small rustic building next to his studio, where he made carved and painted chests, tooled leather, and other hand-crafted furnishings of the kind he had put into his own house.

Logo of the Gothic Shop, the studio opened in 1914 by Morgan Colt. Courtesy of Pedersen Gallery.

In the early 1920s, Colt decided to build a forge next door to the Gothic Shop. He hired as a helper Isaac Wallwork, a young man from Gladwyn looking for work. Colt then asked Amos Armitage, a well-established local blacksmith, to provide his wrought-iron designs: fire screens, lamps, weather vanes, chairs, and tables, and to teach Wallwork and himself the craft.

Armitage, a fourth-generation descendent of millers and carpenters, had set up his forge in nearby Solebury in 1926 to fulfill his desire to be a blacksmith. Then twenty-five years old, he hired expert smiths to teach him the trade, and soon became a master in his own right. In a sense, Armitage was a traditional craftsman, much like the ones honored in the Mercer Museum, but he was so by choice rather than necessity. His liaison with Colt moved him naturally into the Arts and Crafts Movement. After Colt's untimely death at age 49, in 1926, Armitage continued to work in his own smithy and to his own individual style, more akin to folk art than to fine art, while also plying his trade as a practical blacksmith. Wallwork stayed on for a few years to make iron objects for Colt's widow to sell at the Gothic Shop. In later life, when the craft market had dried up, he joined the machine age by putting his skills to work in industry.

Colt's artistic work in iron and wood now strikes the eye as a curiously eclectic synthesis of early American, rustic Italian, and provincial

French styles. He decorated many pieces with painted figures, foliation, and views. There was nothing "modern" about this work in the sense that Art Deco and Bauhaus design were then modern, but there was nothing old-fashioned about it either. His work came from a mind freed from the older distinctions between art and craft that had ruled the world of American art. His Gothic Shop held much in common with other "Gothic" crafts enterprises in the area: the Rose Valley Community west of Philadelphia, the building of Bryn Athyn Cathedral in Montgomery County, and the Arden Studios in Delaware, where Colt exhibited some of his work.

Like a number of other New Hope artists, Colt maintained his membership in the Salmagundi Club in New York; this kept him abreast of all that was new in the visual arts. As a man of some means, he was free to work as he pleased. He dressed as a country gentleman and had great fun creating for himself an environment of buildings, furnishings, gate, and garden by drawing on things both new and old, American and European. He set an example of originality of thought in the crafts that cut across categories, functions, and media. In continuing the Gothic Shop, his widow designed such works as an elaborate painted Italianate cupboard, a Spanish style chair with a wrought iron frame and a painted copper seat, and a carved Gothic chest.

In his letter to Dana, Henry Mercer had identified the Davenports as weavers of rugs. Ethel Ramsey Davenport (1874–1965) was the sister of the painter Fred Ramsey, the member of the New Hope School most drawn to modernism. She had studied design in her native city at the Philadelphia Museum School of Industrial Arts, and then in Florence at the Accademia di Belle Arti. She traveled widely and worked in social services until she was nearly forty, then followed her brother to New Hope.

Ethel Davenport played a crucial role in making the village's crafts and art more widely known to the outside world. Her future husband, Don, who had trained in the Philadelphia Museum School in the mid-1890s and then worked as a professional textile designer in industry, came to New Hope in 1911 to visit Ethel and found a new life in the country. They married a year later, surviving at first off their garden and their chickens. Putting their specialized training to use seemed to make more sense than selling eggs, so in 1916 they bought a colonial loom and began to make rugs for kitchens. Because their product could not compete with machine-made rugs, they soon developed an original

tapestry technique based on a combination of Navaho and Gobelin methods and thereby transformed the nearly lost art of American handweaving. Don dyed the materials and Ethel made the designs that he then wove into rugs. They opened their Homespun Shop of Handweaving in 1924, bought more looms, and trained girls just out of high school as assistants. At the time, only the Davenport and Colt studios welcomed the general public.

In 1916, the Davenports convinced the Farmers Club to exhibit some paintings, inviting local artists to show their work among the farm exhibits. This was probably the first art exhibit to be held in New Hope, according to Ethel's unpublished autobiography, *Ladies Didn't*, a source of many insights into life in the art community. In 1921 *Arts and Decoration* magazine reported that she and her brother Fred were responsible for the craft revival that then flourished in the New Hope colony, and that they were "putting decoration and village-crafts on a practical and artistic level that would enable one to bring beauty into the humblest of homes as well as extract it from them."

When the Irish painter Peter Keenan (1892–1952) arrived in New Hope in 1932, he saw the opportunity for the community to cash in on the tourist trade. He suggested that the Davenports put an empty gallery to use by showing the work of local artists in frequently changing exhibitions. They did just that by opening the Independent Gallery on the Old River Road. They charged exhibiting artists two dollars a canvas to hang their pictures "on line"; the public paid ten cents for admission. "We showed only first class paintings and soon people began to come by the bus load," Ethel wrote. She sent reviews of the shows to papers in New York and Philadelphia. In 1934 they changed the name of the Independent Gallery to the Davenport Gallery, fearing that the term "independent" would be confused with that of "modern" as applied to painting.

In August 1933, Keenan began *The New Hope*, a small magazine "written for and by residents of the Delaware Valley," on its art, literature, crafts, and music. Ethel served as its craft editor (without pay); the magazine ran for twelve issues. In 1936, the Davenports helped establish the Phillips Mill Art Association. Ethel organized and directed its second art exhibit. She was asked to do so, she said, not because she had standing with the group as an artist, but because she had a typewriter. In the late 1930s she organized studio weekends at which local artists and craftspersons, including William Mercer, exhibited together.

In the September 1933 issue of *The New Hope*, Keenan wrote a glowing review of the new furniture collection of Fred Harer (1880–1949), then on view at the Independent Gallery. Trained as a painter, sculptor, and printmaker at the Pennsylvania Academy of the Fine Arts and the Art Students League in New York, Harer had learned woodworking from his father, a successful furniture maker in Blossburg, Pennsylvania. This skill, which he applied to the craft of frame making, secured his career. Working out of his Red Cliff Studios up river from New Hope in Uhlerstown, he became one of the nation's finest frame makers.

Harer traveled widely. His frames show the influence of his exposure to the primitive arts of Spain and the West Indies, as well as his sympathy for the "folk art" of the United States which, freshly discovered in the 1920s and '30s, became part of cosmopolitan modern culture. Meticulously proportioned, Harer's frames incorporated such techniques as carriage stenciling, incising, matte and burnished gilding, and punching with nails and tools that he made for that purpose. Each of Harer's frames was unique. In color and material they established a vibrant relationship with the paintings they showcased. They enhanced paintings by Redfield, Garber, and many others, including his own. At the annual Phillips Mill exhibition, frames sometimes received nearly as much comment as paintings.

Harer continued to paint and etch, and in 1933 he exhibited his collection of furniture at the Independent Gallery. Keenan commented, "one feels of Harer that anything he creates will fall into one of the categories of art and rank high therein; but his water colors, his oils, his decorations, and his sculpture seem to be embodied and totalized in his latest adventure in art—the making of furniture. It is a capsheaf for all his other exploits." Harer's bookcases, desks, dressing tables, and stands were structural and combined beautiful woods with painted decoration. He said that he based his designs on "fundamental truths" which he hoped would survive their own time and all others, as the primitives had done: "There is no such thing as modernism—furniture is first practical and then ornamental. I have spent as much as three months perfecting one piece, giving the back as much consideration as the front, as with a piece of sculpture."

Not all New Hope frames were Harer's. Bernard "Ben" Badura (1896–1986) also made them. A native of Wisconsin, he studied fine arts and design in Milwaukee and at the Pennsylvania Academy of the Fine Arts. Badura worked as a stained glass maker in Reading before coming to

A 1980s portrait of framemaker Ben Badura and his wife, painter Faye Swengle Badura. Photograph by Jack Rosen. Courtesy of the James A. Michener Art Museum.

New Hope as a young man with his wife, the painter Faye Swengle, to learn the art and craft of frame design and fabrication from Harer. Although Harer tended to be secretive about his methods even with his pupil, Ben's tenacity enabled him to create high-quality frames on his own. He eventually opened a shop in New Hope in friendly competition with his teacher. He synthesized Harer's primitivism with a more overt modernism, learned in part from the great Philadelphia abstract painter, Arthur B. Carles, who, while not a year-round resident of New Hope, summered there for a few years.

Textiles travel, but stained glass tends to stay put. The first glass of major repute in Bucks County during the colony years was painted by George W. Sotter, a native of Pittsburgh. He began as a landscape painter in the New Hope School's brand of American Impressionism. As a young man, he had fallen in love with the rolling fields, verdant woodlands, stone buildings, and quiet life of Bucks County, and wanted to paint them. In 1902, at age twenty-three, Sotter convinced Redfield to accept him as a pupil while he was studying at the Pennsylvania Academy of the Fine Arts under William Merritt Chase, John Sloan, and others. He was on leave from the influential stained glass studio of J. Horace Rudy in Pittsburgh, and after working for a while at the William Willet studio in Philadelphia, he returned to Pittsburgh in 1910 to teach painting, design, and the art of stained glass at the Carnegie Institute of Technology.

He returned to the New Hope area in 1919 with his wife, the painter Alice Bennett, who was also a graduate of the Fine Arts School of the Carnegie Institute. They settled west of the village at Holicong. Over the next thirty years Sotter received many important stained glass commissions from throughout the Northeast; at one point he employed fifteen craftsmen. His windows grace churches across the country, including Our Lady of Lourdes in New York City, St. James in Cleveland, St. Gregory in Los Angeles, Sacred Heart in Pittsburgh and, closer to home, St. Paul's Episcopal Church and the Church of Our Lady of Mount Carmel in Doylestown. He continued to paint landscapes on canvas even as he painted figures on glass. He exhibited his paintings—he was known especially for his winter moonlight and cloud paintings—for twenty-two years at the International Exhibition at the Carnegie Institute. He won a silver medal for painting in 1915 at the San Francisco Pan American Exhibition, and many "firsts" over the years at the annual Phillips Mill exhibitions. When he died in 1953, he was working on a window for the Chapel of Sacred Heart Church in Pittsburgh. His wife, who had worked with him on many projects, completed it.

Sotter and stained glass drew Valentine d'Ogries to New Hope in 1925. Born in Carynthia, Austria, in 1889, d'Ogries graduated as an engineer from the Technical College of Klagenfurt and studied at the Sorbonne in Paris before immigrating to America in 1908. He attended the Carnegie Institute from 1914 to 1916 where he taught modeling and studied with Sotter, who directed him toward stained glass.

D'Ogries went on to work in the Henry Wynd-Young stained glass studio in New York where he painted murals and altarpieces for the firm

while he apprenticed as a stained glass artist. His windows for the Church of St. Thomas the Apostle in Chicago, a project that took seven years to complete, established his reputation. After moving to Bucks County, he located his home and studio west of New Hope on Glass Mountain above Manchester Valley in a remodeled schoolhouse that in its earlier state dominates the scene in Joseph Pickett's folk painting *Manchester Valley*. He transformed this school building into a "castle" of color and light, full of his own murals and paintings, original sketches for windows, and a unique crystal chandelier of his own making, lit with candles that he had dipped himself.

Where Sotter's windows were darkly Gothic in character, d'Ogries's were lighter and brighter, typical of his generation's approach to stained glass. D'Ogries collaborated with Colt on the exquisite Phillips Chapel in New Hope. Colt designed the iron work not long before his death, while d'Ogries made the stained glass windows.

In 1934, d'Ogries wrote an article, "The Future of Stained Glass," for *The New Hope*, in which he disclaimed the idea that stained glass was on its death bed. He believed that this eight-centuries-old tradition still worked its magic and would survive "dechurchification" of modern life, though it was an art that had always depended on religious houses for its patronage. "Stained glass workers have never run shouting down the streets in noisy revolt," he wrote. "They have accepted the mutations of their craft as they came, with geologic slowness." He added, "I think, though, that it will be a healthy day for Christianity when it comes about that great changes are made in windows; for a threadbare style is a spiritless style, and art without spirit is a sail without wind."

Another of Sotter's students followed him to Bucks County. Edward J. Byrne, Sr. (1899–1969), a native of Pittsburgh, opened his stained glass shop in Doylestown in 1933. He collaborated with the Moravian Pottery after Henry Mercer's death to design, among other tiles, a series of relief panels depicting the Stations of the Cross. Edward Byrne, Jr., has continued the business after his father's death to the present day.

Ethel Wallace (1885–1968), a fine painter originally from New York, found in the ancient art of batik new opportunity for modern expression and innovation. She was a deliberate bohemian, almost flamboyantly so by New Hope proprieties. She succeeded in giving the village at least a little sense of the unbuttoned life expected of arts colonies. Her home and studio in New Hope became a gathering place for artists from near and far.

Working with traditional dyes and wax resists on silk to create a highly original imagery, she helped to revive the ancient craft of Balinese batik, elevating this medium to an art worthy of national attention. In 1923 *International Studio*, the leading American magazine of art, published a feature article on her work, reproducing four striking batiks that reflected her keen interests in myth, other cultures, printmaking, and modern design. Her portraits, infused with influences from Matisse and other modernists, were a tonic to those who found the Bucks County landscapes of the New Hope School excessively conservative.

Other craft enterprises flourished in New Hope in the decades before World War II, some only briefly, but all adding character to the village's life. Albert Huber (1907-1983) came to New Hope in 1933 and for two years operated the Swiss Workshop on the canal bank on the east side of the village. He made hammered copper metalwork in the spirit of the Arts and Crafts Movement, sometimes incorporating Mercer's tiles into such objects as bookends and boxes. He then moved to California in 1935, where he studied design and toolmaking. In 1944, he returned to New Hope. Sporting a waxed mustache and goatee and occasionally wearing sequined sneakers, he became a colorful addition to the community. In addition to redecorating, remodeling, and rebuilding homes, he constructed his own house, played double bass in the Solebury Chamber Orchestra, and ran two restaurants before finally going to work as a toolmaker for a local manufacturer. Like Ethel Wallace, he lived well beyond the days of the old New Hope crafts colony.

Many others had contributed to those days. Lambert Rose of Point Pleasant, a traditional basket weaver, already eighty in 1934, found his work highly prized and collected by Dana, Colt, and others. Michael McCombs of Titusville, a master carpenter, built houses before he, too, took up frame making in New Hope. He branched into furniture making in the early 1930s, producing sturdy and beautiful modern pieces, affordable to those of limited means even in Depression times. And the list goes on of those who in the decades between the World Wars gave New Hope its reputation as a place where the arts and crafts were interwoven into life.

By the end of World War II, New Hope as a crafts colony seemed past its prime. Some of its masters had died. Others, such as Sotter and Wallace, worked on with distinction, but little new blood arrived that made an impact on the community. The Arts and Crafts Movement had lost its impetus, and with it went the special value that it had accorded to

handicraft. The Depression tightened markets; the war brought shortages of materials, made travel difficult, and further limited the market for crafts.

Then, soon after the war, there arrived in New Hope one of the most remarkable figures in the history of the crafts in all of America, George Nakashima (1905–1990). An American born in Spokane of Japanese parents, Nakashima grew up close to the woods in his native state of Washington, working for a while on railroad gangs and, later, in salmon canneries. He studied forestry and architecture at the University of Washington, during which time he spent a fellowship year in Paris. He then earned a master's degree in architecture at the Massachusetts Institute of Technology. After working as a muralist and architectural designer for two years in New York, he boarded a steamship in 1933 to go around the world, stopping off in Paris for a year.

In 1937, Nakashima went to work in Tokyo for the architect Antonin Raymond, who had come with Frank Lloyd Wright in the early 1920s to oversee the construction of Tokyo's Imperial Hotel. Raymond sent Nakashima to work on the design and construction of a monks' dormitory in India, where he stayed until 1939. In 1940, once again in Tokyo, he met his future wife, Marion Okajima, an American-born English teacher, and returned to the United States in 1941.

Having spent seven years in Asia, with its ages-old traditions of fine crafts, he found modern American architecture so lacking in workmanship and sensitivity of design that he left the profession to follow a career of woodworking. He established a furniture workshop in Seattle, but with the outbreak of the war, he and his wife were interned in Idaho. There he joined forces with a nisei carpenter who taught him many fine woodworking skills.

His old friend and former employer, Antonin Raymond, had in the meanwhile purchased a farm in Bucks County. In 1943, Raymond arranged for the release of the Nakashimas by offering George employment on his farm. This introduced him to New Hope. In 1944, Nakashima began to make furniture of his own design in solid wood, which he carved and finished with great respect for texture and organic structure. The use of machines for tasks beyond the practical powers of handwork enabled him to make his famous large slab tables. Perhaps for this reason he came to prefer to be called a woodworker rather than a craftsman. Derek E. Ostergard, in his *George Nakashima, Full Circle*, suggests that Nakashima's most important contribution to furniture lies in his use

of the free edge—the natural edge of
a tangential cut of wood—as part of
the finished piece, thereby giving his
furniture a highly dynamic quality
that can be categorized as organic
naturalism. The spirituality of both
Shaker and traditional Japanese furni-
ture influenced his designs.

Nakashima titled his 1981 auto-
biography *The Soul of a Tree*. In it he tells
of how by scrounging raw materials,
bartering, and working with friends,
he and his family first built a house
and then a business that synthesized
hand with machine to make fine
furniture—the chairs, tables, cabinets,
and other pieces that established him
as one of the great craftsmen of his

era. For more than a third of a century he brought forth in Bucks County
extraordinary works of wood that transcend what we usually mean by the
word "furniture." He did this in the spirit of the American pioneers, inte-
grating work with life, close to trees and soil.

George Nakashima with his daughter,
Mira, who is also a designer and
woodworker. Photograph by Jim Schmidt.
Courtesy of the Nakashima Studio.

The crafts-making tradition in Bucks County achieved many things
of lasting value. Some of those, like Wallace's batiks and Colt's
furniture, serve as striking mementos of the taste of their era.
Others, like Harer's frames and Sotter's glass, seem to transcend their time
as they remain in close alliance with other arts. Nakashima's wooden
objects, now the most widely praised of all Bucks County crafts, inspire a
new generation of workers in wood, here and abroad, to find spiritual
meaning in their materials and their work.

George Nakashima sitting on one of his
trademark tables. Courtesy of the
Nakashima Studio.

Color Plates

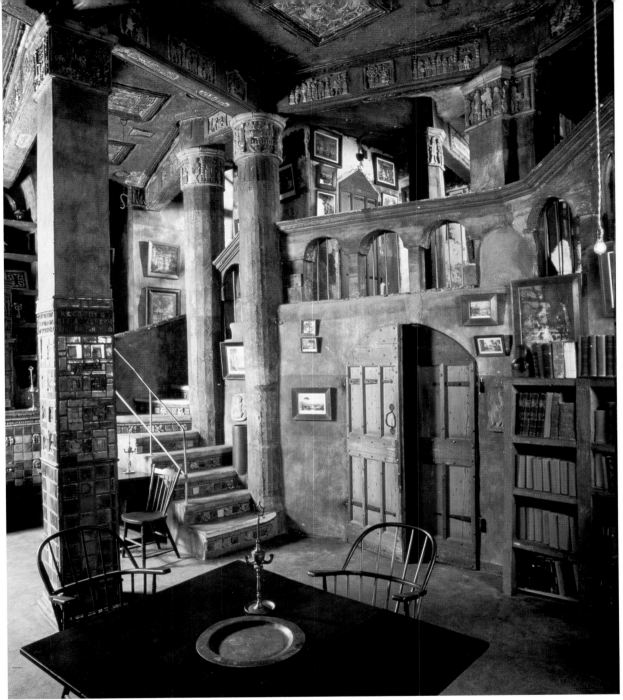

Plate 1 This view of the Saloon, the largest room in Fonthill, shows Henry Chapman Mercer's characteristic interweaving of poured concrete and intricate tile designs. Photograph © 1996, Scott Dorrance. Courtesy of the Bucks County Historical Society.

Plate 2 George Sotter (1879–1953).
 The Nativity and The Resurrection.
 Stained glass. Courtesy of Bianco Gallery
 Archives.

*These two stained glass windows by
Sotter can be seen in St. Paul's Episcopal
Church in Doylestown, Pennsylvania.*

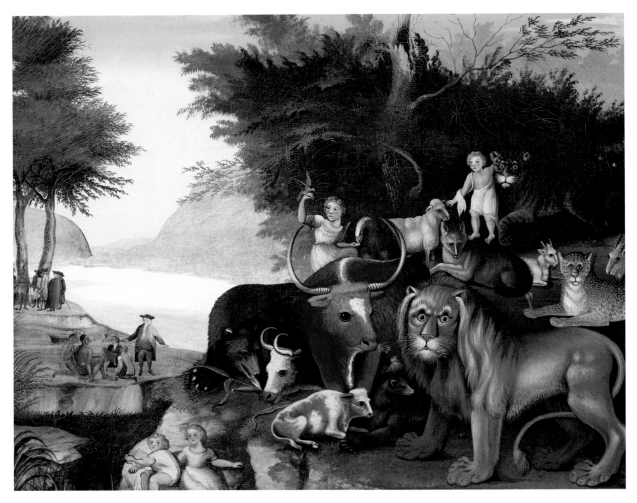

Plate 5

Edward Hicks (1780–1849).
The Peaceable Kingdom, c. 1837.
Oil on canvas. 28 x 35 in. Courtesy of
the Mercer Museum of the Bucks County
Historical Society.

Hicks painted over sixty versions of the
theme from the Book of Isaiah, which for
Hicks embodied Quaker ideas of peace
and brotherhood.

Plate 7 (opposite)

William B. T. Trego (1859–1909).
Civil War Battle Scene, 1887. Oil
on canvas. 19.25 x 29.5 in. Courtesy of
the James A. Michener Art Museum.
Purchased with funds provided by Anne
and Joseph Gardocki.

Influenced by his training at the
Pennsylvania Academy of the Fine Arts,
Trego dressed his neighbors in Civil War
uniforms and used them as models in his
quest for historical accuracy.

Plate 8

Edward Willis Redfield (1869–1965).
Winter Wonderland, n.d.
Oil on canvas. 50 x 58 in.
Private collection.

This is one of Redfield's large, highly textured snow scenes, painted outdoors in harsh winter conditions and completed in one day.

Plate 9

Daniel Garber (1880–1958).
The Studio Wall, 1914.
Oil on canvas. 56.25 x 52 in.
Private collection.

Inspired by design principles of Japanese art, this work portrays Garber's wife, Mary Franklin Garber.

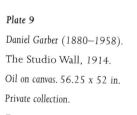

Plate 10

John Fulton Folinsbee (1892–1972).
River Ice, 1935. Oil on canvas.
32.25 x 40 in. Courtesy of the John
Folinsbee Art Trust.

A view of the Delaware River in winter,
painted in the dark blues and browns that
typified Folinsbee's mature, expressionist
style.

Plate 11

Fern Isabel Coppedge (1883–1951).
The Road to Lumberville, 1938.
Oil on canvas. 18.25 x 20.25 in.
Courtesy of the James A. Michener Art
Museum. Gift of Dr. William and
Mrs. Ruth Purcell Conn.

Like Redfield, Coppedge painted Bucks
County in the winter, becoming a
familiar sight around New Hope, dressed
in her bearskin coat.

Plate 12

C. F. Ramsey (1875–1951).
The New Hope-Lambertville Bridge,
1919. Oil on cardboard laid on Masonite.
12.5 x 9 in. Courtesy of Roy Pedersen
Gallery.

Influenced by European modernist movements
like Cubism, Ramsey saw this familiar motif
as simple geometric forms rendered in pastel
colors.

Plate 13

Charles Sheeler (1883–1965). The
Artist Looks at Nature, 1943. Oil
on canvas. 21 x 18 in. (53.3 x 45.7
cm). Gift of the Society for
Contemporary American Art, 1944.32.
Photograph © 1996, the Art Institute of
Chicago, All Rights Reserved.

This enigmatic work juxtaposes what
the painter sees before him in nature with
his rendering of an image from memory.

The Visual Artists

One June day in 1783, widower Isaac Hicks carried his youngest son, three-year-old Edward, from Newtown, a village in Pennsylvania's Bucks County, to the nearby farm of David and Elizabeth Twining. Hicks, a Loyalist to the British Crown and thus ostracized by his former friends, found it necessary to place all three of his children in what we would call foster care. Farmer David Twining, a Quaker pacifist, bore Hicks no grudge. He seemed a suitable role model for young Edward, who would become—and remain to this day—Bucks County's most famous painter.

Though the virtuous Twinings provided an exemplary upbringing, Edward wasted most of his youth carousing. Changing from a shy toddler into a hail-fellow-well-met in the course of a few years, he pursued, in his own words, the "broad way that leads to destruction ... tippling, lewd talk, and unruly passions." Meanwhile, apprenticed to coachmakers, he learned the craft of sign painting that he would apply later to his own works.

Following an illness, he converted to Quakerism with such fervor that he became an itinerant preacher, reportedly attracting large crowds with the power of his sermons. In 1811, he settled in Newtown despite its reputation as a "tavern town" and helped found the Newtown Meeting. Unhappily, his commitment to the ministry took precedence over time for the family he had started in the meantime. To support his wife and children, he painted signs between his preaching journeys. He also tried farming—an occupation he valued above all others—but ended up bankrupt. Had he succeeded, he would gladly have "sacrifice[d] all my fondness for painting," for he considered farming "more consistent with the Christian [life.]"

These, then, were the forces that would shape the works of Edward Hicks (Plate 3): his talent, his religious zeal, his sign-painter skills, his reverence for farming, and, to unify it all, the guilt bestowed on him by Quakerism for pursuing, as he put it in his Memoirs, "one of those trifling, insignificant arts, which has never been of any substantial value to mankind...."

Quakerism, with its emphasis on individual religious expression, pacifism, and a simple life, was the legacy to Bucks County—and thereby to Hicks—of William Penn, himself a convert to that creed. In 1684, after founding Philadelphia, Penn established Newtown (then called New Town) and built his own country seat,

Pennsbury Manor, on the banks of the Delaware River. He owned all surrounding land, a grant from King Charles II in payment of a debt owed his father. The vast tract, which Penn called Pennsylvania (meaning Penn's woods), possessed more beauty, in his eyes, than any landscape in England, including his native Buckinghamshire, from which Bucks County took its name. He saw in its beauty a "divine presence" that he did not find in Philadelphia. "The country life," he said, "is to be preferred, for there we see the works of God, but in cities little else but the works of men; and the one makes a better subject for our contemplation than the other."

The county's early settlers, predominantly Quakers, did not value the fine arts. For religious as well as practical reasons, they disdained ornamentation, regarding it as aristocratic—a tradition from which they sought escape. In any event, life in colonial America allowed little time for reflection, never mind aesthetics. Surviving proved challenge enough.

Not until the cities grew did an interest in the arts develop. The desire for more than simple box dwellings gave rise to architecture. The wish to be immortalized allowed portrait painters to proliferate. Later, sculptors and history painters glorified the American Revolution. But all this happened largely in the cities. In rural Bucks County, the natural beauty inspired artists then, and has since—the tranquil river banks, the woods of sycamore and elm, the fields of wildflowers, the cliffs of distinctive local stone. The simple life possible in an area of such tranquillity appealed to Quakers—like Edward Hicks.

For much of his life, to be sure, he devoted himself mostly to the painting of signs, a calling that appealed to him because of its utilitarianism. Besides, he had to make a living. In an advertisement he placed in the *Newtown Journal and Workingman's Advocate* as late as 1843, when he was already fifty-three, he offered to "letter and ornament [the signs] with hands, etc. on both sides, completely, for thirty-five cents per board." He painted the sign for the Newtown Library Company, the oldest private library in the country, located a few blocks away from the stone house he built in 1821 on Penn Street. The Newtown Library Company still owns this sign, on which Hicks reproduced a portrait of Benjamin Franklin, an appropriate image for the building's function. The bridge across the Delaware River at Washington Crossing also boasted two signs, one for each side. Here, he chose a motif appropriate to local history, basing his image of Washington at the Delaware on a painting by

the well-known portraitist and history painter Thomas Sully. Hicks would have known these popular images through prints; as an integral part of his trade of sign painting, he would have built up a stock of them that he could use for jobs like these.

Not until 1846 did he concentrate on the landscapes that some consider his finest paintings. That year, he executed four versions of *The Residence of David Twining* (Plate 4) in his naive style. They depict the farm, complete with house, barn, farm animals, and a nostalgic image of the artist himself as a boy, read to by Elizabeth Twining.

The link between Hicks's Quakerism and his landscapes occurs most clearly in another panorama, of which he did six versions, *The Grave of William Penn*. Hicks venerated Penn. Never having visited England and not having seen Penn's grave in Buckinghamshire, he used an "ingraving" after the Dutch painter Hendrik Frans de Cort's scene for his source. His versions of *The Grave of William Penn* vary in form and detail, proving his ability to go beyond mere copying to composing.

Hicks's landscapes seem his most assured work. He considered *The Cornell Farm* (with prize cattle and horses in the foreground; house, barns, and neatly planted fields in the distance) his finest painting. He completed this largest and most ambitious of his farmscapes in 1849, the last year of his life. He died that August, after putting the final touches on a *Peaceable Kingdom* and confiding to his daughter he knew it to be his last work.

Throughout his life, Hicks painted some sixty versions of *The Peaceable Kingdom* (Plate 5)—the paintings by which he would be remembered. Even those who have never visited Bucks County recognize his many versions of *The Peaceable Kingdom*, variations on the themes of peace and brotherly love, based on Isaiah 11:6: "The wolf also shall dwell with the lamb and the leopard shall lie down with the kid, the cow and the bear shall feed, the young shall lie down together and the lion shall eat straw like the ox." As a Quaker, Hicks practiced painting as a craft, done in the service of religious beliefs. Often using the Delaware as the setting for his *Peaceable Kingdoms*, he discovered in Bucks County a metaphor for the Quaker view of paradise.

Like many other artists of his day—particularly those not close to cities—Hicks learned through self-instruction and apprenticeship rather than by academy training. Had he started out twenty years later and had the means and inclination, he could have obtained such

training in nearby Philadelphia, where a fledgling academy developed in the early nineteenth century. With time, Americans able to afford the expense studied abroad, most often in London. Boston's John Singleton Copley trained there as did Gilbert Stuart, who spent thirty-seven years in England before setting up his portrait studios in New York and Philadelphia. Benjamin West, born near Swarthmore, went to Europe to study in 1759. A history painter who revolutionized the genre by using contemporary dress, he never returned to America. Instead, he helped found the Royal Academy and taught many young Americans who studied in London.

Charles Willson Peale, one of West's students, benefited from West's instruction and example. Peale established his own private museum in 1786, offering not only paintings but bones, stuffed animals, and other curiosities. Eight years later, he founded the Columbianum, his first attempt at an art academy. Because its thirty artist-members could not get along, it folded within a year. In 1805, Peale tried again, this time founding the Pennsylvania Academy of the Fine Arts, which included more pragmatic businessmen, lawyers, and physicians, as well as artists, in its membership.

The Pennsylvania Academy grew in influence through the nineteenth century, despite competition from institutions in other cities and a devastating fire (1845), and became one of the most well-respected art schools in the country. It linked Philadelphia and Bucks County, as many artists living and working in the county also studied and/or taught in the city.

Although Edward Hicks did not receive academy training, his younger cousin, Thomas Hicks, did. Born in Newtown in 1823, Thomas Hicks apprenticed with Edward, showing an early aptitude for doing "likenesses." By the age of fifteen, he had already completed over thirty portraits, each of which brought six dollars of income to the shop. He painted Edward Hicks (1838), the only record of what *The Peaceable Kingdom* painter looked like. He also painted Martin Johnson Heade (1841), who would later gain fame internationally as a landscape painter. Both Heade and Thomas Hicks apprenticed with Edward Hicks, though in fact the precocious Thomas Hicks served as instructor to Heade.

Unlike Edward, Thomas Hicks set his sights on the wider world, studying first at the Pennsylvania Academy of the Fine Arts and later at the National Academy of Design in New York. In 1845, he traveled to London and Paris before settling in Rome, where he became close to the American expatriate community. On trips to Florence, Bologna, and

Thomas Hicks (1823–1890).
Portrait of Martin Johnson Heade
as a Young Man, *early 1840s.*
Oil on canvas. *Courtesy of the Mercer
Museum of the Bucks County Historical
Society.*

This portrait was painted before the two
artist friends traveled together in Italy.

Ferrara, he painted numerous picturesque genre scenes, few of which
survive today. In Rome, he painted a portrait of the feminist writer
Margaret Fuller, and shared a studio for a time with the American land-
scape painter John F. Kensett.

An extended tour of Venice in 1847 may have influenced his decision
to study with Thomas Couture in Paris on his way home the following
year. Many Americans studied with Couture, who emphasized the tradi-
tion of the Venetian Renaissance, with its emphasis on the direct qualities
of the sketch, and the recording of initial impressions. Study with
Couture influenced Hicks's mature portrait style, which combined
elements of Romanticism with a classical approach.

After his return from Europe, Thomas Hicks achieved success in New York, where the National Academy of Design elected him an academician in 1851. He painted portraits of such well-known nineteenth-century figures as Henry Wadsworth Longfellow, Harriet Beecher Stowe, and William Cullen Bryant. His most famous subject, Abraham Lincoln, sat for him in Springfield, Illinois, just after receiving the Republican nomination. Hicks's written reminiscences describe Lincoln's good humor and even temper through many sittings, the future president not ruffled even when his young son, Tad, and a friend got into Hicks's paints, smearing the brightest blue, yellow, and red pigments over the wall of Lincoln's office. The Lincoln portrait, commissioned by a publishing house, had wide dissemination during the presidential campaign.

Thomas Hicks's friend, Martin Johnson Heade, who had apprenticed with him under Edward Hicks, became a key figure in the Luminist movement. Heade (born Heed) had grown up in Lumberville, on the Delaware north of New Hope. Walking along the river as a boy, he had daydreamed of the world that lay beyond Bucks County; as an adult, he obeyed the wanderlust that took many American painters of his generation to distant lands. While traveling in Italy with Thomas Hicks, he produced the only genre scenes of his career, *The Goat-Herd* (lost) and *Roman Newsboys*. In Brazil, the Emperor Don Pedro II commissioned him to produce an ambitious series of engravings illustrating that country's hummingbirds. Although the project never came off as planned, it inspired some of Heade's most interesting work: paintings that juxtaposed the tiny birds with sensuous orchids against a romantic background of tropical landscape (Plate 6). Between trips, he worked in his New York studio, often on commissioned portraits, while writing poetry on the side.

Heade married late in life and settled in Florida, where he produced a series of floral paintings. He always maintained strong ties to Bucks County; members of the Heade family still live in the area. His work lapsed into oblivion after his death in 1904, but revived following the 1944 exhibition of American Romantic paintings in New York, which featured his *Storm over Narragansett*.

Like Thomas Hicks and Heade, Samuel DuBois, a portrait painter and photographer, studied at the Pennsylvania Academy, in his case with Thomas Sully. His portrait style differed from Sully's, with its nearly cloying peaches-and-cream-complexioned figures. Influenced by the

Samuel DuBois (1808–1889).
Self-Portrait. Daguerreotype.
Courtesy of the Spruance Library,
Bucks County Historical Society.

Both a portrait painter and photographer,
DuBois had set up a daguerreotype
photography studio in Doylestown
by 1847.

limners, DuBois depicted his subjects more severely. As his reputation
spread beyond his native Doylestown, he painted a well-known series of
portraits for the U.S. Mint in Philadelphia. For a number of years, DuBois
spent part of his time in Wilkes-Barre, apparently drawn there by a
romantic interest. When that affair ended, he returned to Doylestown,
where he lived until his death in 1889.

Jonathan Trego, who studied with DuBois in the 1840s, would start a family of painters, all associated with Bucks County. After apprenticing with DuBois, Trego studied at the Pennsylvania Academy. His portraits reveal the influence of Sully's style. Prosperous Quaker farmers sought his services to paint their prize animals; successful businessmen and professionals hired him to record their likenesses. A versatile artist, he also painted (imagined) scenes of the American West and sentimental genre works known as "fancy pictures."

Trego's son, William B. T. Trego, a Pennsylvania Academy graduate as well, specialized in Civil War battle scenes (Plate 5). Born in Yardleyville in 1859, he suffered a mishap at the age of eighteen months that left him permanently paralyzed, a disability he compensated for by investing the subjects of his paintings with physical vigor. Hating public school, the young Trego reportedly burnt off his hair to convince his parents to allow him to drop out and so to concentrate on painting. When the Tregos temporarily moved to Detroit, he exhibited *The Charge of Custer at Winchester* at the Michigan State Fair of 1879.

Departing from his father's utilitarianism, William B. T. Trego saw himself as an *artiste* and art as a noble calling. In the 1880s, he studied with Thomas Eakins at the Academy, winning the First Charles Toppan Prize. From 1887 to 1890, he studied in Paris, where he saw works by military painters like Meissonier and Detaille. After returning from Europe he set up a studio in North Wales, painting over two hundred Civil War scenes. His studies of galloping horses, viewed head-on as in *Charge at Gaines Mill* (1893), won critical acclaim. However, with the rise of Impressionism, his popularity declined. In 1883, hoping to win the newly established $3,000 Temple Prize, he put everything he had into his entry, *The March to Valley Forge, December 16, 1777*. When the Academy declined to award first and second prizes to any of the four entrants and gave Trego third place, he sued—unsuccessfully.

This rejection, the general decline of his genre, and the failure of his own health led Trego to despair. He tried to publish some of his works as magazine illustrations, but without success. Among his occasional students, he favored Bucks County landscape painter Walter Baum, whose wife and baby daughter posed for him. Trego shot himself in his studio on June 24, 1909, bequeathing to Baum his large easel, sketches, unfinished paintings, and his collection of swords, guns, and uniforms.

While Trego drew mainly Civil War scenes, another Bucks County artist, Thomas P. Otter, dealt with the post-Civil War westward expansion in his most famous painting, *On the Road*. This work depicted the movement west by both covered wagon train and steam-powered locomotive, their paths about to cross at an arched bridge, built over the trail to accommodate railroad tracks. Exhibited at the Pennsylvania Academy in 1860, *On the Road* became a symbol of the popular doctrine of Manifest Destiny and of a golden age of technological progress. Its reproduction in books by Mark Twain, cookbooks, and calendars made it a familiar image, though few would later recognize Otter's name. In 1864, Otter gained a degree of national reputation when Abraham Lincoln included one of his works in a collection of paintings by some of the country's "most noted artists" given to the actress Charlotte Cushman in "recognition of her outstanding services to the Civil War Cause."

Born in 1832 and raised in Montgomery County, Otter moved with his family in 1845 to Philadelphia, where he apprenticed with engraver David Scattergood and painters James Hamilton and Paul Weber, both well-known in their time, although obscure today. A graduate of the Pennsylvania Academy, Otter set up a studio on Chestnut Street, where he painted and taught. He became active in the Art Club and the Artists'

Thomas P. Otter (1832–1890).
On the Road, 1860. Oil on canvas.
22 x 45.375 in. (55.8 x 115.3 cm).
Courtesy of the Nelson-Atkins Museum
of Art, Kansas City, Missouri (Purchase:
Nelson Trust).

Otter's painting gained popularity as an
archetypal image of American progress
and movement westward.

Fund Society. He married in about 1860 and in a short time had four children. After the Civil War, with opportunities for artists diminished, he moved to Bucks County, living first in New Britain and then in Doylestown. By 1871, he taught art at the Linden Female Seminary in Doylestown. On the side, he illustrated local scenes and did landscapes, his real love.

Otter became an active member of the local community. "Ever ready to aid any worthy local enterprise with the brush and pencil," as well as with his time, he organized annual art shows for the Doylestown Agricultural Fair. With Henry Mercer and several others, he founded the Bucks County Historical Society. He designed and painted the curtain—"a romantic, Venetian landscape"—for the stage of the new Lenape Building in Doylestown, designed by Philadelphia architect Addison Hutton. Otter contributed most significantly to the community by recording now-lost architectural landmarks such as the Doylestown Courthouse, demolished in 1960, and the Ship Tavern in Doylestown, demolished in the 1870s to make way for the Lenape Building. The first edition of General William Davis's *History of Bucks County* included three lithographs after drawings by Otter. Davis's second edition of 1905 included more illustrations after works by Otter (as well as several by his daughter Marion). According to his patron Davis, Otter did not possess ambition and energy to equal his talent, and thus gained neither reputation nor financial reward. He died in 1890, never having owned property and with no more than local renown. As one reviewer put it, when Otter moved to Bucks County, "he moved out of art history."

Shortly after Otter's death, a group of artists working a small distance to the east of Doylestown along the banks of the Delaware, took up his interest in painting the scenery of Bucks County. This group became the Pennsylvania Impressionist School.

In 1894, Dr. George Morley Marshall, a Philadelphia surgeon, purchased the property of Phillips Mill (the mill, the race, the miller's house, and an adjoining farm) just north of New Hope. The physician described the site as "suggesting something classical, if not Greek." The mill, built in 1756 by Aaron Phillips and operated for three generations by his descendants, intrigued Marshall with its "slow-moving overshot water wheel that set in motion the great wooden wheels, the cogs of which were hickory pegs." Marshall convinced his long-time friend, painter William Lathrop, to rent the miller's house across the road in

1898. Taken with the beauty of the area, Lathrop and his English wife, Annie, bought the house the next year. They had taken the first step in establishing a social and spiritual base for the New Hope art colony.

The Lathrops' home became the hub of the colony, remaining so until 1929 with the founding of the Phillips Mill Association. Mrs. Lathrop played a maternal role, housing and feeding students and serving tea and homemade bread in the afternoons. Her Sunday teas became a social event at which area artists exchanged ideas. On his barge, "Sunshine," Lathrop transported students on sketching expeditions up-river. An avid seaman, he died in the 1938 hurricane, sailing his boat, "The Widge," off the coast of Long Island.

Lathrop painted in a Tonalist style, more poetic and evocative than descriptive, emphasizing atmosphere and unity through the use of single tones, simple compositions, and low horizon lines. Following a year of study with William Merritt Chase at the Art Students League in New York, he traveled in 1888 to England, where he came in contact with Tonalists who, along with American Birge Harrison, influenced his approach. He believed "the final picture must always be painted from memory, and I seriously question if any really great landscape was ever painted wholly in the open." This technique represented a significant departure from the typical Impressionist practice of working *en plein air*—in the open air. Teacher to both the first and second generations of Pennsylvania Impressionists, he convinced many to settle around New Hope. The artists began to move in.

Henry Bayley Snell, a member of the New Hope School's first generation, visited the Lathrops in 1898. Snell and his wife, Florence, also a painter, continued to spend summers with the Lathrops, returning regularly to their native England, where they painted in the artists' colony at St. Ives on the coast of Cornwall. At times they took along groups of students from the Philadelphia School of Design for Women, where Snell, affectionately called "Uncle Harry," taught portraiture from 1899 until his death in 1943. He forbade his students to use black and required each student to keep a sign with the word "luminosity" hanging above her easel.

The Snells eventually moved to New Hope, living on the top floor of the Solebury Bank Building. From there, Snell completed *The Barber Shop*, which became part of the large collection of regional art of Dr. Kenneth Leiby, a local physician who cared for many of the New Hope artists and often took their works in lieu of payment for his services.

In 1898, Edward Redfield, who would become one of America's most decorated painters, moved into a small, run-down farmhouse on the Delaware Canal. He chose Bucks County not for its natural beauty but because, as he said, "this was a place where an independent, self-sufficient man could make a living from the land, bring up a family and still have the freedom to paint as he saw fit." A self-reliant Quaker, he grew his own crops, collected his water supply in a storage tank on the roof of his house, constructed his own furniture from driftwood, and built a boat and pontoon bridge from cast-away kegs and casks. According to legend, he acquired winter fuel by taunting bargemen on the canal, who pelted him with pieces of coal he then gathered. Redfield transformed the county's beauty into large-scale, boldly conceived paintings (Plate 8).

Somewhat a loner, Redfield never considered himself a member of the art colony. Born in Delaware in 1869, he had moved to Philadelphia with his family as a child. His father, a produce merchant and nurseryman, encouraged Redfield's early interest in drawing, though he hoped his son would take over his business eventually. Redfield achieved his first artistic success at the age of seven, when the 1876 Centennial Exposition in Philadelphia exhibited his drawing of a cow, entered in a competition for children. To prepare for the entrance examination to the Pennsylvania Academy, Redfield subsequently studied with a commercial artist named Henry Rolfe, who required him to complete his drawings in one sitting, forbidding any reworking. This discipline influenced Redfield's later approach to landscape painting.

Redfield studied at the Pennsylvania Academy from 1885 to 1889 under Thomas Anshutz, a former pupil of Thomas Eakins. He became a friend of fellow students Charles Grafly and Alexander Milne Calder, sculptors, and realist Robert Henri, who often spent weekends at Redfield's home. Redfield's training at the Academy, influenced by Eakins's methods, included study of plaster casts and live nude models, classes in anatomy, and dissection of animal and human cadavers. While at the Academy, Redfield had his first acceptance there (for a landscape, *Wissahickon*) in the annual exhibition of 1888.

In 1889, supported by a fifty-dollars-a-month allowance from his father, Redfield left for Europe. Following a brief stay in London, he settled in Paris, joined there by his friend Henri. He spent his first winter in the village of Brolles on the edge of the Forest of Fontainebleau. There, he met Elise Devin Deligant, an innkeeper's daughter, whom he married in London two years later. In 1890, Redfield and Henri painted together

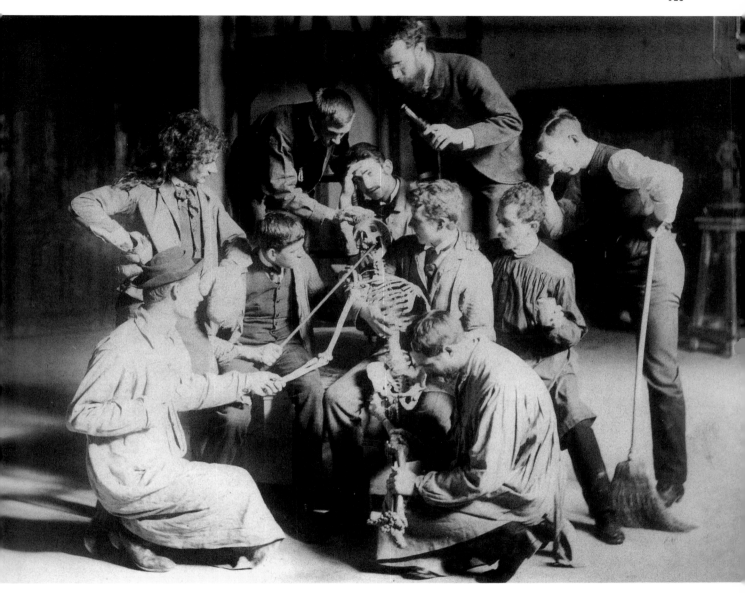

in Saint-Nazaire and Fontainebleau, residing at the Hôtel Deligant, where several other artist-friends joined them. At this time, Redfield turned from portraiture to landscapes, particularly to snow scenes, the hallmark of his mature work.

In Paris, he studied at the Académie Julian and the École des Beaux-Arts. A private art school founded in 1868 to prepare students for entrance to the École, the Académie Julian attracted a large number of American students in the 1870s, '80s, and '90s. Founder Rodolphe

Edward Redfield (with pointer) and fellow students at the Pennsylvania Academy of the Fine Arts. Courtesy of the Charles Grafly Collection, Edwin A. Ulrich Museum of Art, Wichita State University.

Julian, a former wrestler and circus manager, enforced academic standards; established professional artists such as Adolphe-William Bouguereau and Tony Robert-Fleury critiqued Redfield's work. Instruction at Julian's emphasized correct draftsmanship over color. Students drew from casts and, when proficient, moved on to life drawing, working from models eight hours a day. Students learned as much from each other as from the *maîtres*; the American students in particular developed a strong sense of camaraderie.

The Paris Salon accepted one of Redfield's snow scenes in 1891, and later that year he returned to the United States. Redfield and his wife—whom he always called "Madame"—lived first in Glenside, near Philadelphia, where a daughter was born in 1894. While residing in Glenside, Redfield regularly attended gatherings at Henri's Philadelphia studio at 806 Walnut Street with painters who later formed The Eight, a group of urban realists working in Philadelphia and then New York. This association proved instrumental to Redfield, whose approach to landscape paralleled theirs to city scenes. Redfield and Henri spent time together in Maine in 1903 and in New York City in 1909, the year following the initial exhibition of The Eight. (During this 1909 stay in New York, Redfield painted *Between Daylight and Darkness,* a quiet tonal work differing in subject and style from his more typical rural scenes.)

In 1898, the Redfield family, including the artist's father, came to Center Bridge in Bucks County, living first in a small house on an island in the river and then in a farmhouse on the towpath on the Delaware Canal. While his daughter's tragic death in 1898 marred Redfield's personal life, he nonetheless had professional success. The Pennsylvania Academy gave him a one-man show in 1899; he received a Bronze Medal at the Paris Exposition in 1900 and a Bronze Medal at the Pan-American Exposition in Buffalo, New York, in 1901. The Pennsylvania Academy awarded him the Temple Gold Medal in 1903, and the National Academy of Design in New York voted him the Hallgarten Prize in 1904. The awards he won throughout his career made Redfield America's second most decorated artist after John Singer Sargent.

Called the "most American Impressionist," Redfield used a direct approach, emphasizing the physical act of painting. "A picture painted direct from nature must necessarily be hasty, ill-considered, somewhat raw, and lacking in the synthetic and personal quality which is the distinguishing mark of all great art"—so said Lathrop. But Redfield completed his canvases "at one go," out in the open, even in the middle of winter,

Undated snapshot of Edward Redfield outdoors at his easel. Redfield worked directly from nature, completing his paintings "at one go." Courtesy of Patricia R. Ross and Dorothy H. Redfield.

sometimes lashing them to trees in the midst of high winds. He almost never did preliminary sketches but worked directly from the motif, causing Lathrop to ask when he might stop sketching and start painting.

Only once, it seems, did Redfield violate his practice of finishing paintings at one sitting. In July 1923, lightning struck and burned the 112-year-old covered bridge near his home. His daughter-in-law recalled that Redfield, returning with family members from a visit in Huntingdon Valley, saw smoke and flames on the horizon and feared for his own house, where he had left three younger children. Once assured of their safety, he joined the crowd of spectators by the bridge, among them Lathrop, who felt it "a pity it couldn't be painted." Responding to this challenge, Redfield made notes on an envelope and worked all the next day on a painting of the conflagration. The following day he completed a second version, based on notes and memory—a dramatic night scene of the glowing remains of the bridge, with silhouetted firemen and spectators in the foreground, reminiscent of the English painter J. M. W. Turner's similarly executed paintings of London's Houses of Parliament burning in 1834. Redfield's desire to thrust himself headlong into the harsh elements of nature placed him in Turner's tradition of the artist as a superhuman hero. (Turner supposedly lashed himself to the mast of a ship in the midst of a gale to experience nature's fury firsthand.)

In Redfield's bold treatment of material on large canvases and his emphasis on the action of applying paint, he presaged the action painter

Jackson Pollock, whose large abstract canvases share similar qualities of roughness and energy. Both Redfield and Pollock stand for American individualism—independent in their way of life, with a bit of the machismo in their personalities. Redfield, however, had no sympathy for Abstract Expressionism, which he described as "trash," and would have taken offense at a comparison with Pollock. A rugged individualist like Pollock, Redfield remained something of a loner, at least with respect to the New Hope group, declining to exhibit with them at Phillips Mill and refusing to teach. Despite his desire to distance himself from the New Hope group, the public saw Redfield as its leader and central figure.

Not the easiest person to get along with, Redfield developed some lifelong animosities as well as friendships. Walter Elmer Schofield, who studied at the Pennsylvania Academy and the Académie Julian in Paris, painted in Bucks County with a landscape style similar to Redfield's. He never hit it off with Redfield; an early incident between them precipitated lifelong enmity. In 1904, Redfield confided to Schofield his intention to paint the view from his front yard in Center Bridge for submission to the Carnegie Institute Annual that year. Schofield, on his return to St. Ives, England, where he lived part of the year, painted the same scene from memory; he submitted it to the Carnegie and won a First Class Medal. Considering Schofield to have stolen his idea (which Schofield executed from memory to boot), Redfield told him to "stay out of my front yard after this.... and paint your own subjects." Schofield never again painted Bucks County scenes, though he still depicted winter views of Philadelphia and surrounding areas.

Redfield maintained a lifelong friendship with George Sotter, beginning in 1902 when Sotter enrolled in Redfield's sketching class (the only time Redfield taught formally). Redfield later commented to Sotter, "You saved my life.... All those women"—a reference to Sotter as the only male member of the class. Redfield influenced Sotter, who specialized in nocturnal snow scenes until he abandoned painting for the more lucrative craft of stained glass.

In his later years, as Redfield's stamina declined, he found his "at one go" technique increasingly difficult. He spent more time on portraiture and also took up crafts such as painted chests, tole trays, and hooked rugs. In 1947, despondent over his wife's death, he piled hundreds of paintings he considered below his standard in an abandoned barn and, in a final, deliberate, self-critical act, set it ablaze. Recognizing his own decline, he stopped painting in 1953 at the age of eighty-four. As he explained, he

did not want to "be putting my name on 'old man's stuff' just to keep going." He continued to produce crafts until his death in 1965.

Redfield's landscapes, often square or nearly square, four to five feet wide, remain his legacy. He painted snow in the winter, blossoming trees in the spring, and Maine coastal scenes in the summer. Occasionally, as circumstances warranted, he painted more somber cityscapes—most notably New York City in 1909 (*Between Daylight and Darkness*, *The Brooklyn Bridge at Night*) and Pittsburgh in 1919 (*Soho, Pittsburgh* and *Panther Hollow, Pittsburgh*). His renderings of snowy landscapes stand as his prime achievement. His depictions of Phillips Mill in winter, his intimate scenes of brooks lacing through snowbanks, and his panoramic views of fields of snow helped create an American brand of Impressionism.

Along with Redfield, Daniel Garber had an important place in American Impressionism. Born to a Mennonite farm family with roots going back to Pennsylvania-Dutch immigrants, Garber had little exposure to art as a child. His father, however, did not discourage his ambition to become an artist. His "Dunkard" upbringing instilled fastidious habits, familiarity with hard work, and a sense of pragmatism—all of which served him well in later years.

When Garber left his family's farm in North Manchester, Indiana, in 1897, to study at the Art Academy of Cincinnati, his brother commented, "There's Dan down in Cincinnati doin' them obscene drawings." While a student at the Art Academy, Garber won a Home Scholarship, the first of many awards and prizes. He came under the influence of the American Impressionist Julian Alden Weir, admiring not only Weir's style but also his role as a leader of the Ten American Painters who had just broken away from the Society of American Artists in New York to protest the Society's rigid jurying process. For a time, Garber added the name "Julian" and the initial "J" to his own name. Weir's and fellow Impressionist John Twachtman's decorative style, influenced by Japanese prints, in turn influenced Garber's painting. Tightly woven works like Garber's *White Porch* (1909) and *The Studio Wall* (1914; Plate 9) reveal this influence in the use of simple shapes and shallow spaces.

In 1899, Garber "went East," following the footsteps of Weir and Twachtman. He studied with Thomas Anshutz and Hugh Breckenridge at the Darby School near Fort Washington, Pennsylvania, where, as the star pupil, he met his future wife, fellow student Mary (May) Franklin. He enrolled at the Pennsylvania Academy, became a favorite of Anshutz, and

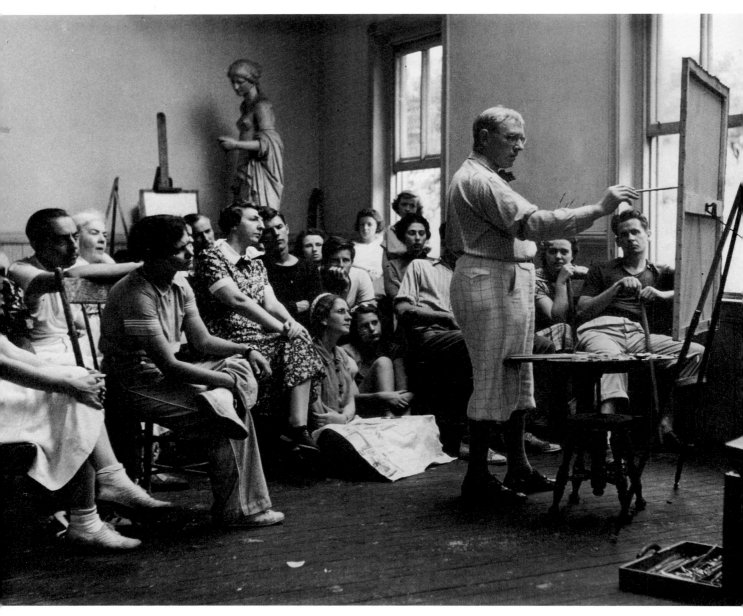

at his graduation in 1905, won a two-year William Emlen Cresson Traveling Fellowship that took him to London, Rome, and Paris. Unlike most other Americans, he did not study at an atelier but worked independently. In Paris, May and Garber had their first child, daughter Tanis. Garber turned down a year's extension of the fellowship, after absorbing the lessons of the European masters, "impatient to get back and paint in

this country" and, with growing family responsibilities, ready to establish himself professionally as a teacher and artist. Along with the critics, he saw his work as truly American in spirit and inspiration. Emily Sartain, director of the Philadelphia School of Design for Women, offered him a teaching position; May's father purchased for the couple a house and outbuildings on the Cuttalossa Creek near Lumberville. Over the coming years, Garber developed Cuttalossa into his spiritual home, an American equivalent of Monet's Giverny, complete with sheep, goats, and other animals.

Garber then began a successful career, winning every major prize possible for an American painter, and some twice. He taught for forty-one years at the Pennsylvania Academy. In 1909, the National Academy of Design awarded him the Hallgarten Prize for *Horses*; the Salmagundi Club and the National Arts Club made him a member. In 1910, he garnered prizes at the International Exposition in Buenos Aires, the Art Club of Philadelphia, the Carnegie Institute, and the Corcoran Gallery. Elected an Associate of the National Academy of Design, he moved up to the position of full Academician three years later.

Awards at national exhibitions brought invitations to exhibit at major galleries like the Macbeth Galleries in New York and the Vose Galleries in Boston. In 1915, he became one of the youngest jury members at the Carnegie Institute and, subsequently, served on juries throughout the nation. He developed a close personal friendship with C. Powell Minnegerode, director of the Corcoran Gallery in Washington, D.C. He won a Gold Medal at the Panama-Pacific International Exposition in San Francisco (1915), the Edward T. Stotesbury Prize at the Pennsylvania Academy Annual (1918), and the Jennie Sesnan Medal at the Pennsylvania Academy (1937). The general public, as well, favored his work, so much so that he received the Popular Prize at the Carnegie in 1933 and the same award at the Pennsylvania Academy in 1934, 1940, and 1941. As Kathleen Foster noted, Garber's rural landscapes displayed "exactly the right mix of technical competence, stylistic progressiveness, and sheer beauty." Some of his most notable landscapes depicted the quarries along the Delaware River, with hints of the negative effects of man's intrusion on nature. In addition to landscapes, he also painted portraits and interiors with figures, primarily of family members.

After the birth of his son, John, in 1910, Garber divided his time between Bucks County and Philadelphia. The family bought a townhouse on Green Street in Philadelphia, and for alternating six-month intervals,

Daniel Garber teaching at Chester Springs, the summer school of the Pennsylvania Academy of the Fine Arts, c. 1935. Courtesy of the American Museum of the Pennsylvania Academy of the Fine Arts, Philadelphia. Archives.

lived in the city, then at Cuttalossa. A few nights each week Garber himself spent in a small cottage on the canal in Lumberville, purchased sometime between 1912 and 1915. The house on Green Street served as the subject of several interiors, such as his prize-winning *South Room, Green Street* (1921), which depicted May, seated in their living room, and their daughter Tanis, standing in front of a window reading a letter.

Bucks County became Garber's true home, with Cuttalossa a symbol of his artistic identity. In the Cuttalossa glen, he created a studio filled with light that streamed through tall French doors. He pictured the studio in *Mother and Son* (1933), depicting May and their son, John, separated by a chess board on a table in front of open French doors. Almost as passionate about the game of chess as about painting, Garber revealed a quixotic nature by throwing chess pieces and board across the room when things did not go his way. Although at most times even-tempered, he could turn irascible and gruff with students and colleagues at the Pennsylvania Academy. Cuttalossa provided him with a haven, where he planted flowers and tended sheep. Helped by the architect Robert Rodes McGoodwin, he renovated his main house, adding a large library and spacious entertainment space, doing most of the physical labor himself. As Garber put it, at Cuttalossa he lived "the life of a very happy man."

In his Cuttalossa studio, Garber painted his only known mural, *A Wooded Watershed*, commissioned for the Ralph Bencker–designed Pennsylvania Building at the 1926 Philadelphia Sesquicentennial. This mural, twenty-two feet wide, took the form of a semicircular lunette, corresponding to the murals there by George Harding and Joseph T. Pearson, fellow teachers at the Pennsylvania Academy. Garber completed the woodland scene in a mere six weeks and rolled up the huge canvas for transportation to Philadelphia. After its six-month showing at the Sesquicentennial, the mural went to the Pennsylvania State Forestry School at Mont Alto, Pennsylvania, where it remained until its installation in the James A. Michener Art Museum in 1995.

In the 1930s and '40s, he continued to win awards and had two retrospective exhibitions, one at the Woodmere Gallery (1942) and another, of major significance, at the Pennsylvania Academy (1945). During this period, which coincided with the growing acceptance of modernism at the Academy, his health deteriorated. Garber found himself at odds with those at the Academy who favored experimental approaches in teaching and abstract styles in students' work. The more traditionalist faction, which he headed, lost ground as time went on. In 1950, he

retired from teaching, though he continued to paint. In 1958, after falling from a ladder at Cuttalossa, he died. He had created a body of landscapes of idyllic beauty, representations of Bucks County during a golden age—an Arcadia, envied by those without the good fortune to live there, as his friend, the Boston art dealer Robert Vose, put it.

Daniel Garber at his easel, framed by the unique French doors of the studio at Cuttalossa in Lumberville. Courtesy of the Garber family.

Not all artists saw Bucks County as a natural paradise. Robert Spencer differed from Garber in his use of somber tones and neutral palette. Born in Nebraska, the son of an itinerant Swedenborgian clergyman, Spencer studied at the National Academy of Design in New York and, then, at the New York School of Art from 1903

to 1905 (influenced by William Merritt Chase and Robert Henri). In 1909, he came to the New Hope area to study with Garber, adopting the latter's approach of building a paint surface with a tapestrylike pattern of brushstrokes, but applying that technique to more industrial subjects. At first sharing living quarters with fellow artist Charles Frederic Ramsey, Spencer visited the Lathrops, where he met Margaret Alexina Harrison Fulton, a niece of painters Thomas Alexander Harrison and Birge Harrison and one of the first female architects in this country. He married her soon after, and the couple took up permanent residence at Rabbit Run, near the bridge at the upper end of New Hope.

Spencer combined landscape elements with depictions of run-down mills of Bucks County and the sketchily painted workers who staffed them, as in *The Silk Mill* (1913), which depicted the William Maris Silk Mill, built in 1813. Critics have found in his works mild social commentary and reflections on the artist's own troubled life. Spencer had several mental breakdowns. In 1931 he committed suicide at Rabbit Run.

While the New Hope group by and large had little sympathy for modern abstract art, one painter, Charles Rosen, became a modernist—but only after he left New Hope. Following his marriage in 1903, Rosen came to New Hope from the coal mining region in western Pennsylvania where he had tried to make a living as a photographer. His premodernist work showed variety but a lack of direction, by turns reflecting the influence of French Divisionism, Redfield's dynamism, Garber's brushstroke, and Japanese art's sense of design. Rosen studied with William Merritt Chase and Frank Vincent DuMond in New York. He developed an interest in landscape after a class in Connecticut with DuMond. While Redfield influenced him mainly, his most successful work, *The Farm: Frosty Morning* (c. 1911), showed Garber's influence in its atmospheric depiction of a large haystack paired with sheep grazing in a meadow. (Both Garber and Redfield praised the work in its exhibition at the Pennsylvania Academy in 1911.) Tiring of Impressionism, Rosen went to teach at the Art Students League Summer School in Woodstock, New York, in 1918. He moved there permanently in 1920, by then working in a Cubist-realist style, associating himself with painters George Bellows, Henry McFee, and Andrew Dasburg (with whom he conducted a painting school).

In 1911, Rosen's friend Rae Sloan Bredin, a graduate of the Pratt Institute in New York and a student of William Merritt Chase, came to New Hope to visit. He studied with Lathrop, and, in 1914, joined one of the most artistically well-connected families in the area when he married

Alice Price, herself an artist and sister of Frederic Newlin Price, owner of the Ferargil Galleries in New York, and M. Elizabeth Price, a noted painter and art educator. Following a honeymoon trip to Europe, Bredin and his bride moved into a home on the towpath in New Hope, across from the Spencers at Rabbit Run. At the time, Bredin remarked, "When I returned here [from Europe] and contrasted the beauty of the Delaware Valley, I realized there was nothing like it in France." Bredin specialized in portraiture, often choosing women and children for his subjects. He also painted pure landscapes. Among the finest of these, a series of five large murals commissioned for the New Jersey State Museum in Trenton (1928), captured the topography of various regions in the state.

In 1929, Phillips Mill became the official center of the New Hope art colony. A group of artists and their friends, headed by painter William Francis Taylor, formed a subscription committee to purchase the mill from Dr. Marshall. The committee raised $6,815 in a few months, more than covering the $5,000 purchase price. The newly formed Phillips Mill Community Association, with Lathrop as president and Ruth Folinsbee, wife of painter John Folinsbee, as vice-president, held two art exhibitions a year (spring and fall) and sponsored dances, plays, lectures, dinners, and concerts. Initially, the association limited participation in its exhibitions to members, with the public admitted free until 1938, when the price of admission became twenty-five cents. In the mid-1930s the association also invited nonmembers to exhibit. The first Phillips Mill exhibition contained 125 works of painting and sculpture, most for sale, by well-known artists of the first and second generation of New Hope painters, like Garber, Redfield, Bredin, Lathrop, Snell, and Sotter. By that time, a third generation of landscape painters, including John Folinsbee, Fern Coppedge, Walter Baum, and Kenneth Nunamaker, had begun to work in the area.

John Fulton Folinsbee came to New Hope in 1916 to visit Tonalist painter Birge Harrison, with whom he had studied in 1912 at the Art Students League Summer School in Woodstock, New York. Folinsbee had his first successes in New York, showing at the National Academy of Design (1913), Macbeth Gallery (1914), and Ferargil Galleries (beginning in 1915). He and his wife, Ruth, whom he had married in 1914, participated actively in the Phillips Mill Community Association. They raised their two daughters, Beth and Joan, in New Hope, where "Jack," as Folinsbee's friends knew him, painted every day. He often passed his

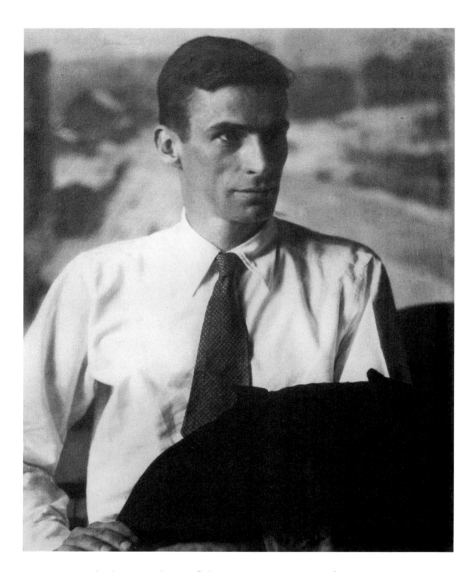

*J*ohn Fulton Folinsbee *as a young man.*
Photograph by Peter A. Juley and Son.
Courtesy of the Folinsbee family.

evenings with the members of the New Hope Scientific Society, a group of artist-friends gathered for the lofty purpose of investigating the various forms of the game of poker.

Folinsbee used soft, light colors in his early Impressionist land-scapes, creating scenes with a pleasant airiness. In his mature work, he turned to darker, somber colors, rendering landscapes and seascapes with a sense of mystery and foreboding (Plate 10). His scenes of shad fishing along the banks of the Delaware River in Lambertville typify his later expressionist style. A familiar sight around New Hope painting in his wheelchair, Folinsbee overcame the disability of childhood polio. He lived long enough (1972), as did his mentor Redfield, to see his work

pass out of fashion in the post-World War II domination of modernist styles.

Because of the Folinsbees, Harry Leith-Ross and his wife, Emily, settled in New Hope in 1935. Born in Mauritius, Leith-Ross came to this country by way of England, where he frequently returned to paint. Before his painting career, he had worked in the coal mines; he escaped them by taking up commercial art. Starting with oils, Leith-Ross found himself at the end of one of his visits to England without paint. Not wanting to purchase more oils nor deal with the slow drying time, he tried water-color as a substitute—and stuck with it. A master of the effects of light, Leith-Ross found watercolor particularly suited to his abilities.

Like Redfield, Fern Coppedge painted winter scenes (Plate 11). One of several prominent women artists working in the area, she lived in Lumberville, and then at Boxwood Studio, which she built in New Hope. Wrapped in a huge bearskin coat, working outdoors in the harshest winter conditions, she was a familiar sight. She once lamented, "Spring seems to be here, and not a single good snow the whole winter!" Her style, influenced by Gauguin and Matisse, differed from Redfield's. She used bright, intense colors interspersed with white areas of snow in works like *Mechanic Street, New Hope*. She had a cosmopolitan outlook and traveled to France and Italy in 1926. She exhibited with the Ten Philadelphia Painters, a group of women who showed their work in Philadelphia between about 1919 and 1945.

M. Elizabeth Price, known for decorative flower paintings and screens, often done with gold leaf, also exhibited with the Philadelphia Ten. Price came from a well-connected family; her sister Alice married painter Rae Sloan Bredin, and her brother, Frederic Newlin Price, owned Ferargil Galleries in New York, where many New Hope artists and members of The Ten showed their work. Educated at the School of Industrial Art in Philadelphia and the Pennsylvania Academy, she moved to New York City in 1917, where she painted, exhibited, and taught. She established several innovative teaching programs, including her "Baby Art School," sponsored by Mrs. Harry Payne Whitney. Elizabeth Price, however, felt most at home at her studio in New Hope, acquired in 1929, which she called the Pumpkin Seed because of its small size and brightly painted orange walls. The garden at the Pumpkin Seed inspired her exotic flower paintings and screens.

Walter Baum, the only member of the New Hope Impressionist group born in Bucks County (Sellersville), studied with the Civil War

painter William Trego, and then with Anshutz and Garber at the
Pennsylvania Academy, where he won the Jennie Sesnan Medal in 1925
for a painting still wet from completion in a mere twenty-four hours.
(His wife complained of "too many trees" in his original entry, so Baum
kicked a hole in it and had to produce a substitute quickly.) He painted
local scenes in a manner like Redfield's, but usually on a smaller scale.
Although working separately from the New Hope group, he shared their
fascination with the area's natural beauty, and resented the intrusion of
development and industry. An art critic and educator, Baum founded the
Baum School of Art in Allentown and the Allentown Art Museum. For
many years he wrote reviews for the *Philadelphia Bulletin* as art editor.

Other artists noted a gradual intrusion of industry into their "pristine
Arcadia." Daniel Garber, in his quarry paintings, addressed the issue of
man cutting into the land and taking its contents. Robert Spencer painted
mills, revealing a darker and more somber side of life in Bucks County.
Painter William Francis Taylor, who played a key role in the formation of
the Phillips Mill Community Association, had such concern for the effects
of pollution that he organized one of the earliest environmental groups
in the area and wrote on his concerns as a naturalist in the *Towpath*, a local
publication that he edited. Taylor, originally from Ontario, moved to New
York in 1905, where he made his living as a newspaper illustrator and
lithographer while studying at the Art Students League. Viewing Lathrop's
paintings in a New York gallery, Taylor came to New Hope in 1910, jour-
neying up the canal in Lathrop's launch to Phillips Mill. He stayed on,
first as a student of Lathrop and then as one of the better-known painters
in the area.

Mary Smyth Perkins, who attended the Philadelphia School of Design
for Women and the Pennsylvania Academy, frequently visited the
Lathrops. Winner of the William L. Elkins European Fellowship from the
School of Design for Women, she traveled to France in 1901. The Paris
Salon accepted one of her paintings. She first came to New Hope in
1909. At the Lathrops' home, she met William Taylor, whom she subse-
quently married. The Taylors joined the ranks of several noted artist-
couples who worked in Bucks County, including George and Alice Sotter,
Henry and Florence Snell, and later, Elsie Driggs and Lee Gatch, and
Paulette van Roekens and Arthur Meltzer. Called "Auntie Bill" by her
family, Mary Perkins Taylor received numerous portrait commissions. She
and her husband ran the Cuttalossa Inn. In addition, she made hooked
rugs, based on painted sketches done in a Pointillist style. William Taylor

survived his wife, who died of cancer in 1931, by many years. He took an active part in organizing and running the Phillips Mill Community Association.

By 1930, the second year of the Phillips Mill exhibition, friction developed between the Impressionists and a new group of painters who experimented with bold, unnaturalistic colors, flattened shapes, and distorted forms. These more avant-garde artists gravitated to Bucks County for reasons similar to those of the Impressionists—to live and work independently in a supportive community, despite little regular income. C. F. Ramsey, working in New Hope on and off since 1905, moved there permanently after World War I. Lloyd Ney and R. A. D. Miller came in the 1920s. Ralston Crawford, Henry Baker, Charles Evans, and B. J. O. Nordfeldt settled there in the 1930s. Despite studying at the Pennsylvania Academy, the modernists, influenced more by the European avant-garde, moved away from the accepted Impressionist and academic styles. This led to their exclusion from awards, teaching positions, and exhibitions. At the first exhibition of the Phillips Mill Community Association in 1929, they faced a jury biased toward the traditional Impressionist style.

In 1930, Lloyd Ney submitted to the Mill exhibition a painting of the New Hope canal and one of its bridges, colored red—though *too* red for juror William Lathrop. Lathrop rejected the painting. Angered by what he considered an unjustified rejection, Ney's friend C. F. Ramsey formed a secessionist group, called the New Group, which opened its own exhibition on May 16, one day before the exhibition at Phillips Mill. In doing so, the New Group followed the pattern of previous secessionist groups. Four decades before, the French Impressionists had held their first independent exhibition in Paris, opening a month prior to the official Salon against whose rigid jurying practices they protested. In the 1890s, secessionist groups held independent exhibitions in Vienna, Brussels, and other European cities. In America, the Ten American Painters broke away from the Society of American Artists and its entrenched conservatism in jurying and exhibition practices. Alfred Stieglitz exhibited the work of European avant-garde painters in his Photo-Secession Gallery in New York City (also called "291" after its location on Fifth Avenue). In 1917, the Society of Independent Artists held its first annual exhibition supposedly open to all comers (though Marcel Duchamp called their bluff by submitting a urinal under the pseudonym "R. Mutt," which they rejected).

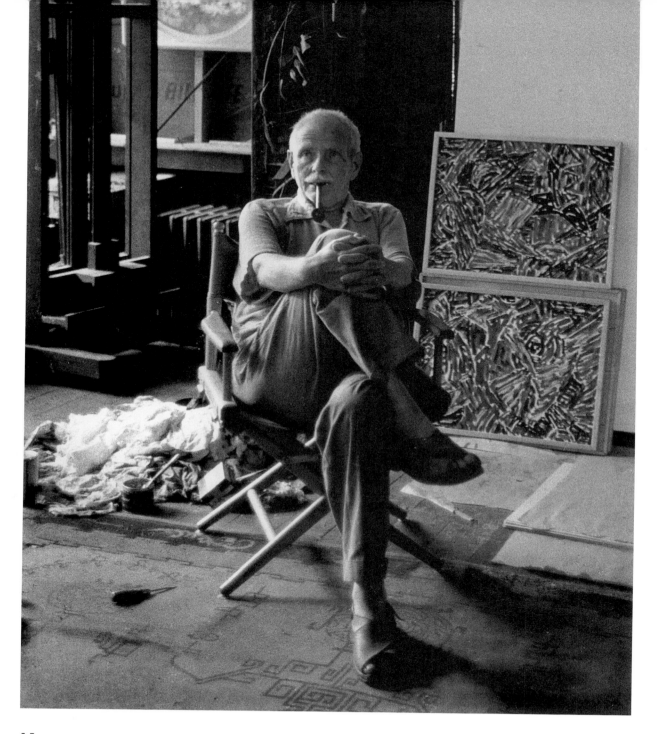

New Hope Mododernist Lloyd ("Bill) Ney in his studio. Photograph by Jack Rosen. Courtesy of the James A. Michener Art Museum.

By 1917, the Pennsylvania Academy had split into two factions: conservatives headed by Daniel Garber and modernists headed by Arthur B. Carles. The Bucks County modernists of the New Group protested not just jury standards, but the existence of juries themselves. They selected *Manchester Valley*, by naive, untrained painter Joseph Pickett, as the focal

point of their exhibition, reflecting further their negative view of academic standards. Born in New Hope in 1848, Pickett followed an itinerant life. Repairer of canal locks and a barker at carnival shooting galleries (for which he sometimes did painted backdrops), he married at age forty-five, settled in New Hope, and, until his death in 1918, ran the local hardware store. Setting up a studio in a rear room of his store and using house paints and sand, he painted local scenes in a colorful, flat, primitive style. *Manchester Valley*, one of his few surviving works, depicted a view of a section of New Hope, where the mill workers who had originally come from Manchester, England, lived.

The group called the Independents succeeded the New Group, holding its first exhibition in September 1933 at the New Hope Gallery (later renamed Pickett Galleries, located in Pickett's former home on Mechanic Street). A second exhibition followed in October 1933, coinciding with the Phillips Mill exhibition.

Reviews in *The New Hope*, a magazine founded by painter Peter Keenan, supported the modernists, while accusing Impressionists of "senile academism." Published between August 1933 and October 1934, *The New Hope* championed the work of the Independents widely, the magazine changing over the course of its twelve issues from a chatty local periodical to a radical proponent of artistic and social revolution.

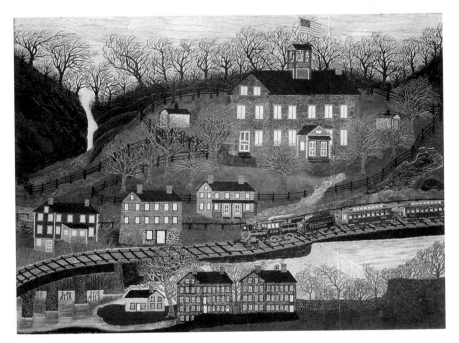

Joseph Pickett.
Manchester Valley, 1914–18?
Oil with sand on canvas.
45.5 x 60.625 in. (115.4 x 153.7 cm).
The Museum of Modern Art, New York.
Gift of Abby Aldrich Rockefeller. Photograph
© 1996, the Museum of Modern Art,
New York.

One of the few authenticated works by this New Hope primitive, little known in his own time, but today viewed as one of America's most important naive artists.

Several artists of the New Hope Independents group studied at the Pennsylvania Academy, some under Arthur B. Carles. In the early 1900s, French-born C. F. Ramsey attended the Academy, winning the first Cresson Traveling Fellowship in 1904. Ramsey explored abstraction in a manner similar to Arthur Dove, Marsden Hartley, and other painters who developed American versions of Cubism. In *The New Hope-Lambertville Bridge* (Plate 12), Ramsey depicted a familiar Bucks County landmark as boxlike cubes in pink, blue, and lavender colors. Lloyd Ney studied at the Academy. Winner of a Cresson Traveling Fellowship to Europe from 1918 to 1921, he settled in New Hope in 1925. Influenced by Wassily Kandinsky, Ney did primarily abstract, geometric compositions, including a 1941 mural for a post office in Ohio under the WPA (which did not think much of his abstract composition). For three and a half years, Ralston Crawford studied at the Academy with Henry McCarter and Hugh Breckenridge. He went on to work in New York City, winning a Louis Comfort Tiffany Fellowship. Part realist, part Precisionist, Crawford painted buildings of local interest, such as that in *New Hope Station* (1932). From 1923 to 1927, R. A. D. Miller attended the Academy. His interest in American rural subjects linked him with Regionalist Thomas Hart Benton (whom he assisted on a mural project in 1932). A frequent exhibitor at Phillips Mill, he had married Dr. George Marshall's daughter.

Charles Evans, born in Atlantic City in 1907, studied at the Art Students League in New York. He spent considerable time in Paris at the Académie Moderne with the Cubist Leger (who influenced his adaptation of the Synthetic Cubist style) and in Saint-Tropez with Hans Hofmann. In Saint-Tropez, he met fellow modernist Louis Stone. For a time, the two lived together in Cézanne's studio in the south of France. After returning to the United States, Evans settled in New Hope, and Stone in Lambertville. Along with C. F. Ramsey, they formed the Cooperative Painting Project in 1938, an experiment in collective art-making, signing their joint creations "Ramstoner," an amalgam of the three artists' names. Jazz and its improvisational style influenced them; so too the Quaker idea of consensus and a socialist philosophy emphasizing group, as opposed to individual, effort.

Swedish-born B. J. O. Nordfeldt, already an established artist, arrived in Lambertville in the year before this cooperative painting experiment. Although friendly with Evans and Ramsey, he did not participate in their project. He had studied in Chicago and Paris, apprenticed in Japanese woodblock printing in England, and worked with Marsden Hartley in

Santa Fe. There he developed an interest in Indian art and culture, as well as in the intense colors of the Southwest landscape. Somewhat depressed because of personal circumstances and disappointed with exhibition opportunities in Santa Fe, Nordfeldt sought in Lambertville the solitude of the countryside and proximity to New York galleries. Nordfeldt focused on landscapes, sea scenes, bird paintings, and religious themes, simplifying and distorting form, heightening color, and applying his paint in a thick impasto with a palette knife. In an expressionist style, he conveyed his personal vision of elemental forces.

Nordfeldt exhibited at the Lilienfeld Galleries in New York. However, poor sales made him despair. In January 1944, he wrote a letter to Emily Abbott, a former student. The letter was wholly composed of questions that revealed his state of mind: "Am I outside the pale? Can I be forgiven? Untouchable? A leperous [sic] skunk? Or what?" Their correspondence continued, with Nordfeldt requesting that Emily Abbott become his heir and cull out of his work the best to remain for posterity. Not only his heir, Abbott also became his wife. (For years estranged from his first wife, Dr. Margaret Doolittle, Nordfeldt finally divorced her, marrying Abbott in 1944.)

German-born Werner Drewes played a significant role in the history of printmaking in America, particularly woodblock printing. He came to the United States in 1930, after studying at the Bauhaus under Kandinsky, Feininger, and Klee, and working with other major European modernists like Mondrian, Albers, and Leger. Known for an expressionistic style, which he employed for both abstract and realistic themes, Drewes moved to Point Pleasant upon his retirement from a teaching position at Washington University in St. Louis. He lived in Bucks County until his death in 1972.

During the 1920s and 1930s, America had turned isolationist. Bucks County remained a relatively conservative area. In art, Americans favored realist styles, especially Regionalism. The progressive artists of New Hope bucked these national and local preferences. At the Academy, they competed with the Impressionist faction, a large number of whom had moved to Bucks County. As Arthur B. Carles put it, "One kind of student goes up the Delaware River and the other kind goes to Paris." The progressives, who had studied in Paris, found themselves living cheek by jowl with those Impressionists who had gone up the river.

Several artists associated with the Independents had national—even international—significance. Japanese-American sculptor Isamu Noguchi

(1904–1988), who leased a studio near New Hope and exhibited with the Independents in the mid-1930s, had an international following. A student of Constantin Brancusi in Paris, Noguchi worked on a large scale, using polished stone and marble. His works, often commissioned for public spaces, remind one of Surrealists Hans Arp's and Joan Miró's abstract, biomorphic forms. Despite the dominance of painters, two other sculptors deserve mention—Charles Rudy and Harry Rosin.

Charles Rudy, who often worked on a large scale and received commissions for public sculpture, produced figurative works dealing with historical or biblical themes. A student of Charles Grafly and Albert Laessle at the Pennsylvania Academy, Rudy won the Cresson Traveling Fellowship (1927–28). From 1931 to 1941, he taught at Cooper Union in New York, then moved to Ottsville, where he spent the rest of his life. His major works include a thirteen-foot-high *Noah*, winner of a 1936 competition for the facade of the Bronx Post Office, *Indian and Bear Cubs* for the courtyard of the Federal Building at the 1939 World's Fair, and *Penn's Treaty with the Indians*, part of a group of famous Pennsylvanians done for the State Museum at Harrisburg in 1964.

Harry Rosin, also a student of Charles Grafly and winner of a Cresson Traveling Fellowship at the Pennsylvania Academy, spent six years in Paris, then moved to New Hope in 1938 and joined the faculty of the Academy in 1939. He executed several familiar public sculptural works in Philadelphia, including the statue of Connie Mack for Veterans Stadium. His paired limestone figures in Fairmount Park, *The Puritan* and *The Quaker*, symbolize the two major founding philosophies of the country. In addition to public sculpture, Rudy and Rosin did portrait sculpture, and Rudy animal sculpture. Noguchi's abstraction contrasted with the work of these more traditional artists.

Not far from Rudy's residence in Ottsville lived Ben Solowey, a native of Poland who had immigrated to the United States in 1914 by way of Russia. Solowey, who studied at the Pennsylvania Academy, developed a skill in executing portraits quickly, a talent helpful in rendering his prime subjects, New York theater people, who usually had little time to spare and sat for him for as briefly as fifteen minutes between rehearsals. Working during the New York theater's halcyon days, he captured in his charcoal drawings the likenesses of Cornelia Otis Skinner, Noel Coward, Helen Hayes, Lawrence Olivier, Spencer Tracy, and Katharine Hepburn. The *New York Times*, *New York Post*, and *Herald Tribune* regularly published his theater portraits, which fellow artist Henry C. Pitz compared to John

Singer Sargent's and William Merritt Chase's work for "… alertness of analysis and a rapidity of execution that have become integral characteristics of his gifts."

Solowey moved to Bedminster in Bucks County in 1942. This change to rural life allowed him more time to paint his favorite portrait subject, his wife, Rae (though he accepted commissions for portraits of notables like FBI Chief J. Edgar Hoover and Pennsylvania Congressman Guy J. Swope). The change also allowed him to paint more landscapes and still lifes, as well as take up sculpture.

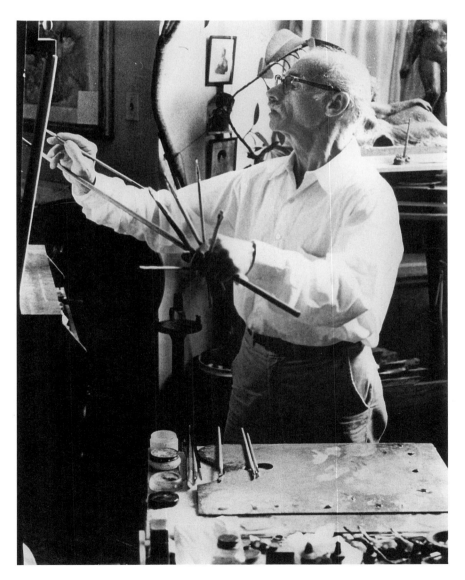

Ben Solowey at work in his studio in Bedminster in 1954. Photograph by Frank Hollin. Courtesy of the Studio of Ben Solowey.

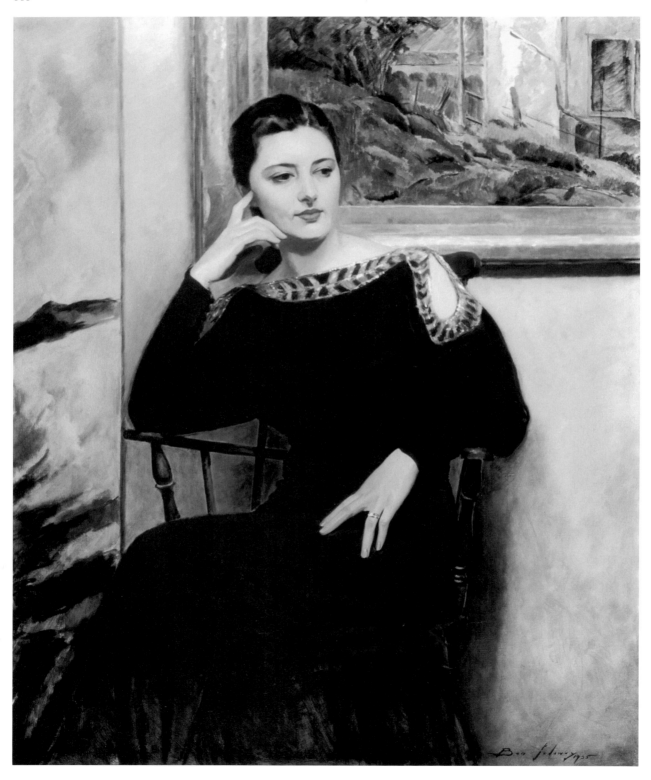

His portraits of Rae reflected the Pennsylvania Academy's training and Solowey's absorption of French nineteenth-century models (particularly the portraits of Ingres, Cézanne, and Degas, which Solowey studied in 1924 and 1925 while traveling in Europe). His 1953 painting of Rae harked back to Ingres's *Valpinçon Bather*, depicting a nude female figure viewed from behind and reflected in a mirror. Solowey, in fact, included a reproduction of the *Valpinçon Bather* in a subsequent painting, *Still Life Materials*. His Ingresque portrait of *Rae in Green Dress* also calls to mind Cézanne's frontal portraits of his wife. His portraits and still lifes reflected the lessons learned from Cézanne and Degas—tightly woven, cropped compositions, using visual quotations. After exchanging the glitter of the New York theater life for a simpler, and less expensive, one in Bucks County, Solowey grew beyond portrait illustration, becoming a painter of true accomplishment.

Although the Soloweys lived at a remove from the New Hope community, numerous artists visited them at their Bedminster farm. Rae especially welcomed the young artist Arthur Meltzer at Passover, as he read the Haggadah. The son of Lithuanian immigrants, Meltzer grew up in Minneapolis, where he learned the craft of stained glass. After serving in the Army during World War I, Meltzer planned to return to the Midwest to set up his own stained glass studio, but an Army buddy from Connecticut, sculptor Ken Bates, talked him into remaining on the East Coast to study art. He enrolled at the Pennsylvania Academy, where he studied with Daniel Garber and muralist Joseph Pearson. In 1921, he won a Cresson Traveling Fellowship to Europe. Upon his return, he taught at the Philadelphia School of Design for Women.

While at the Pennsylvania Academy, Meltzer noticed a canvas signed "P. van Roekens," which he thought a particularly fine work. He discovered the artist—a fellow teacher at the School of Design, Paulette van Roekens. Meltzer and van Roekens married in 1927.

Born in France, van Roekens came to this country while an infant. Her family made frequent return visits to France and, in 1914, managed to catch the last boat back from Le Havre before the outbreak of World War I. Van Roekens studied at the Philadelphia School of Design for Women (where she won the John Sartain Fellowship) and at the Pennsylvania Academy of the Fine Arts. The Academy acquired one of her paintings for its collection.

When van Roekens agreed to marry Meltzer, she stipulated that she must have a house with a fireplace. The Meltzers found a suitable old

Ben Solowey (1900–1978). *Rae in Green Dress*, c. 1935. Oil on canvas. Courtesy of the James A. Michener Art Museum. Purchased with funds provided by Anne and Joseph Gardocki.

Solowey's portrait of his favorite subject—his wife, Rae—reflects his training at the Pennsylvania Academy of the Fine Arts.

stone farmhouse in Trevose, whence they commuted to Philadelphia to
paint and teach on alternate days so that they could share child-rearing
duties. The Meltzers renovated the house, landscaped the gardens, refin-
ished furniture, and made rugs, curtains, and slipcovers at their home.
When the state condemned their property for construction of a highway,
they moved to Huntingdon Valley, building a new house.

Both Meltzer and van Roekens painted in a traditional manner.
Meltzer focused on landscapes while also painting portraits and still lifes;
van Roekens painted primarily colorful scenes of figures in parks and at
the beach, as well as still lifes. In 1924, a year after Meltzer started
teaching at the School of Design, his landscape *The Robe of Winter* took the
Fellowship Prize at the Pennsylvania Academy Annual. Subsequently the
Art Institute of Chicago exhibited this work, which bore remarkable simi-
larity to a later mural Meltzer painted for the Forestry Exhibit in the
Pennsylvania Building at the Philadelphia Sesquicentennial in 1926.
Meltzer installed this mural, done in three sections, each thirty feet wide,
just around the corner from Garber's mural, *A Wooded Watershed*.

Another artist-couple, painters Lee Gatch and Elsie Driggs, moved to
Bucks County from New York in 1937, making their home in
Lambertville, New Jersey, across the river from New Hope. Although they
knew many local artists, they never became part of their community. Yet
they remained in Lambertville over thirty years, until Gatch's death in
1968, even though Elsie Driggs, who had grown up in a house with four
bathrooms, hated life in the country, where she had to use an outdoor
privy and paint in the kitchen instead of a proper studio. After her
husband's death, she went back to New York.

Elsie Driggs's family had encouraged her interest in art from child-
hood; her mother had hoped to give birth to an artist and had taken
every course at the Metropolitan Museum while pregnant. She saw her
wish fulfilled in Elsie. Soon after graduating from the Art Students
League, Driggs produced several notable canvases. In watercolors, such as
Cabbage (1927), she displayed a loose expressionistic style. In her
geometric renderings of industrial subjects like *Pittsburgh* and *The
Queensborough Bridge* (both also 1927), she pioneered the Precisionist style
along with Charles Sheeler and Charles Demuth. After her marriage to
Gatch, she seemed content to help him achieve the kind of success she
already had enjoyed.

Relating more easily to the natural beauty of the area than she did,
Gatch produced abstract mixed-media collages, incorporating local stone

as symbols of his feelings about nature. A friend of Abstract Expressionist Karl Knaths, influenced by Milton Avery and the French modern masters, Gatch departed from the conservative standards of the landscape painters even more than had the New Hope Independents. He used paint, stones, cut-up fabric, sand, and newspaper in compositions that spilled out onto their frames. Lambertville's isolation allowed him to develop his mature style.

Elsie Driggs had followed in the steps of a major artist who, for a time, lived and worked in Bucks County—the painter and experimental photographer Charles Sheeler. A graduate of Philadelphia's School of Industrial Art as well as of the Pennsylvania Academy, Sheeler pursued an independent path. He spearheaded the Precisionist movement, which applied the forms of French Cubism to buildings, machines, and factories. Sheeler thus played a key role in the development of modernism in America. Along with Edward Hicks, he stands as one of the most important artists in Bucks County's history, and, like Hicks, one of national significance.

Between 1910 and 1926, Sheeler rented the Jonathan Worthington House, a small, eighteenth-century fieldstone farmhouse in Doylestown. Henry Chapman Mercer, with whom he shared an interest in early American artifacts and architecture, helped him negotiate the rental of the house, which Mercer had helped to restore. Sheeler lived there with Morton Schamberg, whose iconoclastic found-object sculptures helped introduce the ideas of the European Dada movement to America. Sheeler and Schamberg traveled together to Europe several times, there absorbing the lessons of Cézanne, Matisse, and Picasso. Until Schamberg's death in the influenza epidemic of 1918, the two artist-friends used the Worthington House as a weekend and summer retreat.

Drawn to the abstract patterning of the home's winding staircase, windows, doorway, hardware, and wood-burning stove, Sheeler made photographs of the interior. Innovative works of art in their own right, these photographs inspired later paintings like *Staircase, Doylestown* (1925) and *The Upstairs* (1938). In 1917, Sheeler began to sketch eighteenth-century barns. In his first one, *Barn Abstraction*, he reduced irregular, textured surfaces of wood, stone, and stucco to a few simple elements— to lines, planes, and rectangular shapes. (Collectors Walter and Louise Arensberg acquired this work the following year; it now hangs in the Philadelphia Museum of Art.) Numerous other studies of Bucks County

Charles Sheeler (1883–1965).
Self-Portrait at Easel, 1932.
Silver print photograph. The Lane
Collection, courtesy of the Museum of
Fine Arts, Boston.

Sheeler at work on an interior view of
the Worthington House in Doylestown,
the small stone house he rented with his
friend, Morton Schamberg.

barns followed. Finally, Sheeler alluded to Bucks County architecture in a
later, autobiographical work, *The Artist Looks at Nature* (1943; Plate 13). Here,
the artist, seated at his easel, out-of-doors, works on a large conté crayon
drawing of the Worthington House interior. In such a panoramic setting,
Hicks would have found a *Peaceable Kingdom*, and Redfield or Garber a pure
landscape. But Sheeler took inspiration from man-made objects as
opposed to nature, and from memory rather than what he saw directly
before him.

In *America as Art*, Joshua Taylor commented that in Sheeler's vision, the
city and the camera seemed well matched. So too were Bucks County
architecture and Sheeler's camera. The simplicity of the area's architecture,
a result of its distance from the urban centers of Philadelphia and New
York, and its strong Quaker tradition going back to Penn and Hicks,

appealed to Sheeler. He said, "The shapes of the early barns of Bucks County … were determined by function; one sees that, feels it. The strong relationship between the parts produces one's final satisfaction." Sheeler appreciated the interdependence of form and function in factories and machines, and equally, in the county's early homes, barns, and meetinghouses. In his analytical, detached, cool manner, he followed his purist vision. He left Bucks County before the start of the Independents' exhibitions in New Hope. But he took with him a distillation of the area's beauty (albeit man-made), in eighteenth-century architecture, in clapboard and stone barns, in the interior of the Worthington House—and with these, the foundation of a modern American artistic movement.

In the work of an artist like Sheeler, one can see that Bucks County has offered to artists more than its natural beauty. It continues to attract visual artists of many persuasions—those who picture the countryside, as well as those who do not depict the scenery but rather find in the area—despite the increasing suburbanization—a place to replenish the soul. Artists with national reputations lived here or spent time in the county as visitors or temporary residents: the early painter Thomas Birch; sculptors Jo Davidson, Jane Teller, and Selma Burke; painter Louis Bosa; and illustrator and painter William A. Smith. Other artists gained prominence locally: Faye Swengel, Ethel Wallace, Paul Crosthwaite, John Sharp, John Foster. Still others make up the contemporary scene: painters Katharine Steele Renninger and Clarence Carter; sculptors George Anthonisen, Barry Snyder, and Charles Wells; illustrator Charles Hargens; and photographer Emmet Gowin. They continue to make Bucks County a center of artistic production.

Charles Sheeler (1883–1965).
Staircase, Doylestown, 1925.
Oil on canvas. 25.125 x 21.125 in.
Courtesy of the Hirshhorn Museum and
Sculpture Garden, Smithsonian
Institution, Gift of the Joseph H.
Hirshhorn Foundation, 1972.
Photograph by Lee Stalsworth.

T*he pattern created by the boards of the*
winding staircase in the Worthington
House inspired this painting.

Select Bibliography

Chotner, Deborah. *American Naive Paintings*. Washington, D.C.: National Gallery of
Art, 1992.

Danly, Susan. *Telling Tales: Nineteenth-Century Narrative Painting from the Collection of the
Pennsylvania Academy of the Fine Arts*. Philadelphia: The Pennsylvania Academy of
the Fine Arts, 1991.

Davies, Karen. "Charles Sheeler in Doylestown and the Image of Rural
Architecture." *Arts Magazine* 59 (March 1985): 135-39.

Folk, Thomas C. *Elsie Driggs: A Woman of Genius*. Trenton, New Jersey: New Jersey State
Museum, 1991.

————. *The Pennsylvania School of Landscape Painting*. Allentown, Pennsylvania:
Allentown Art Museum, 1984.

————. *Edward Redfield: First Master of the Twentieth Century Landscape*. Allentown,
Pennsylvania: Allentown Art Museum, 1987.

Ford, Alice. *Edward Hicks: His Life and Art*. New York: Abbeville Press, 1985.

Foster, Kathleen. *Daniel Garber (1880-1958)*. Philadelphia: The Pennsylvania
Academy of the Fine Arts, 1980.

Hunter, Sam. *B. J. O. Nordfeldt: An American Expressionist*. Pipersville, Pennsylvania:
Richard Stuart Gallery, 1984.

In This Academy: The Pennsylvania Academy of the Fine Arts, 1805-1976. Philadelphia: The
Pennsylvania Academy of the Fine Arts, 1976.

Pedersen, Roy, and Barbara A. Wolanin. *New Hope Modernists, 1917-1950*. New Hope,
Pennsylvania: New Hope Modernist Project, Inc., 1991.

Stebbins, Theodore E., Jr. *The Life and Works of Martin Johnson Heade*. New Haven and
London: Yale University Press, 1975.

Troyen, Carol, and Erica E. Hirshler. *Charles Sheeler: Paintings and Drawings*. Boston:
Museum of Fine Arts, 1987.

————. *Charles Sheeler: The Photographs*. Boston: Museum of Fine Arts, 1987.

Afterword
A Brief History
of the James A.
Michener Art
Museum

None of us really knows how, or if, the events in our lives affect the currents in time's great river. So we just put one foot in front of the other, day after day, never imagining that the things we say and do could somehow make a difference to those who follow us. Yet it's surprising how often the course of history hangs precariously on a seemingly insignificant moment, a simple decision in the life of a single man or woman that ends up having consequences inconceivable at the time. Thus when a young surgeon, Dr. George M. Marshall, purchased the abandoned Phillips Mill in New Hope in 1894, he never dreamed that he was setting in motion a chain of events that would eventually lead to the founding of a museum in nearby Doylestown.

Unable to visit the mill more than a few days a week, the busy doctor convinced a friend to rent the property in 1898, and this friend, William Lathrop, was an accomplished artist. Lathrop so loved the area that the next year he bought part of the mill, and soon his many artist friends began to visit, of course bringing their easels and palettes. Within a few years the old mill had become the center of an art colony, and Lathrop and his wife were its muses. Their house became the favorite gathering place for spirited conversations and informal exhibitions. Afternoon teas, hosted by Mrs. Lathrop, soon were the stuff of legend, as creative people regularly came together to engage in lively discussions on art and the issues of the day.

One of Mr. and Mrs. Lathrop's afternoon teas at Phillips Mill, 1908. Courtesy of William Lathrop Bauhan.

As Dr. Sydney has pointed out in the previous chapter, Lathrop was certainly not the first significant artist to live in Bucks County. Painter Rembrandt Peale was born here in 1778; Edward Hicks fashioned his many *Peaceable Kingdoms*, as well as untold numbers of tavern and apothecary signs, while living in Newtown in the early nineteenth century; and the famous nineteenth-century landscape painter Martin Johnson Heade was born and raised in Lumberville. But it was Lathrop and the New Hope art colony, whose members developed a characteristic style known as Pennsylvania Impressionism, who firmly established the visual art tradition in Bucks County. In 1915, this movement was referred to by one well-known critic as "our first truly national expression," and is now recognized as one of the most important movements in the history of American landscape painting.

Other painters influenced by the modernist urge to abstraction also took up residence, and to this day the hills and fields of Bucks County are dotted with artists' studios. It's safe to say that if you come across something beautiful as you explore the county's natural areas, an artist has been there before you, and somewhere there is probably a painting of that place signed by Redfield, Garber, Spencer, Schofield, Folinsbee, Coppedge, Nordfeldt, Price, or one of a hundred other serious workers.

Artists, like prophets, are rarely honored in their own land, and to some degree this was true in Bucks County in the first half of the twentieth century. But by the late 1940s a few people in positions of influence had begun to realize that something special had been happening in their own backyard. In 1949, the county's Superintendent of Schools, Dr. Charles Boehm, with the help of artist Walter Baum, organized the Bucks County Traveling Art Gallery, a major collection of paintings by regional artists that for many years hung in the corridors of the area's schools. This collection is now owned by the Bucks County branch of the state's school system, Intermediate Unit 22. And in the 1950s, the county itself became an art collector, as civic-minded artists began to donate and bequeath works that were to be preserved for future generations.

These efforts were an important first step, but it soon became clear that what was really needed was a museum whose principal mission would be to commemorate and preserve the region's artistic heritage. There was no more passionate believer in this idea than Doylestown's best-known native son, James A. Michener. In the early 1960s, the author donated a substantial sum of money to a group of people who at least claimed to be interested in starting a museum. But this early effort was

unsuccessful. According to Michener, the money was wasted "on cocktail parties, lunches, and trips, with never a constructive step having been taken."

Frustrated by this experience, Michener abandoned his dream for a museum and the idea lay dormant until 1974, when a group of concerned citizens started the Bucks County Council on the Arts (BCCA). Led by the artist Denver Lindley, Jr., and with the assistance of Katharine Steele Renninger, Selma Bortner, Florence Schaffhausen, Herman Silverman

A view of one of the Bucks County jail's dilapidated corridors in 1982, three years before the prison closed. Photograph by James Pitrone. Courtesy of The Bucks County Courier-Times.

and others, the BCCA quickly became the focal point for the encouragement and promotion of the arts in the region. The council sponsored regular exhibitions and public programs at the Rodman House in Doylestown, and for a time published a bimonthly newsletter. With the help of the organization's first volunteer, Evelyn Fairstone, the BCCA also created an extensive archive that today contains information on more than 1,500 artists.

Problems with the size and location of the Rodman House led the Bucks County Commissioners to purchase a two-story house on Swamp Road in 1983, which they intended to convert into a museum. But the poor condition of the house made the necessary remodeling impractical, and the building was eventually torn down. It was two years later that the members of the Board of Trustees of the BCCA, along with the County Commissioners, were visited with an inspiration: Why not convert the recently abandoned county jail on Pine Street into the much-needed museum, thus preserving a historic landmark and giving the county's future generations a place to look and learn about their artistic legacy? With the energetic support of Commissioners Carl Fonash, Lucille Trench, and Andrew Warren, as well as Herman Silverman, Robert Byers, and many members of the board of trustees of the BCCA, the necessary funding was obtained and a new institution was born that was appropriately named for the man who had wanted it to happen so badly twenty-five years earlier.

The James A. Michener Arts Center was opened in September 1988 at a ceremony that was presided over by Michener and his wife, Mari, Governor Robert P. Casey, and the institution's first director, Linda Constant Buki. Soon after the ceremony, Michener provided a generous endowment gift. So the old "Pine Street Hotel," where prisoners had been kept in squalid, overcrowded cells and murderers died on the gallows, became a place where children could learn about and celebrate humanity's creative spirit. The dark, brooding dungeon that had frightened countless Doylestown children (including young Jimmy Michener) was now a symbol of the freedom and limitless possibilities of the human soul.

But what sort of symbol was it? The new facility did not have enough space to mount major exhibitions, and, even worse, the storage space for the growing collection was hopelessly inadequate. A dispassionate observer could well have argued that the place was more hype than substance. So when Bruce Katsiff took over as director in 1990, a major commitment was made to create the kind of first-rate institution that the community deserved. First the name was changed—to the James A. Michener Art Museum—in order to reflect the principal focus of the institution on the region's visual art heritage.

Two guards stand watch in 1980 in front of the prison doors, which now mark the entrance to the Michener Art Museum. Photograph by Bill Johnson. Courtesy of The Bucks County Courier-Times.

The deserted guardhouse of the Bucks County prison on April 25, 1987, just prior to the initial construction of the museum. Photograph by James Pitrone. Courtesy of The Bucks County Courier-Times.

A view of the Michener Art Museum showing the transformation from an abandoned prison to a state-of-the-art museum facility. Photograph by Brian Peterson. Courtesy of the James A. Michener Art Museum.

Then a drive was begun to raise the funds necessary to construct a professionally oriented facility, with greatly expanded exhibition areas and a storage vault that would meet the highest museum standards. With support from a remarkable range of businesses, members of the community, the board of trustees, and local and national foundations, the fund-raising campaign was completed in January 1993. The elegant new museum, designed by the Doylestown architectural firm Lynn Taylor and Associates, was opened to the public on July 18, 1993.

The dramatic moment in March 1993 when workers complete the granite sign at the entrance to the museum. Photograph by Gian Luiso.

It would have been very easy at this point for people to simply sit back and congratulate themselves on a job well done. With the new building up and running, and the many fine exhibitions it would house, the story of the visual arts in Bucks County would be told. But as the contents of this book demonstrate, that story is but one chapter of a much larger tale. The need to tell people about the "big picture" particularly haunted Mr. Michener, since he had known and worked with some of the most famous figures present during the county's "golden years."

So it was that in the late summer of 1992, the museum's namesake summoned several of the institution's key personnel to his Maine residence. His reasons were mysterious, but he assured them that it was "a matter of substance." When they all sat down in his spartan kitchen to talk, Mr. Michener began to speak passionately about the contributions of artists to our society, and how those contributions often go unrecognized. He eloquently expressed his concern that the larger story of the arts in Bucks County be told, in the form of an exhibition that celebrated the region's artistic heroes. He was prepared to back up his concern with a substantial sum of money that would be used to create a physical and intellectual monument to the county's artists, and, by inference, to artists in general.

The response of the museum's board and staff to this idea was a mixture of enthusiasm and fear. What the famed author was proposing was an exciting and worthwhile idea, and it represented an unprecedented level of commitment on his part to the institution. On the other hand, the museum was less than four years old, and was in the middle of an ambitious expansion project whose success was by no means certain.

Though the board of trustees decided to begin the project in the fall of 1992, it was clear when the construction bids arrived several months later that to continue the effort with the available funds would have endangered the financial health of the institution. Mr. Michener's response to the board's decision to postpone the project was gracious, but there was no hiding the fact that he was deeply disappointed.

When the author's wife, Mari, died in September 1994, she left both her husband and the people of Bucks County a final gift. She bequeathed five million dollars to the museum, with the specific instructions that the institution finally realize her husband's dream of honoring the memory of the artists who had given Bucks County its cultural identity. At this point, the museum had successfully completed its expansion and was financially stable, so the board decided enthusiastically to finish the project, and to name the new wing after her. The Mari Sabusawa Michener Wing was opened to the public on October 27, 1996.

A worker puts the finishing touches on the roof of the Mari Sabusawa Michener Wing just prior to its being lifted and attached in November 1995. Photograph by Bruce Katsiff. Courtesy of the James A. Michener Art Museum.

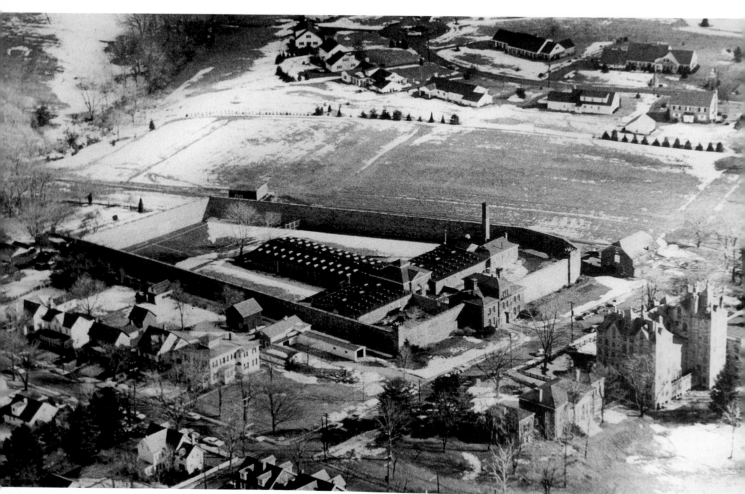

*A*erial photograph of the Mercer Museum and the Bucks County jail taken in January 1967. Photograph by Ron Brown. Courtesy of The Bucks County Courier-Times.

The centerpiece of the new wing is a major long-term exhibition that focuses on twelve of the best-known artists who lived and worked in the county: Pearl S. Buck, Daniel Garber, Oscar Hammerstein II, Moss Hart, Edward Hicks, George S. Kaufman, Henry Mercer, Dorothy Parker, S. J. Perelman, Edward Redfield, Charles Sheeler, and Jean Toomer. The multimedia, hands-on exhibition also includes a computerized database with information on hundreds of historic and contemporary Bucks County artists, as well as a video theater showing clips from more than forty movies that feature the work of Bucks County novelists, screenwriters, actors, etc.

So in less than ten years, the Michener Art Museum went from a forlorn-looking, abandoned guardhouse in an empty field to a thriving institution that is now truly the home of Bucks County's artistic soul.

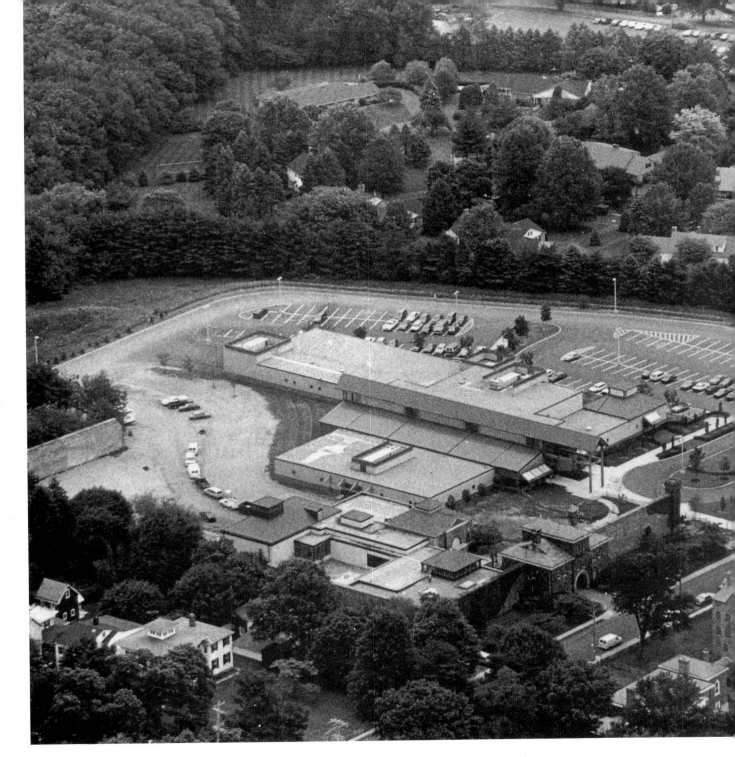

*A*erial photograph, taken in June 1993,
showing the newly renovated Michener Art
Museum and the Bucks County Free Library
complex. Photograph by Alex Prince.

In a place where prisoners once stood, two generations share a moment of quiet reflection. Photograph by Brian Peterson. Courtesy of the James A. Michener Art Museum.

William Lathrop hard at work building "The Widge," his beloved boat, which he used as an outdoor studio while painting seascapes. Photograph by Robert Neff Longacre, from American Magazine, November 1927. Courtesy of William Lathrop Bauhan.

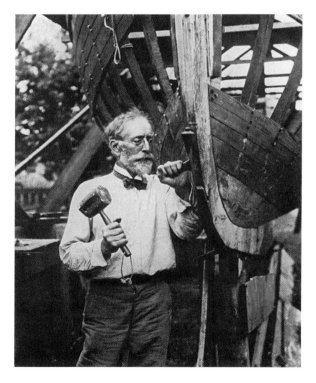

William Lathrop, of course, didn't live to see the day when the art colony he had nurtured so selflessly finally found a permanent home. In 1938, while painting seascapes from a boat near Long Island, Lathrop was caught in a great hurricane. His tiny vessel broke free from its mooring, and he drowned while trying to swim back to land. His last painting was found lying on the bottom of the boat when it finally washed ashore, creating what must have been a poignant memory for his friends and family. But while Lathrop and most of the other artists are gone, their work remains, and the tradition they created continues. In a very real sense their memory will live on, as will the memory of future generations of the region's artists, because the people of Bucks County in the 1980s and '90s had the imagination, the commitment, and the vision to turn a prison into a museum.

Appendix 1
"Revolutionary
Theater" at
Washington Crossing

On June 27, 1939, Philadelphia's *Evening Bulletin* sent a writer named Paul Cranston to interview me for the opening of the Bucks County Playhouse, slated to take place four days later. I had been told that Cranston was the paper's top feature writer, and that made me uneasy. We met on the front steps of the Playhouse. He had apparently been drinking before he arrived, and that made him edgy and opinionated. He confided to me that he did not care for the theater. It looked like a difficult evening ahead.

I was very trepidatious because of my inexperience. I was twenty-two years old and anxious to get off on the right side of the press, the most important component of a successful summer theater. I was still more fearful that my inexperience would betray my naïveté. I had a very good press agent and I thought he could share my dilemma with this snarling reporter. So I suggested my agent join us. "Nah," Cranston replied. "I didn't come up here to talk to a goddam press agent." "Okay, let's have dinner," I suggested. "Where?" he inquired. I recommended Colligan's, up-river in Stockton, New Jersey, a favorite with the press during the Lindbergh trial in nearby Flemington. "Let's go," he agreed.

As we drove out of the theater parking lot, I tried to divert the conversation from the theater by saying, "The family who lives in that house, known as the Parry Mansion, have occupied it since the American Revolution." "What do you know about the Revolution!" he snapped. "That's my specialty!"

From that inauspicious beginning grew one of the nicest friendships I have ever had. Cranston did not take any notes that night. He asked a few vague questions and, in general, gave no indication of what he was going to write. I was so intimidated by his manner, I made no suggestions. The story appeared two days later—and it was wonderful. His style was just right. Every quote from me was exactly as I had spoken it. This was one of his many talents. It was his last story written as a reporter— he was promoted the next day to feature editor.

Cranston was my inspiration. We often talked about George Washington and the American Revolution. It was his favorite subject, and it fast became mine. In the spring of 1953, I visited Washington Crossing State Park, on the Pennsylvania side of the Delaware River between New Hope and Yardley, and was amazed to be shown a rock about four feet high with a brass plate that read, "It was alleged that from this spot, George Washington, with 200 soldiers, launched the attack against the British in Trenton on Christmas Night, 1776."

Residents of the area didn't seem very impressed with the crossing site. There was little to distinguish it from the rest of the countryside. Around the park, there were a few unidentified, boarded-up stone buildings that had probably stood there since the Revolution. There was also a nondescript public park on the New Jersey side of the river, in Hunterdon County. In it stood a small old cottage with pathetic examples of early American furniture. A stone barn behind it was used for storage. Nearby was the ferry landing spot where Washington presumably stood with Nathanael Greene, witnessing the hazardous night crossing of his men through the floating ice and blowing snow. The State of New Jersey had thoughtfully converted this historic site into a public toilet, which was actually more convenient than the facility provided for tourists on the Pennsylvania side of the river.

It seemed to me that the public should be more aware of this spot and the role it played in early American history. Had Washington not defeated the British at Trenton and Princeton, the leaders of the Revolution might well have been captured and hanged as traitors. Taking an almost impossible gamble with untrained men and no finances or trustworthy backers, Washington reversed the trend of failure with an unexpected victory and revitalized the hopes of liberty lovers all over the world.

Paul Cranston and I decided we would try to increase public awareness of the Washington Crossing site by crossing the Delaware River as Washington did, on Christmas Day. Our idea for reenacting Washington's surprise invasion of New Jersey was greeted mostly by laughter and ridicule. The Park Commissioner would not condone it because the Park was closed on Christmas Day and the guards were not on duty. "It can't be done," he declared. My silent reply was "Try and stop us."

A week before the first scheduled reenactment in December 1953, I sent press releases to newspapers in Philadelphia, Camden, Trenton, Lambertville, and Doylestown, as well as *The New York Times*. Of all the papers, only the *Times* covered the event. When the *Times* reporter arrived, he kept asking, "What's your gimmick?" "I have none," I answered. "Well, I don't believe you!" he said. I replied, "If you find out what my gimmick is, you tell me, because I would like to know it." Apparently the young man changed his attitude. He wrote a very nice piece. He *did* write, kiddingly, that "the only ice that day was in the participants' drinks following the Crossing." The *Times* story made the event "big time." Even

so, it took the Park Commissioners five years to open the park for visitors on Christmas Day. The guards were very unhappy.

Over the years, a number of personages have joined me to celebrate Washington's passage and eventual triumph. Among them were James Michener, impersonating Colonel Henry Knox; writer Budd Schulberg playing James Monroe; and Ann Hawkes Hutton, the head of the Washington Crossing Foundation, who disguised herself as a soldier and I looked the other way while she clambered aboard the forty-four-foot Durham boat.

With each year's reenactment of the crossing, the public and the press became more enthusiastic. It was estimated that by 1957 over 5,000 people had witnessed the event from both sides of the Delaware.

*S*t. John Terrell as George Washington, preparing to cross the Delaware River. Courtesy of Pennsylvania Historical & Museum Commission, Washington Crossing Historic Park.

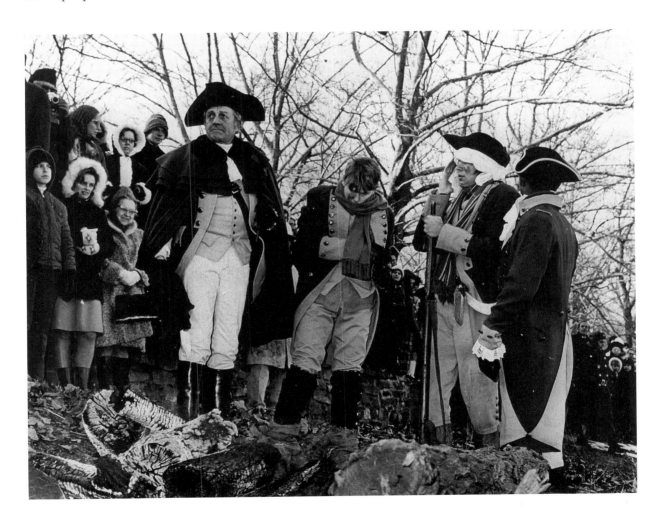

Appendix 2
Memories of the
Early Bucks County
Playhouse

I first time I saw St. John Terrell, the founding producer of the Playhouse, was in New York's Martin Beck Theater in 1935. Young, lithe, and handsome, he was cast in a supporting role of a sailor in Maxwell Anderson's poetic *Winterset*, which won the New York Drama Critics Award. The leads were played by veteran stage stars Burgess Meredith, Margo, and Richard Bennett. Terrell would later bring Bennett and Meredith to New Hope.

When I saw Terrell again, it was 1939. The opening of the Playhouse was only weeks away, and he was saturating Bucks County with publicity. A born showman, he was eloquent, warm, and witty. Elizabeth North, his stage manager, spoke endlessly to civic and women's clubs, and other gatherings about the new theater, which was being rushed to completion.

The first play was *Springtime for Henry*. In the cast, along with leading man Edward Everett Horton, were Haila Stoddard of Springfield Township in upper Bucks County, and Julie Haydon, who was to become famous for her roles in the Broadway productions of *Shadow and Substance* and *The Glass Menagerie*.

In that initial season, Terrell joined Richard Bennett and Haila Stoddard in a revival of Sidney Howard's *They Knew What They Wanted*. Bennett recreated his original role in the 1924 Pulitzer Prize-winning production. Stoddard and Terrell were superbly exciting as the lovers. Bennett, crusty and outspoken, told me off-stage that his daughter, Constance, was the only one of his three daughters who could act. "I used to read Shakespeare to her in the backyard and teach her how to perform," he said.

During Terrell's one-year reign, he always appeared on the porch of the Playhouse before performances, giving theatergoers their money's worth even when he wasn't on stage. A fashionplate, he invariably wore his hat rakishly, at just the right angle. One evening when my best friend, writer Grace Chandler, and I approached the theater, she suddenly stopped in her tracks. "Lester," she said, shocked. "St. John has no shirt on!" I looked over at Terrell greeting people on the porch, and he did indeed appear to be shirtless. When we got close enough, we saw that he was actually wearing a shirt of the faintest, palest pink. That was Terrell for you, always ready to be different. Every other man in the crowd was wearing a conventional white shirt.

Shrieks of glee and bursts of applause echoed through the Playhouse in 1941 when two Bucks County playwrights appeared in their own

Broadway play, *The Man Who Came to Dinner*. George S. Kaufman and Moss Hart were joined on stage by the famous Harpo Marx. The show played to standing-room-only audiences at every matinee and evening performance.

One of my favorite character actresses, long on Broadway, was Mildred Natwick. In 1963 she appeared in *Nobody Loves Me* at the Playhouse. Also in the Neil Simon play was a handsome young actor by the name of Robert Redford. While Natwick and I talked, laughed, and enjoyed each other, Redford listened quietly. He was superbly good-mannered, and behaved himself all through the two-way gabfest. Before he left, he told me he was worried about a sty on his face. After all, an actor's face is his showcase. I told him that with a smudge of makeup, no one could detect the sty on his handsome face. The tryout of *Nobody Loves Me* turned into *Barefoot in the Park* on Broadway, and Redford went directly to Hollywood to become a star.

W. Lester Trauch presents a commemorative edition of the Doylestown Intelligencer to his friend and classmate, James A. Michener, in May 1985. Courtesy of W. Lester Trauch.

Index

Locators in **semibold italics** indicate photographs, illustrations, or reproductions of works by an artist.